KOREAN LANDSCAPE PAINTING:

Continuity and Innovation Through the Ages

KOREAN LANDSCAPE PAINTING:

Continuity and Innovation Through the Ages

by
Yi Song-mi

HOLLYM

Elizabeth, NJ·Seoul

KOREAN LANDSCAPE PAINTING : Continuity and Innovation Through the Ages
by Yi Song-mi

Planning, management, and financial support provided by

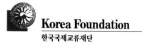
Korea Foundation
한국국제교류재단

Edited by Rose E. Lee

First published in 2006
by Hollym International Corp.
18 Donald Place, Elizabeth, New Jersey 07208, U.S.A.
Phone: (908) 353-1655 Fax: (908) 353-0255
http://www.hollym.com

Published simultaneously in Korea
by Hollym Corp., Publishers
13-13, Gwancheol-dong, Jongno-gu, Seoul 110-111, Korea
Phone: (82-2) 735-7551~4 Fax: (82-2) 730-5149, 8192
http://www.hollym.co.kr e-mail: info@hollym.co.kr

Hardcover edition ISBN: 1-56591-230-6
Paperback edition ISBN: 1-56591-231-4
Library of Congress Control Number: 2006921691

Printed in Korea

Contents

PREFACE AND ACKNOWLEDGEMENTS

This book was planned and published by the Korea Foundation as part of the Korean Culture Series. The series is aimed at disseminating ideas and knowledge of Korean art and culture to English-speaking areas of the world. Books in this series are comparable to the set called "The Great Centuries of Painting" by Editions d'Art Albert Skira, particularly to those volumes on the "Treasures of Asia" published in the 1960s. However, the "Treasures of Asia" included volumes on Chinese, Japanese, Persian, Arab, Central Asian, and Indian painting, but not on Korean painting. This book was written in the hope of filling that gap.

Like the Skira series, the books in the Korean Culture Series have numerous color illustrations, but for easy reading, no footnotes. Books of any size or scope are not possible without the previous contributions of scholars in that particular subject, and this book is no exception. Thus, at the end of this book, a detailed bibliography has been provided to acknowledge the debt owed to other scholars, and to help readers find sources for further reading. If I may single out one scholar to whom I owe most, it is Professor Ahn Hwi-joon of Seoul National University, who has laid the basic groundwork for the study of Korean Painting since the late 1970s. For readers with knowledge of Chinese, Sino-Korean, and Sino-Japanese characters, a glossary of names and terms in those characters is provided.

I would like to express my gratitude to my editor Rose E. Lee, a longtime friend, who has patiently transformed my manuscript into more readable form through several edits. My thanks should also go to my research assistant, Sin Seon-yeong, a graduate student at the Academy of Korean Studies, for her tireless effort in locating and putting together material for the illustrations, glossary, and bibliography.

Finally, my heartfelt gratitude should go to my husband, Professor Han Sung-joo, former Ambassador to the United States (2003 to 2005). He has always made my working environment as comfortable as possible, especially after our move last February back to Seoul from Washington, D.C. Without his thoughtful care and unfailing support for my work, this book might not have gone to press on time.

January, 2006

I. Introduction: Continuity and Innovation in Korean Landscape Painting

Korea, a peninsular nation approximately half the size of California in the United States, is a land of mountains. More than 70 percent of its landmass is mountainous and from time immemorial, Koreans have defined their existence by the mountains around them. Physically and spiritually, man and mountain in Korea have been interwoven, forming an integral whole, and giving birth to a distinctive art and culture.

In Korea's mountainous terrain, there are waters everywhere: imposing mountains with high waterfalls, steep gorges with swiftly gushing streams, and rolling hills with meandering rivers. Unsurprisingly, the word landscape in Sino-Korean consists of two characters: *san*, meaning mountain, and *su*, water. To make the word landscape painting, or *sansu-hwa*, the suffix *hwa* which means painting is added.

Korea's geographical proximity to continental China promoted the spread of Chinese art and culture to the peninsula from early times. Landscape painting was no exception. From the Three Kingdoms period (53 BCE-668 CE) to the mid-Joseon period (17th century), Korean landscape painting developed in close connection with that of China in underlying philosophy, theme, media, and style. However, Korean painters were able to assert their native character in ways that were distinct from their Chinese counterparts. The Koreanization of *sansu-hwa* on Korean soil eventually blossomed in the eighteenth century in true-view landscape or *jingyeong sansu* which depicted the scenic spots of the peninsula. In the nineteenth century, after the introduction of Western painting techniques, at first by way of China, and then later by way of Japan or directly from the West, Koreans became extremely conscious of their own cultural roots. This consciousness of tradition has persisted into the landscape paintings of contemporary Korea.

In the following overview, five works from the early Joseon period to the present that represent important themes and developments in Korean landscape art will be introduced. The works will not appear in chronological order, but in a way that modern viewers can see some of the continuums which link Korea's artistic past and present.

The *Late Autumn* (fig. 1) dated to 1961 by Yi Sang-beom (1897-1972), is a soothing view of countryside with a hill in the background, a row of poplar trees in the middle ground, and a stream in the foreground. Like many of Yi's landscape paintings, this does not depict a specific scenic spot, but a generalized view of the Korean countryside in the 1960s. Although Yi also painted true-view landscapes in the celebrated true-view (*jingyeong*) tradition of eighteenth-century Korea, it is for this type of unspecified scenery that he is best known. By not limiting himself to a given scene, he was able to compose his own image, or unique concept of a Korean landscape. In this landscape, we see the "immobile mountain" and the constantly "moving water" in the foreground harmoniously integrated by sweeping bands of mist. Thus

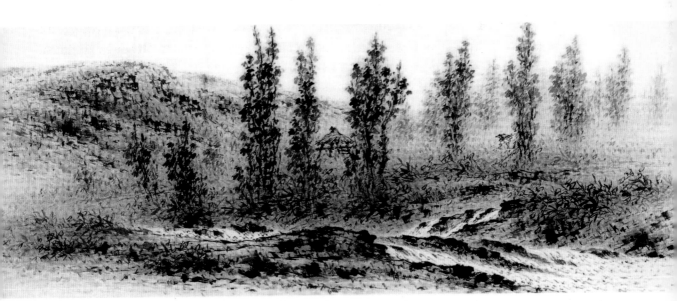

Fig. 1) Yi Sang-beom, *Late Autumn*, dated 1961. Ink and light color on paper, 78 × 210 cm. Ministry of Foreign Affairs and Trade, Korea

we are reminded of the oldest reference to mountain and water in East Asian literature, the *Analects of Confucius*: "The Wise man delights in water, the Good man delights in mountains. For the Wise move; but the Good stay still. The Wise are happy; but the Good secure." (*The Analects*, VI: 23, Arthur Waley trans.)

The above passage is generally credited for the elevation of landscape painting to its supreme position in the hierarchy of painting themes in East Asian art. Thus, it was the Confucian view of the universe that gave blessing to landscape painting in China, Korea and Japan. Yet it was the Daoist view of the harmony between man and nature that gave birth to the monumental Northern Song landscape paintings where tiny human figures are tucked into unobtrusive positions. Man should not intrude upon the magnificence of the landscape, but should quietly be a part of its complete whole. Yi Sang-beom acknowledged his indebtedness to this age-old Daoist tradition of East Asian landscape by diminishing the presence of man in his landscape. A farmer comes into focus in the middle ground only when the viewer tries hard to find him. He is walking toward the right with an A-frame on his back. Also in the middle ground is a thatched structure erected on stilts, a perch from which farmers could rest or watch over their crops. Often seen in Korean countryside, this anecdotal detail adds another human element to the idyllic pastoral scene.

Yi Sang-beom executed this painting mostly in the age-old media of ink accented with light colors. However, his brush strokes do not follow the texture strokes that are readily found in traditional Joseon ink landscape paintings. Instead, his painting consists of a series of hook-like strokes created by very rapid, repeated movements of the brush, and dots of indistinct shape. Yi's signature dots are unlike conventional Mi ink-dots, named after the Northern Song painter Mi Fu, and also unlike the standard axe-cut texture strokes used to texture land or rock surfaces in traditional East Asian ink landscape painting. No Chinese or Japanese landscape painting of any period compares with this landscape by Yi in uniqueness of theme and technique.

The *Mountain* (fig. 2) painted in 1966 by Yu Yeong-guk (1916-2002) in oils on canvas represents the same philosophical approach to

Fig. 2) Yu Yeong-guk, *Mountain*, dated 1966. Oil on canvas, 163.2×130 cm. Ho-Am Art Museum, Seoul

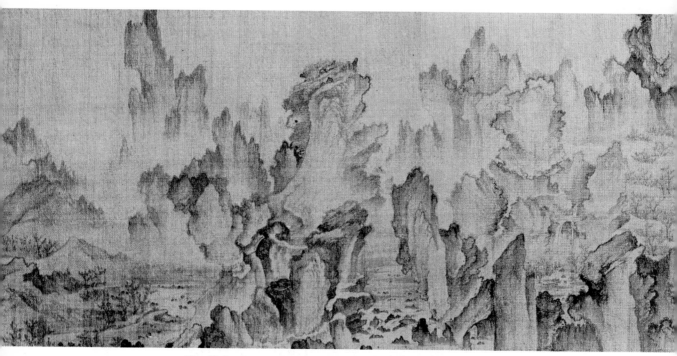

Fig. 3) An Gyeon, *Dream Journey to the Peach Blossom Spring*, dated 1447. Handscroll, ink and light color on silk, 38.6×106.2 cm. Tenri Central Library of Tenri University, Nara.

depicting mountain landscapes found in Yi's painting. The main feature in both landscapes is the immobile mountain with a conical peak that has been flattened at top. Although very abstract, we see in Yu's canvas what can be understood as water, a yellow horizontal line that separates the mountain from its reflection below. The triangular patch of sky in the upper right corner is in the same bright yellow, so the yellow horizontal line is also the sun shining on the water. To the left of the mountain, the sky is blue, and there are rays of blue and green light both on the mountain and on the water rendered in flat, but gradually textured color.

Yu was one of the first few Korean artists to train and experiment with Western geometric abstractionism in Japan during the 1940s. His works of the post-1960s period, however, tended to be representational. They are less about pure geometric forms, and more about the abstracted forms of nature based on concrete reality as in this *Mountain*. Yu's older contemporary, Yi Sang-beom was also influenced

by Western methods of rendering landscape space. Early in his career Yi used chiaroscuro but soon reverted back to the more traditional East Asian practice of obscuring the middle ground with a band of mist or using lighter ink for objects in the far distance.

Although very different in appearance, media, and style, and painted by two Koreans who were nearly 20 years apart in age and who were both exposed to the influx of Western art, a common thread runs through these two paintings. Both are interpretations of the mountain as a "landscape of the mind." In this fundamental concept of East Asian landscape art, the artist paints the landscape not as his eye sees it but as his heart-mind sees it.

The third painting is an early Joseon painting by the celebrated court painter, An Gyeon (act. mid-fifteenth century) entitled *Dream Journey to the Peach Blossom Spring* dated to 1447 (fig. 3). Done in ink and color on silk, this handscroll painting is the earliest securely dated and documented landscape painting of the Joseon period. An Gyeon was asked to paint Prince Anpyeong's (1418-1453) dream in which the Prince roamed around the landscape of the Peach Blossom Spring that had been described in the famous literary piece of the same name by the Chinese fourth-century poet Tao Qian (365-427).

Tao's short lyric poem was composed during the Six Dynasties period when China underwent repeated political unrest between the fall of the Han dynasty in 220 and the establishment of the Sui dynasty in 518. In the story, a fisherman entered the mouth of a cave by a stream, lost his way, and took a journey to the Peach Blossom Spring where presumably descendants of the Qin Empire lived peacefully without knowledge of the fall of the Han or of any political change since then. After spending several dream-like days in the pastoral paradise, the

fisherman returned home, carefully marking his way. When he attempted to return to the Peach Blossom Spring, he could not find his way. Since then, no one has ever succeeded again in finding this "utopia," although An Gyeon has successfully painted it.

To depict Prince Anpyeong's dream vision, An Gyeon chose the so-called Li-Guo style of the two famous Northern Song landscape painters, Li Cheng and Guo Xi. This style is characterized by dramatically shaped mountain peaks of soft earthen masses shrouded in drifting bands of mist, accentuated with gnarled trees terminating in branches that resemble crab's claws. An's choice of the dramatic Li-Guo style for this painting is fitting as the theme of this painting calls for fantastic scenery. The traditional viewing order of a handscroll progresses from right to left, but this painting should be read from left to right. At the entry point, there is no path through which we can enter the scene due to the steep peaks that block the misty area where the peach trees can be seen in full blossom. In a hidden nook, we see the small boat the fisherman had moored under an arching tree. In the upper right corner fantastic rocks hang overhead. Snugly tucked beneath the rocky masses are thatched houses around which several "ancient" villagers can be spotted.

As it is based on a Chinese literary theme, paintings of the *Peach Blossom Spring* are by definition once removed from reality. An Gyeon's *Dream Journey* is yet another step further removed from reality as it depicts the vision of Prince Anpyeong's dream. The mountains and waters in this landscape painting masterfully evoke the beauty of that "unreal" world. There are many Chinese and Japanese paintings that depict Tao Qian's *Peach Blossom Spring*, but none show such a high degree of other-worldliness as this. In that sense, this is a unique painting in the history of East Asian landscape art. An's influence is evident in many late fifteenth- and sixteenth-century Korean landscape paintings.

In the late seventeenth and early eighteenth century, Korean landscape painters shed Chinese-inspired themes and turned their attention to the depiction of Korean scenery. The painter whose name is

almost synonymous with the birth of true-view landscape painting, or *jingyeong sansu*, is Jeong Seon (1676-1759). This new trend of landscape art, however, existed side by side with traditional non-Korean landscape themes, which Jeong Seon and his contemporaries continued to paint. True-view landscape was an expression of Koreans' pride in their own land and a novelty in the development of Korean landscape painting. Jeong's *jingyeong* masterpiece, *Clearing after Rain on Mount Inwang* (fig. 4) dated to 1751 is a work of his mature period. Mount Inwang (fig. 5), which defines the traditional western border of Seoul, looms prominently over downtown Seoul west of the Gyeongbok-gung palace.

In his painting, Jeong Seon rendered Mount Inwang's large rocky peak in bold sweeping strokes of dark ink to maximize the effect of the contrast between the bright creamy tones of the rock surface and the unpainted clear blue sky. Like Yi Sang-beom, Jeong Seon is famous for creating his own texture strokes rather than employing the traditional texture strokes that had been developed and used since the tenth century in China. These bold dark strokes are Jeong's own creation at its best. The dark drama of the rocky surfaces is enhanced by the soft dots texturing the earthen hillocks of Mount Inwang on which small vegetation grows. The dots are reminiscent of texture strokes that originated in Song China by the artist Mi Fu. Jeong Seon had no qualms about utilizing borrowed elements along with texture strokes of his own creation to achieve bold effects. We will return to this masterpiece and the historical and cultural background that gave rise to true-view landscape painting in Chapter V.

The last work in our overview is a digitalized image of a traditional landscape by Whang Inkie [Hwang In-gi] (b. 1951) called *Like a Breeze* (fig. 6), that was exhibited in the Korean Pavilion at the 50th Venice Biennale. This work, hard to call it a "painting," proclaims the breaking of conventional distinctions between the mediums of painting, sculpture, ceramics, etc., in contemporary Korea. And yet, Whang takes as his model a well-known landscape in the An Gyeon style by Yi Seong-gil (1562-?) entitled *Nine-Bend [Stream] at Mount Wuyi* dated to

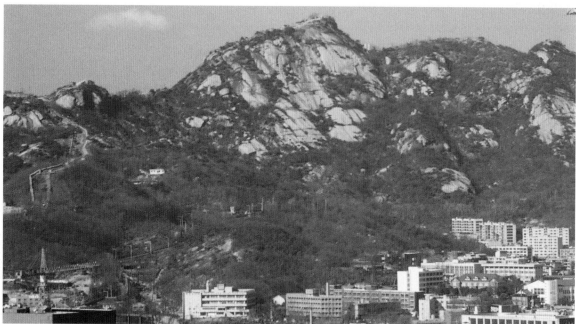

Fig. 4) Jeong Seon, *Clearing after Rain on Mount Inwang*, dated 1751. Hanging scroll, ink on paper, 79.2×138.2 cm. Ho-Am Art Museum, Seoul

Fig. 5) Mount Inwang, Seoul. Photograph by Yi Song-mi, 1998

1592 (fig. 7). This landscape is a representation of an actual scene in China. Due to the scene's strange geological formations, Yi's use of An Gyeon's style, based on the Li-Guo style, is well suited to the subject.

Whang realized the possibility of transforming Yi's relatively "small" painting which measures 33.6 x 398.5 cm, into a large work that filled the long curving wall and three other smaller walls of the Korean Pavilion. He blew up Yi's painting to 240 x 2,800 cm or about 50 times the original size. When seen from a distance, anyone who is familiar with the history of Korean painting immediately recognizes it as Yi Seong-gil's painting. Once again, there is the common thread that connects past and present.

Whang's use of the ultramodern techniques of digitalization and blown-up pixels onto glass walls as the painting surface instead of traditional silk or paper brings us up to the twenty-first century. A work of art is just a work of art; it can be one thing or many things all at once. The viewer goes through the entire 28-meter length of Whang's "wall painting" as if it were a piece of installation art. Like the installation of *The Gates, Central Park, New York, 1979-2005* (fig. 8) by Christo and Jeanne-Claude which was unveiled on January 22 of 2005, we "experience" Whang's work physically as we walk along the wall mounted with his painting. While we walk, we cannot help but think of all the historical and cultural events of Korea that fill the time span between the end of the sixteenth century and the beginning of the twenty-first century. The more erudite viewer might even go back to the time of Confucius when the mountains and waters were blessed with the highest realm of human thought.

The two common threads of continuity and innovation, which we have briefly previewed, is a phenomenon that occurs time and again through successive dynasties of Korean landscape painting history. Throughout its 5,000-year history, contacts between Korea and other cultures gave fresh stimuli to Korean art and self-awareness and creative energy to Korean artists for innovations that transformed existing conventions and created new styles. In the chapters ahead, we

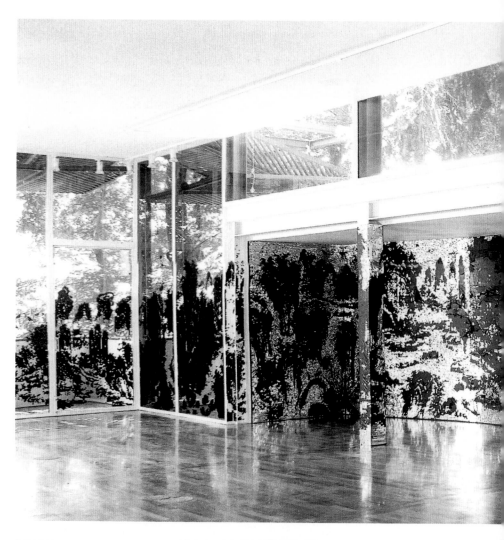

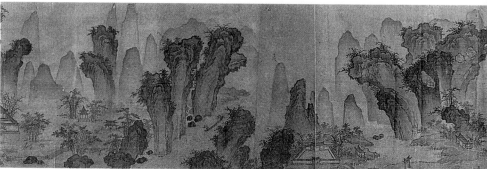

Fig. 6) Whang Inkie [Hwang In-gi], *Like a Breeze*, dated 2003. Silicon, acrylic mirrors and vinyl, 240 × 2,800 cm. Korean Pavilion, 50th Venice Biennale
Fig. 7) Yi Seong-gil, *Nine-Bend [Stream] of Mount Wuyi*, dated 1592. Handscroll, ink and light color on paper, 33.5 × 398.5 cm. National Museum of Korea, Seoul

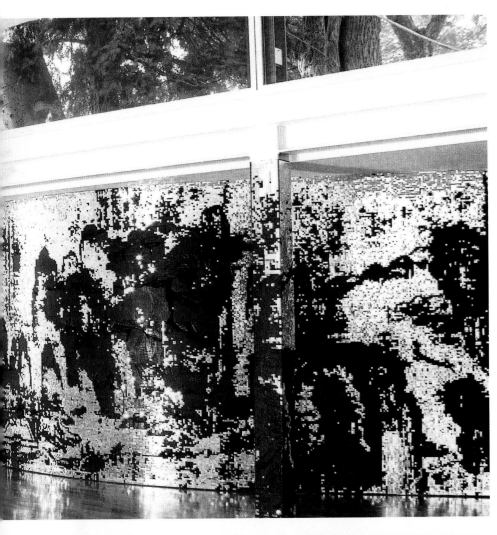

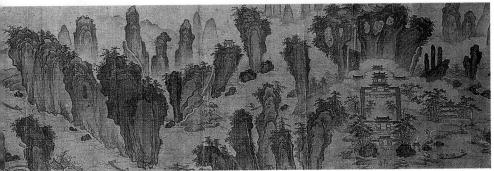

will explore in greater detail and in chronological order how these two dynamic forces played out in Korean painting history. We will also introduce the great artists who made it happen and explore the exhilarating world of their landscapes.

Fig. 8) Christo and Jeanne-Claude, *The Gates, Central Park, New York, 1979-2005*.
Photograph by Erica H. Ling, 2005

II. Formative Stages: The Three Kingdoms and the Unified Silla Periods

Historical Overview

Vestiges of painting in Korea, including landscape painting, can be traced back to the Bronze Age (10th century-1st century BCE). The earliest specimens of landscape art are from the Three Kingdoms and the Unified Silla periods.

The Three Kingdoms period spans the first century BCE to 668 CE, when three separate kingdoms, (Old) Silla (57 BCE-668 CE) in the southeast, Baekje (18 BCE-660 CE) in the southwest, and Goguryeo (37 BCE-668 CE) in the north, which included much of Manchuria, shared control over the Korean peninsula. Map 1 shows the division of the Three Kingdoms during the reign of the Silla king Jinheung (r. 540-576). There was another political entity, the federation of Gaya in the lower reaches of the Nakdong-gang river in Gyeongsangnam-do province, but it was absorbed into Silla in 562. This three-part division of the peninsula ended in the mid-seventh century when Silla, with the help of Tang China, took over the territories of Baekje and Goguryeo in 660 and 668 respectively.

However, Silla failed to capture the whole territory of Goguryeo, and in the area north of the Daedong-gang river in today's Pyeongannam-do province, another nation called Balhae was established by Dae Jo-yeong, who succeeded in capturing much of the old Goguryeo territory as shown in Map 2. Therefore, the period after 668 to the beginning of the Goryeo dynasty in 918 is called either the Unified Silla period or the period of the Southern and Northern Dynasties. Historians, archaeologists, and art historians in recent years have been trying to reconstruct Balhae's culture. Since there is not much surviving painting from the Balhae and no signs of landscape painting, we cannot include it in this book.

From the Three Kingdoms to the Unified Silla period, Korea received the advanced culture of continental China, and in turn, transmitted it to Japan. Goguryeo was the first to receive Buddhism from China's Eastern Jin dynasty in 372, and soon Baekje followed in 384. Silla finally accepted the foreign religion in 521 from China's Liang dynasty, and in 527 Buddhism became the official court religion after the martyrdom of Yi Cha-don. Along with a new religion, Koreans also received Chinese Buddhist sculpture, architecture, and medicine, which they transmitted to Japan.

Confucianism was also introduced to Korea around the fourth century. Confucian moral values were greatly stressed among all classes of people in each of the Three Kingdoms. In 372, Goguryeo established the Taehak (National Confucian Academy) and in 640, sent students to Tang China for study. It is recorded that the people of Goguryeo were reading the Five Classics of Confucianism as well as other Chinese history books. In Baekje, Chinese characters were used to record history as early as the fourth century. Japan received Chinese characters as well as Chinese classics from a Baekje scholar named Wang In (act. during the reign of King Geunchogo, r. 346-375), who, at the invitation of the Japanese king taught those classics to Japanese courtiers. In Silla, we learn that kings attended Confucian classics lectures, and after unification, a Confucian college was established in 682. In 747, during the reign of King Gyeongdeok (r. 742-765), the college changed its name to Taehak-gam (National Confucian University). Prior to unification, Silla established a youth corps called *hwarang* (flower-youths) that abided by the Five Injunctions of Hwarang (*hwarang ogye*) which incorporates Confucian morals with Buddhist teachings. Members of the *hwarang* played a crucial role in the unification process.

During the Unified Silla period, especially in the mid-eighth century, Silla's Buddhist culture reached its peak. Present-day Gyeongju, the capital city of the Silla kingdom for ten centuries, is dotted with the remains of many Buddhist stone and gilt-bronze images, large temple bells, and old temple sites. Some of the temples, such as Bulguk-sa temple, which had been destroyed many times in the

past, have been rebuilt to their original form after the Korean War. Along with the man-made cave temple of Seokguram, which boasts the finest stone Buddhist images in Korean history, Bulguk-sa temple was designated as a UNESCO World Heritage site in 1995.

Landscape paintings of the Three Kingdoms and the Unified Silla periods are mostly from Goguryeo and take the form of tomb mural paintings. Surface decorations on small-scale metalwork and clay tiles from Baekje also give us insight into the formative stages of Korean landscape painting.

Goguryeo Tomb Murals

There are about 80 painted tombs from Goguryeo, which are located principally in three areas. The three are the Jian district of Jilin province, China; the area around Pyeongyang in the Gangseo district of Pyeongannam-do province, North Korea; and in the lower reaches of the Daedong-gang river in Hwanghaebuk-do province, also in North Korea. Only two painted tombs bear inscriptions with dates. The earlier mural, known as the Tomb of Dongsu, dated to 357, does not have any landscape elements. The later one, located in Deokheung-ri, near Pyeongyang, bears an inscription with the date 408, and is decorated with a *Hunting Scene* (fig. 9) on its ceiling. An equestrian figure turns backward to shoot an animal in a mountain enclosure in the shape of the Chinese character *san* ("mountain"). On the top of the mountain's triangular peaks as well as on four other smaller "mountains," trees with branches and leaves are painted to reinforce the idea that these triangular shapes should be read as mountainous terrain. Early painting in China also utilized this triangular element to represent a landscape setting. The *Hunting Scene* is the earliest dateable "landscape" in Korean painting.

Another more widely-known Goguryeo tomb mural is the *Hunting Scene* (fig. 10) from the Tomb of the Dancers now in China's Jian district. The tomb is dated to the early 6th century based on the

Fig. 9) *Hunting Scene*, tomb dated 408. Ceiling Painting at Deokheung-ri Tomb, Gangseo district, Pyeongannam-do province

Fig. 10) *Hunting Scene,* 5th-6th century. Wall Painting at the Tomb of the Dancers, Jian district, Jilin province, China

structure of the tomb and the painting style of its murals. In this hunting scene, we also see a hunter on horseback turning his body backward to shoot running deer above stylized mountain peaks depicted in undulating bands of light and dark colors. In this scene, there are other hunters and animals as well as smaller mountain peaks surmounted by abbreviated trees similar to the ones in the Deokheung-ri ceiling painting.

Fig. 11) Hunting Scene on Inlaid Bronze Tube, Eastern Han dynasty (25-220 CE). Tokyo National University of Fine Arts and Music

In these two representations of mountain peaks and trees, there are lingering stylistic vestiges of Han Chinese painting. Goguryeo, the northernmost of the Three Kingdoms, came in closer contact with Chinese art of the Han and post-Han Northern Dynasties. It was in the Pyeongyang area that the Han colony of Lolang [Lelang] persisted until 313, continuing to exert influence on Goguryeo culture. The undulating bands of mountains on Goguryeo murals can be seen in the decor of an Eastern Han Inlaid Bronze Tube showing a hunting scene (fig. 11), now in the collection of the Tokyo National University of Fine Arts and Music. Also the abbreviated tree forms resemble the landscape elements painted on the Clay House Model (fig. 12) of the Han period in the Nelson-Atkins Museum of Art, Kansas city.

In the *Mountain Landscape* mural of the Great Tomb at Gangseo (fig. 13) near Pyeongyang, which represents the last stage of development of Goguryeo tombs, we find a more plausible depiction of overlapping layers of distant mountain peaks. The four mountain peaks were rendered so the viewer can establish a sequence of peaks receding in landscape space. Also there are vertical parallel lines on the surface

Fig. 12) Landscape Elements on Painted Clay House Model, Han dynasty (206 BCE-220 CE). Nelson Gallery-Atkins Museum of Art, Kansas City

Fig. 13) *Mountain Landscape*, 6th-7th century. Wall Painting of the Great Tomb at Gangseo. Gangseo district, Pyeongannam-do province

Fig. 14) *Landscape*, 6th-7th century. Wall Painting of Tomb No. 1 at Pyeongjeong-ri. Anak district, Hwanghaenam-do province

of the peaks that resemble the texture strokes of later landscape painting. Drifting clouds are even added on either side of the mountain peaks to enhance the effect of natural scenery. This scene, which fills one side of the lantern ceiling in the tomb is small, but shows how far landscape painting of the Three Kingdoms period had evolved.

The three early Goguryeo tomb murals above were all executed on dry plastered wall with natural mineral colors. A North Korean excavation of 1989 reports that at Tomb No. 1 of Pyeongjeong-ri in the Anank district, Hwanghaenam-do province, there is another early mural *Landscape* (fig. 14) done only in ink that spans three walls of the tomb, on the east, north, and west. From the tomb, according to the report, a continuous screen of Mount Woram and Mount Guweol can be seen to the north, the northeast, and the west. The wall mural depicts mountain peaks and an inscription of several characters appears on the upper right corner. However, since some of the characters cannot be deciphered, this inscription does not help date the tomb. It is significant that the mountains were done only in ink. Scholars of Chinese painting now trace the beginning of ink monochrome landscape painting in China to some time in the mid to late Tang period, or the late eighth to ninth century. Therefore, it seems that, independent of the Chinese, there existed in Korea the practice of painting landscape in ink monochrome before Goguryeo ended in 668.

We do not know who the occupant of the tomb is, but it is tempting to assume that the person was aware of the biography of Zhong Bing (375-443) in which Zhong was recorded to have said that when he became old and unable to roam around in the mountains, he would like to paint mountains on the walls of his room and lie in bed roaming around the mountains of his imagination. Zhong Bing was the first Chinese to write an essay on landscape painting that has survived under the title of *Preface to Painting Landscape*. His story is responsible for the creation of the term *wayu*, or "roaming mountains while at rest." This term came to symbolize the yearning for wandering in unspoiled landscape settings, and has been the theme of countless landscape paintings in East Asia. The occupant of Pyeongjeong-ri Tomb No. 1 might have been someone who was so steeped in the tradition of *wayu* that he had his tomb mural decorated only with mountains.

The Baekje and Silla Kingdoms

Goguryeo's cultural influence reached into the southwest to the kingdom of Baekje, which also produced several painted tombs. However, none of the Baekje murals have landscape elements. Instead, we find vestiges of landscape art in Baekje craft items. The decor on the lidded Silver Cup with Saucer (fig. 15) excavated from the tomb of King Munyeong (r. 501-523) is an example. The dome-shaped lid is topped with a small flower bud that serves as a knob. Around the outer rim of the lid is a circle of undulating linear designs that crest into mountain peaks. Even in this stylized form, the main peak in the center and the two flanking it are differentiated. Vegetative elements grow from the sides of the flanking peaks and, within the boundary of the main peak, a symmetrically branched tree flourishes. Even though this is a small and extremely stylized rendering of landscape, it should still be viewed as a distant relative of Baekje landscape paintings from the early sixth century that have not survived.

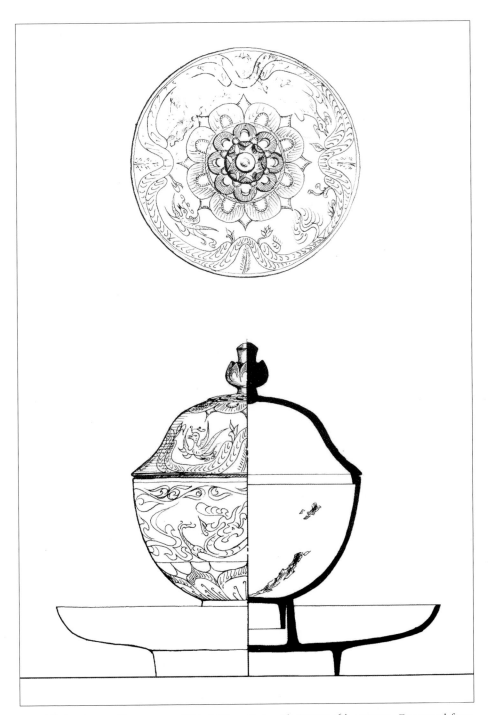

Fig. 15) Landscape Elements on Lidded Silver Cup with Saucer, 6th century. Excavated from Tomb of King Munyeong. Buyeo National Museum

Fig. 16) Landscape Scene on Earthernware Tile, 7th century. 29.6×28.8×4 cm. National Museum of Korea, Seoul

In the seventh century a better picture of Korean landscape painting emerges from a series of clay tiles that were used as wall and floor coverings in tombs and palaces. From a tile known as the Landscape Tile (fig. 16), discovered in Gyuam-ri, Buyeo, the last capital of Baekje, and dateable to the early seventh century, we find depictions of mountain peaks in the form of the character *san* with three peaks. They are not unlike the mountains in the Deokheung-ri Tomb ceiling painting, but here the peaks are rounded on top to represent soft earthen mounds. They overlap one another to create an impression of

layered mountains with tree growth on top. Among the soft earthen peaks are occasional upright members with sharp triangular tops, which likely represent rocky peaks. In the foreground are horizontal lines and rough oblong shapes, which might be simplified rendering of water flowing below the mountains. The linear depiction of drifting clouds in the sky adds an atmospheric effect.

By far the most interesting feature of this Landscape Tile is the representation of a human figure in thin relief lines at the lower right corner. In Goguryeo murals the mountains are conspicuously smaller than the figures of hunters. In this landscape, the standing figure, while large, is inconspicuously tucked into the mountain on the lower right as if roaming among the mountains and waters. The Confucian spirit of taking delight in mountains and waters finds its full artistic expression in this depiction of landscape on a small Baekje clay tile.

The third and longest-lasting kingdom of the Three Kingdoms period, Silla, also left a few painted tombs, but none comparable to those of Goguryeo. There are landscape elements in a tomb located in Eumnae-ri, Sunheung district in Yeongju, Gyeongsangbuk-do province, but the murals have been severely damaged. Only a group of barely visible mountain peaks have survived on the painted murals.

Silla, however, provides us with the only documentary evidence of an eighth-century Korean painter. He was named Solgeo, and he seemed to have painted in the blue-and-green landscape style developed during the Six Dynasties period (222-589) in China. According to the *Memorabilia of the Three Kingdoms* (*Samguk yusa*), Solgeo painted a pine tree on the wall of Hwangnyong-sa temple that looked so real birds would fly head on into it only to fall to their deaths. Years later, the painting faded, and another painter retouched some parts to refresh the colors, but no birds were ever fooled again into flying into the wall. This story suggests that the blue-and-green landscape tradition was known in Silla, and temple walls were decorated with landscapes of convincing realism. Since Solgeo is recorded to have painted an image of the Indian sage Vimalakhirti on the wall of the Dansok-sa temple in Jinju, Gyeongsangnam-do province which dates to

the Unified Silla period, he was probably active during the eighth century.

The abundant remains of landscape painting on Goguryeo tombs, the landscape elements on small Baekje craft items, and the documentary reference to Silla landscape painting all point to the existence of a highly developed tradition of landscape art in Korea before the tenth century. It is regrettable that the Korean peninsula has been subject to much warfare and little remains of Korea's early painting. The tomb murals of Goguryeo were collectively designated a UNESCO World Heritage site in 2004, and hopes for preservation from further destruction are high.

III. Crosscurrents: The Goryeo and the Early Joseon Periods

Historical Overview

The Goryeo Dynasty:

Toward the end of the 9th century, Unified Silla began to show signs of decline, and two other powers arose that claimed to be the rightful heirs to Goguryeo and Baekje. The former was led by Gungye who declared himself king of Later Goguryeo in 901. The latter, led by Gyeonhwon, was established as Later Baekje in 892. These two powers, together with Unified Silla, ushered in a period known as the Later Three Kingdoms. In 918, a general named Wang Geon, a subordinate of Gungye, seized power and established a new kingdom, Goryeo. In the following year, Wang Geon moved his capital from Cheolwon in Gangwon-do province to Songdo in Gyeonggi-do province. Songdo is in present-day Gaeseong, now part of Hwanghaebuk-do province. Wang Geon dealt a final blow to Unified Silla in 935 and defeated Later Baekje in 936, thus bringing an end to the Later Three Kingdoms period. Map 3 shows that the vast territory of Goryeo in the late 10th century extended north beyond the Cheongcheon-gang river in Pyeonganbuk-do province.

During the eleventh century, Goryeo suffered two devastating invasions from China: the Khitan Liao invasion of 1056, and the Mongol Yuan invasion of 1231. During the Mongol invasion, the Goryeo court had to flee from its capital in Songdo to Ganghwado island on the mouth of the Han-gang river. Prior to the Mongol invasion, General Jeong Jung-bu seized power in 1170, and established military rule over Korea until 1270, when the Goryeo court returned to

its capital after the victorious Mongols left. However, the Mongols demanded that Goryeo kings marry Mongol princesses, and that Goryeo crown princes stay in the Chinese capital, Yanjing, as hostages. This humiliating situation lasted until the end of the Goryeo dynasty. A positive by-product of this humiliation was the cultural exchanges between the two countries. The Mongol princesses brought to Korea many useful things, including a great deal of Chinese painting. While a hostage in Yanjing as the crown prince, King Chung-seon (1275-1325) established a famous studio called *Mangwon-dang*, or the "Studio of Ten Thousand Volumes." This is where Goryeo as well as Yuan scholars gathered for cultural exchanges.

Due to the patronage of the early Goryeo court, Buddhism flourished throughout Korea, resulting in the production of high quality Buddhist paintings, sculptures, and architectural monuments. Another notable contribution was the woodblock printing of the first edition of the Buddhist canon, the *Tripitaka Koreana*, completed in 1087. The Mongol invasion all but destroyed this valuable set of woodblocks, and there remain only scattered volumes printed from the set, to which we will return shortly. On Ganghwado island, the Goryeo court launched an ambitious project to produce a new set of woodblocks of the *Tripitaka Koreana* in hopes of enlisting the power of the Buddha to expel the Mongols. Finally, in 1251, a set of 81,258 new blocks was completed. This set still remains at the Haein-sa temple in Hapcheon, Gyeongsangbuk-do province and was designated a World Heritage object by UNESCO in 1995.

Another important cultural achievement of the Goryeo was the creation of celadon wares. Goryeo celadon first developed under the influence of Chinese celadon, but soon surpassed it in quality. The Goryeo also invented the new technique of inlaying decorative motifs with white slip and iron-saturated clay. No culture other than Goryeo has developed this technique, making inlaid Goryeo celadon unique in the history of world ceramics.

During the Khitan and Mongol invasions, the country lost many of its architectural monuments as well as paintings made with the

perishable materials of paper and silk. That is why we have so few extant paintings from the Goryeo period. Furthermore, many post-invasion Goryeo Buddhist paintings were looted in the subsequent Japanese invasion of 1592 and still remain in Buddhist temples and private collections in Japan.

The Early Joseon Period:

The Joseon dynasty (1392-1910) was established in 1392 by General Yi Seong-gye (1335-1408) who seized power from the ineffective rulers of Goryeo. The territory of Joseon at the beginning of the fourteenth century was somewhat smaller than its territory in the fifteenth century (Map 4). In 1394 Yi Seong-gye, who later became King Taejo (r. 1392-1398), moved the capital from Songdo to Hanyang (present-day Seoul) and began the building of palaces, royal ancestral shrine, and other important structures. Most of these still remain intact even though heavily reconstructed at various times in the past. Two of the structures, the Changdeok-gung palace and the Jong-myo royal ancestral shrine, were refurbished for the last time after the Korean War and both are now registered as UNESCO World Heritage sites.

Unlike Goryeo, which patronized Buddhism, the Joseon dynasty adopted Neo-Confucianism as its state creed. In the Neo-Confucian world order, everything in the universe exists in a hierarchical yet harmonious relationship. This view of the universe also extended to the world of man, where ideal relationships among the components of human society were defined according to the Confucian concept of "the three bonds and the five cardinal relationships" (*samgang oryun*). Throughout the Joseon period officials were recruited by state examinations that tested for knowledge of Confucian classics. For a man, the ideal in life was to pass the state examinations, enter officialdom, and gain fame and wealth. The scholar-official in Joseon times exerted a greater control over the affairs of the state than ever before.

During the 512 years of the Joseon dynasty, the country suffered devastating invasions from Japan and China. There were the two major invasions from Japan instigated by the Japanese shogun Toyotomi Hideyoshi. The first is known in Korean history as the *Imjin waeran* (Japanese turmoil in the cyclical year *imjin*, 1592), and the second is known as the *Jeongyu jaeran* (Japanese repeat turmoil in the cyclical year *jeongyu*, 1597). It was during this turmoil that many Korean potters were taken to Japan, to play key roles in the development of Japanese ceramics. Several potters who are famous in Japan today are descendants of those captured Korean potters.

As soon as the country recuperated from the two Japanese invasions, two equally devastating invasions came from the Manchus who were expanding their control over China. The first was the invasion of 1627, known as the *Jeongmyo horan* (Chinese barbarian turmoil in the cyclical year *jeongmyo*, 1627). Nine years later, the Manchu emperor Taizhong [Abahai, 1592-1643], drove his army south to the Joseon capital in no time. The Korean king Injo (r. 1623-1649) fled to Namhan Mountain Fortress but was met with the invading Manchu army. King Injo's surrender to the conquering Manchu generals is the most humiliating one in Korean history. This second invasion is known as the *Byeongja horan* (Chinese barbarian turmoil in the cyclical year *byeongja*, 1636). The Manchus gave themselves the dynastic name of Qing, overthrew the Ming dynasty in 1644, and ruled China until 1911.

The height of early Joseon culture occurred during the reign of the fourth king, King Sejong the Great (r. 1418-1450). In 1420, he established in the palace the scholarly institution called *Jiphyeon-jeon* (Hall of Assembled Worthies), where able young scholars were privileged to research various academic fields. From this institution came numerous contributions to Korean culture during Sejong's reign. By far the most important achievement is the invention of the phonetic Korean alphabet *hangeul* in 1446. This is the writing system Koreans still use today. Sejong was interested in music and ordered Bak Yeon (1378-1458) to create *aak* ritual music to be played at the ancestral rites of the Jong-myo royal ancestral shrine. He also ordered the *Jiphyeon-jeon*

scholars to establish the basic rites of the nation. This effort culminated in 1474 with the publication of the *Five Rites of State* (*Gukjo orye ui*) during the reign of King Seongjong (r. 1469-1494). This manual served as reference for important state rites throughout the dynasty with some revisions in the late Joseon period. It was also during Seongjong's reign that the first National Code (*Gyeongguk daejeon*) of Korea was compiled.

Landscape Painting of the Goryeo Dynasty

Although there is only a small number of surviving Goryeo paintings, documentary evidence dated to both Goryeo and Northern Song times abound with sources from which we can trace the crosscurrents of artistic activity between China and Korea. It is through such contacts that Korean literati painting evolved under the influence of Song literati culture. There are records of paintings of the Four Gentlemen (plum, orchid, chrysanthemum, and bamboo) as well as landscapes, portraits, and other themes produced by both literati and professional painters during the Goryeo. The documentary evidence testifies to the presence of a more active and diverse art milieu on the peninsula than in previous periods. We learn from Guo Ruoxu's *Experiences of Painting* (*Tuhua jianwenzhi*) of the 1070s that King Munjong (r. 1047-1082) sent Kim Yang-gam to Song China to buy paintings. Later in 1076, the king sent another emissary, Choe Sa-hun, along with several court painters, on a similar mission. Choe had the painters copy the wall paintings in the Xiangguo-si temple, and, upon return to Goryeo, recreate them on the walls of Heungwang-sa temple at the capital in Songdo.

In Guo Ruoxu's *Experiences of Painting*, it is also recorded that the Goryeo court sent folding fans decorated with landscapes to China. Guo describes the painting style of the fans as quite atmospheric, making us believe that impressionistic ink paintings of landscapes were already prevalent in the early Goryeo period. Unfortunately, no Goryeo monochrome ink landscapes have survived to support Guo's statement. But it is interesting that Guo's word for the folding fan is *aishan*, or

Fig. 17) *Landscape*, 11th century. Woodblock print from the *Imperially-Composed Explanation of the Secret Treasure* (IX-3), 28×54.4 cm. Nanzen-ji temple, Kyoto

"Japanese fan," suggesting that the folding fan originated in Japan. From there it went to Korea and then to China. This provides evidence that the practice of painting landscapes on folding fans in Korea began as early as the early Goryeo period.

Also preserved by the Chinese is the *Illustrated Book on Goryeo* (*Gaoli tujing*, Kor. *Goryeo dogyeong*) written in 1124 by Xu Jing, who visited Goryeo as the Song emperor Huizong's (r. 1101-1125) emissary. Xu's observations on Goryeo life were quite extensive and included architecture, food, costume, cosmetics, ceramics (particularly Goryeo celadon), transportation, and of course, the political system. Unfortunately, the original illustrated version of Xu's book has not survived. Only the text survives and it contains information on things Goryeo unavailable from other sources. For example, it is likely that inlaid celadon had not been invented in Korea by the time of Xu's visit to Goryeo during the first quarter of the twelfth century because he makes no mention of it.

The most famous court painter of the mid-Goryeo period was Yi Nyeong (act. first half of the 12th century). According to his biography in the *History of Goryeo* (*Goryeo-sa*), Yi accompanied a Goryeo emissary to the court of Emperor Huizong, where he was asked to teach painting to several scholars at the famous Hanlin Academy. The Song emperor also asked him to paint the scenery of the Yeseong-gang river in Korea. Upon seeing the painting, Huizong praised Yi as the best painter of Goryeo, and awarded him with bolts of silk, fine food, and wine. The records also show that Yi painted a scene of the South Gate at Cheonsu-sa temple. There is no way to determine Yi's painting style, but since his paintings made a strong impression on Huizong, one of the finest connoisseur-painters of art to sit on the Chinese throne, we can be sure that Yi's landscapes must have been quite accomplished. The emperor's high praise suggests that the scenery Yi painted was refreshingly different from the scenery found in contemporaneous Song paintings. From the above, we can deduce that the practice of depicting Korean scenery started as early as the twelfth century, much earlier than the so-called true-view landscape painting that emerged on the peninsula in the eighteenth century.

Like China, Goryeo undertook the production of the Buddhist canon as early as the eleventh century. As mentioned earlier, the Goryeo court launched the ambitious project of printing the entire Buddhist canon for the first time in hopes of expelling the Liao forces through the power of the Buddha. This project most probably began in 1011 and lasted until 1087. All the woodblocks of this first edition of the *Tripitaka Koreana* were destroyed during the Mongol invasion in 1232. But a few printed versions of the edition, complete with landscape illustrations, still survive. Of the surviving versions, the Nanzen-ji temple in Kyoto, Japan, has a 30-volume set entitled the *Imperially Composed Explanation of the Secret Treasure* (*Eoje bijangjeon*). Scene no. 3 of vol. IX is shown here (fig. 17). The SungAm Archives of Classical Literature in Seoul has vol. VI of another set of the same edition (fig. 18). It is in these woodblock illustrations that we find vestiges of early Goryeo landscape painting. Both the Nanzen-ji and

Fig. 18) *Landscape*, 11th century. Woodblock print from the *Imperially-Composed Explanation of the Secret Treasure* (VI-3), 22.7×52.6 cm. SungAm Archives of Classical Literature, Seoul

the SungAm illustrations show landscapes depicting Buddhist priests preaching in mountainous settings with streams in the foreground.

This eleventh century edition of the *Tripitaka Koreana* was based on the Northern Song Kaibao era (968-976) editions, which contained illustrations of contemporaneous Chinese monumental landscape styles. Since the format of each printed section of the *Tripitaka* is horizontal, unlike the vertical format of most Northern Song landscape hanging scrolls, the tall mountain peaks of the landscapes in the *Tripitaka* illustrations appear compressed. To compensate for the loss of spatial depth, the illustrator created space by overlapping the peaks and by inserting deep gorges between the peaks. Clouds and mist are rendered in linear fashion due to the limitations of the woodblock printing technique, but they nonetheless convey the atmospheric effects of ink monochrome painting.

The artistic results of cultural exchanges that took place in King Chungseon's aforementioned "Studio of Ten Thousand Volumes" in

Yanjing can be seen in Korean paintings of the fourteenth century. The famous Yuan literati painters, Zhao Mengfu and Zhu Deren were among the Chinese scholars who frequented the studio. The scholar-official Yi Je-hyeon (1287-1376) was their Goryeo counterpart. Both Zhao Mengfu and Zhu Deren were practitioners of the Li-Guo style of landscape painting in the thirteenth century and their influence is reflected in the only surviving landscape painting by Yi Je-hyeon, entitled "Crossing the River on Horseback" (fig. 19). Yi has depicted a wintry scene with a frozen river below a diagonal cliff from which hangs a pine tree with exposed roots, painted in the characteristic Li-Guo style. The snow-covered shore across the river is rendered in linear fashion with slightly graded ink. Two men on horseback are seen crossing the frozen river and three others are about to cross on the right shore. Wintry trees with sharp branches are scattered about, also rendered in the Li-Guo style. It is easy to assume that Yi Je-hyeon, through his contacts with Yuan literati painters, picked up the Li-Guo syle of painting landscapes practiced by the Chinese.

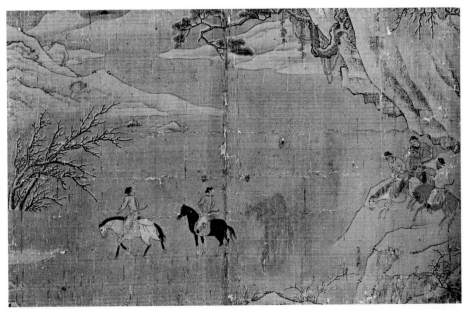

Fig. 19) Yi Je-hyeon, "Crossing the River on Horseback," 14th century. Album leaf, ink and light color on silk, 28.8 × 43.9 cm. National Museum of Korea, Seoul

Goryeo is perhaps more famous for its Buddhist figure paintings. Many have survived in Buddhist temples and private collections in Japan, and, though smaller in number, also in museums and private collections in Korea and the West. These Buddhist figure paintings are of very high quality, and a few have landscape elements in them. According to the inscription on the left edge of the *Bodhisattva Ksitigarbha* (fig. 20), a painting done with gold pigment on a small lacquer screen, the artist was a monk named No Yeong of the Seonwonsa temple in Gangdo island and the date of execution was 1307. Measuring only 22.5 x 13 cm, it depicts a seated Buddha in the lower half of the panel with a standing Bodhisattva Ksitigarbha at the upper right. In the lower left, we see a tiny kneeling image in prayer. The rest of the space is filled with wavy lines that represent rocks amidst sea waves and jagged mountain peaks emerging from clouds. The linear depiction of the mountain peaks recalls those in the landscape handscroll of the Northern Song painter Xu Daoning now in the collection of the Nelson-Atkins Museum of Art in Kansas City. Xu's landscape is painted in the manner of the Li-Guo school, to which this panel also belongs stylistically.

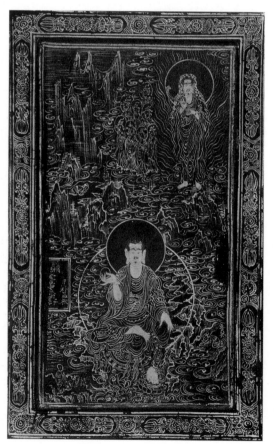

It has been suggested that this painting might be the depiction of King Taejo (r. 918-943) praying in Mount Geumgang, or the Diamond Mountains. Located in Gangwon-do province, the Diamond Mountains are considered the most scenic spot in the peninsula. It was recorded in the *History of Goryeo* that a painting of these mountains was sent to the Yuan court in 1304 during the reign of King Chungnyeol. It is plausible that the mountain peaks in this small

Fig. 20) No Yeong, *Bodhisattva Ksitigarbha*, dated 1307. Lacquered screen with gold pigment, 22.5×13 cm. National Museum of Korea, Seoul

panel represent the jagged peaks of Mount Geumgang. They would be immortalized later in the eighteenth-century true-view landscapes of Jeong Seon and other painters.

Another Buddhist figure painting with some landscape elements is the famous *Water Moon Bodhisattva with a Willow Branch* (fig. 21) painted in 1323 by the monk Seo Gu-bang. In this large, accomplished painting on silk, the Bodhisattva is seated on a rocky promontory extending upward from the sea. The rendering of the jagged, scalloped edges of the rocks shows the same iron-wire brushstrokes used in the decorative blue-and-green landscape paintings of China since the Sui dynasty.

Aside from the few Buddhist figure paintings with landscape elements, there are several monochrome ink landscapes in Japan that Korean scholars now claim to be of Goryeo origin. Such is the *Pair of Landscapes* (fig. 22a-b) in hanging scroll format which looks like a Yuan interpretation of a Song dynasty Mi-style landscape. This pair of landscapes is attributed by Korean scholars to a

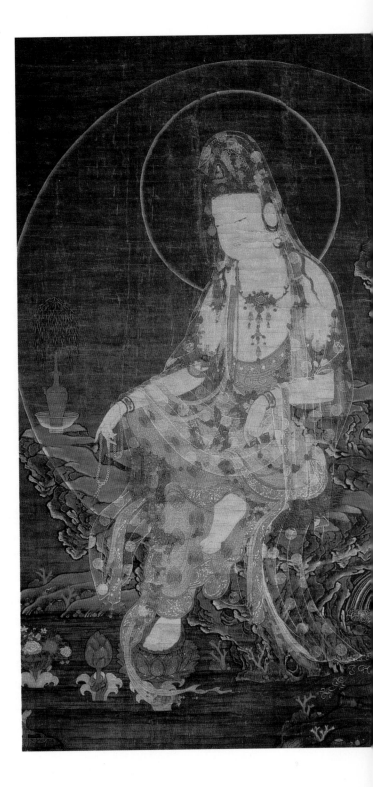

Fig. 21) Seo Gu-bang, *Water Moon Bodhisattva with a Willow Branch*, dated 1323. Hanging scroll, ink and color on silk, 165.5 × 101.5 cm. Private collection, Japan

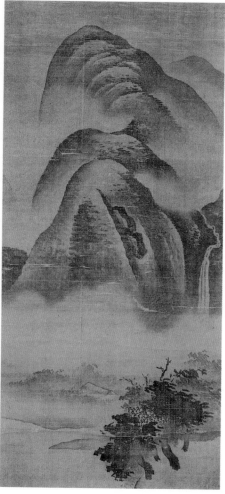

Fig. 22a-b) Attributed to Go Yeon-hui, *Summer Landscape* (right) and *Winter Landscape* (left), 14th century. Pair of hanging scrolls, ink on silk, 124×57.9 cm. Konchi-in temple, Kyoto

certain Go Yeon-hui. No painter by that name is recorded in Korean sources. It has been suggested that Yeon-hui is Yuanhui, the sobriquet of the Chinese painter Mi Youren (1075-1151). It is further suggested that the name is a Japanese corruption of Yanjing, the sobriquet of the Chinese painter Gao Kegong (1248-1310). Gao was the most prominent painter of Mi-style landscapes during the Yuan period. Although it is difficult to pinpoint Go Yeon-hui as a Goryeo painter, neither Chinese nor Japanese sources claim Go as one of their own. If Go proves to be

Korean, this pair of landscapes would be the missing link to the Yuan version of Mi-style landscape painting in Goryeo.

The pair of landscapes consists of a summer and a winter scene. The summer scene shows a series of mountain peaks partly hidden by bands of mist rising above the clouds. On the sides of the mountain, we see the soft ink-dots that typically represent vegetation in the Mi style. On the lower right corner of the foreground, stands a group of trees with full summer foliage that droops over the river. Near the shore beyond the river, a thatched house is barely visible amidst woods and thick mist. Unlike "Crossing the River on Horseback" attributed to Yi Je-hyeon, this landscape and its winter counterpart are filled with soft atmospheric effects. Such atmospheric effects continue into early Joseon landscapes painted in the Mi style.

Landscape Painting of the Early Joseon Period

In the study of Korean painting history today, most scholars divide the Joseon dynasty into four periods. This system of periodization was initiated by Ahn Hwi-joon in his *History of Korean Painting* (*Hanguk hoehwa-sa*), first published in 1980. According to Ahn's chronology, the early Joseon period is from the start of the dynasty in 1392 to about 1550, or the last years of King Jungjong's reign which ended in 1544. This is followed by the mid-Joseon period, which Ahn designates as spanning from about 1550 to 1700, or the first half of the reign of King Sukjong, 1667-1720. Lastly comes the late Joseon period spanning from 1700 to the end of the dynasty in 1910. The late Joseon is further divided into two phases. The first phase is from 1700 to about 1850, or the last years of the famous scholar-official *cum* calligrapher and painter, Kim Jeong-hui (1786-1856) and the second phase is from 1850 to 1910, or the last sixty years of the dynasty before Korea was annexed to Japan.

In this book, we will approximately follow Ahn's four chronological divisions in discussing Joseon painting, except for our last

chapter where we deal with the art of the nineteenth and early twentieth centuries. Artistically, after the deaths of King Jeongjo in 1800 and Kim Hong-do around 1806, the spirit of true-view landscape painting was never again at the level achieved by artists of the eighteenth century. Politically, the situation in the nineteenth century was also quite detrimental to the arts. Keeping in mind that a chronological division of history often does not coincide with changes in artistic styles or new art movements, we will proceed with an examination of early Joseon landscape painting.

Documentary evidence of contacts with China during the early Joseon period abounds in the *Veritable Records of the Joseon Dynasty* (*Joseon wangjo sillok*). The Joseon court sent emissaries to Ming China several times a year and the Chinese reciprocated by sending emissaries to the Joseon court, resulting in active cultural exchanges. We also have records of contacts between Joseon and Muromachi Japan in the form of inscriptions written on paintings by artists who traveled to Japan in the early fifteenth century. Korea played an important role in transmitting ink monochrome painting styles and techniques to Japan in the Muromachi period.

Several different styles of landscape painting were in vogue at the beginning of the Joseon period and they all came from China. As we have seen, the Li-Guo and the Mi styles of landscape art were transmitted to Goryeo during the late Goryeo period. Another important Chinese landscape style that was transmitted to Korea was the Ma-Xia style, named after the two leading Southern Song court painters of the first half of the thirteenth century, Ma Yuan and Xia Gui. The Ma-Xia landscape tradition became the basis of academic landscapes painted during the early Ming by the so-called Zhe School. This style was named after the Zhejiang province where Dai Jin, the founder of the school, practiced his art. All four Chinese landscape styles, three from the Song and one from the Ming period, can be seen in early Joseon landscape paintings.

The most representative early Joseon landscape painting in the Li-Guo style is the previously examined *Dream Journey to the Peach*

Blossom Spring (fig. 3) by the court painter An Gyeon dated to 1447. The cultural figure behind the introduction of the Li-Guo style to Korea was Prince Anpyeong (1418-1453), the third son of King Sejong the Great. It was Prince Anpyeong who commissioned An to paint a dream he had of roaming around the landscape of the Peach Blossom Spring with several high ranking scholar-officials such as Seong Sam-mun (1418-1456) and Bak Paeng-nyeon (1417-1456). The painting collection of the art-loving prince, as recorded by Sin Suk-ju (1417-1475) in his *Hwa-gi*, or *Record of Painting*, included 17 paintings, mostly of landscapes, by the Northern Song painter Guo Xi.

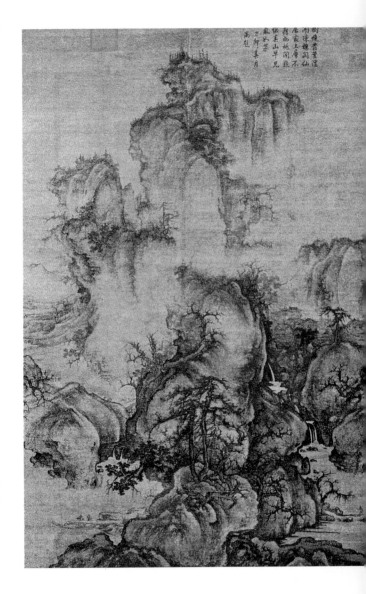

An Gyeon, the most prominent artist at the court of King Sejong, naturally had access to Prince Anpyeong's painting collection and therefore firsthand experience with landscapes painted in the Li-Guo style. An Gyeon synthesized his learning into the masterful *Dream Journey*. Guo Xi's best-known landscape, the *Early Spring* of 1072 (fig. 23) not only illustrates the characteristics of the style but also illuminates how An's interpretation of it differs from the Northern Song prototype.

It is also possible that contemporary Ming interpretations of the Li-Guo style made their way to Korea in the early fifteenth century through diplomatic contacts between the Ming and the Joseon courts. A typical early Ming version of a landscape painted in the Li-Guo style

Fig. 23) Guo Xi, *Early Spring*, dated 1072. Hanging scroll, ink and light color on silk, 158.3 × 108.1 cm. National Palace Museum, Taipei

would be the *Landscape in the Manner of Guo Xi* (fig. 24) by Li Zai, who was active during the Xuande era (1426-35). In this painting as well as in An's *Dream Journey*, there is less sense of three-dimensionality in the mountain masses than in the Northern Song original by Guo. Also the strong dark contour lines of Guo's landscape forms have become softer in An Gyeon's painting. The softness is in keeping with the dream

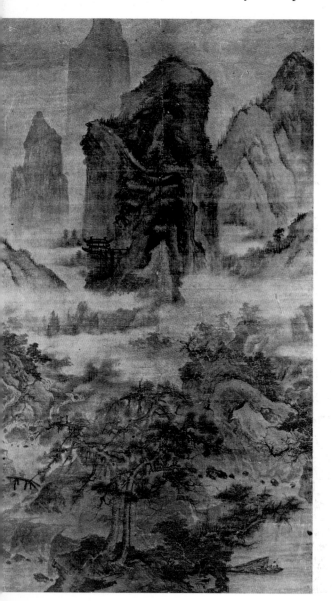

theme of An's painting. Other paintings attributed to An tend to depict subject matter of Chinese orientation such as the *Red Cliff*, the famous prose-poem by Su Dongpo and landscapes of the four seasons. None of them, however, can compare with the *Dream Journey* in uniqueness of vision and beauty of execution.

An Gyeon's vast influence in early Joseon landscape painting has prompted art historians today to acknowledge the presence of a "School of An Gyeon" (*An Gyeon pa*) which prevailed roughly up to the seventeenth century. A good example of a work from the school of An Gyeon would be the "Late Winter" (fig. 25), a leaf from an album of eight paintings entitled *Eight Scenes of the Four Seasons* now in the collection of the National Museum, Seoul. This winter landscape is attributed to An, but certainly painted by a later hand.

The second style, the Ma-Xia school should be understood both in its Southern Song version and its early Ming version. Additionally these interpretations cannot be separated from the landscape paintings of the so-called Zhe School of China. The characteristics of the Ma-

Fig. 24) Li Zai, *Landscape in the Manner of Guo Xi*, early 15th century. Hanging scroll, ink and light color on silk, 83.3×39 cm. Tokyo National Museum

Xia style can be found in a painting attributed to Ma Yuan, entitled *Banquet by Lantern Light* (fig. 26). This composition has Ma's characteristic diagonal division of the picture plane and use of light mist to gradually obscure objects, conveying a sense of depth. Another trait of Ma's style is the use of large axe-cut texture strokes, not seen in this painting, but in other works by him and also in works by Xia Gui. This type of texture stroke is applied boldly to rock surfaces to make them look as though hewn by a large axe. To create the "axe-cut" effect, the brush is half dipped into ink, placed on the paper sideways, and then drawn with such speed that blank space (white) is left behind with each stroke. This area of blank space within a brushstroke is called "flying white" (*bibaek*, Ch. *feibai*), a technique that had first developed in calligraphy, and later incorporated into the repertoire of painting techniques. Other characteristics of the Ma-Xia style include the use of strong light and dark contrasts, and pine trees with abruptly bent tops. All of these elements were adopted by Dai Jin and his early Ming followers who were active in the Zhejiang

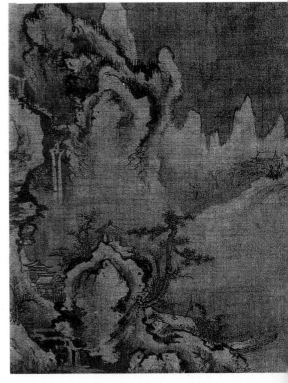

Fig. 25) Attributed to An Gyeon, "Late Winter," one leaf from *Eight Views of the Four Seasons*, 15th century. Album of eight leaves, ink and light color on silk, 35.2 × 28.5 cm. National Museum of Korea, Seoul

province. This is the area where Hangzhou, the Southern Song capital had been located.

Extant early Joseon landscape paintings in the Ma-Xia style are very rare. *Walking Under a Pine Tree in Moonlight* (fig. 27), attributed to Yi Sang-jwa (act. 1st half of 16th century) shows several characteristics typical of the Ma-Xia style. At the lower left corner of the painting, a rocky boulder extends diagonally up to form a cliff that provides the solid diagonal element typical of a Ma-Xia composition. From the mid-point of the cliff, a pine tree juts out toward the open space to the right. The jagged treatment of the trunk of the pine with its abruptly broken top and branches that veer to the left suggests the strong presence of the wind. At the lower right corner of the painting, we see a man in white

garment, also blown by the strong wind, walking toward the cliff, followed by a boy servant carrying his master's staff. The painting is in such poor condition that we no longer see the moon in the dim sky, but there must have been one as indicated by the traditional title of the painting.

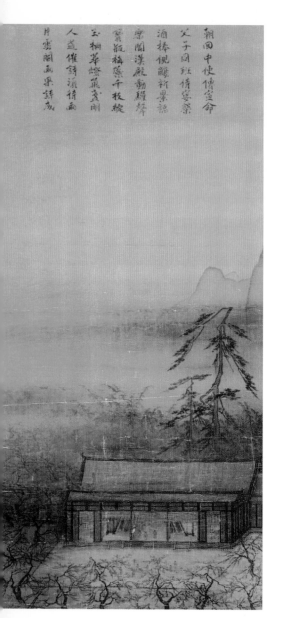

We know very little about Yi Sang-jwa, except that he was a court painter active in the late fifteenth and the early sixteenth century, and that he painted a portrait of King Jungjong (r. 1506-1544) in 1545. The painting has not survived to testify to Yi's talent in portraiture, but the record suggests that Yi was primarily a figure painter. The only extant figure paintings by Yi are sketches of *Lohans* (disciples of the Buddha) now kept in the Korea University Art Museum. Several extant small-scale landscape paintings are also attributed to him. Although few in number, these are important in that they support the existence of landscape painting in the Ma-Xia style during the early Joseon period. Such early Joseon landscape paintings in Ma-Xia style, in turn, became the foundation of a fully developed tradition of Zhe School (Kor. *Jeol-pa*) landscape painting in Korea.

The Zhe School style is amply reflected in a small painting with a seal reading "Injae," the sobriquet of the famous scholar-official Gang Hui-an (1417-1465). This small painting entitled "Scholar Gazing at Water" (fig. 28), shows a composition that is typical of Zhe School painting in the Ming. There is a cliff on the right that sharply bisects the picture plane, leaving the left side almost a void. Below the cliff, a scholar leans forward on a rock gazing into a pool of water. The pitch

Fig. 26) Attributed to Ma Yuan, *Banquet by Lantern Light*, 13th century. Hanging scroll, ink and color on silk, 125.6 × 46.7 cm. National Palace Museum, Taipei

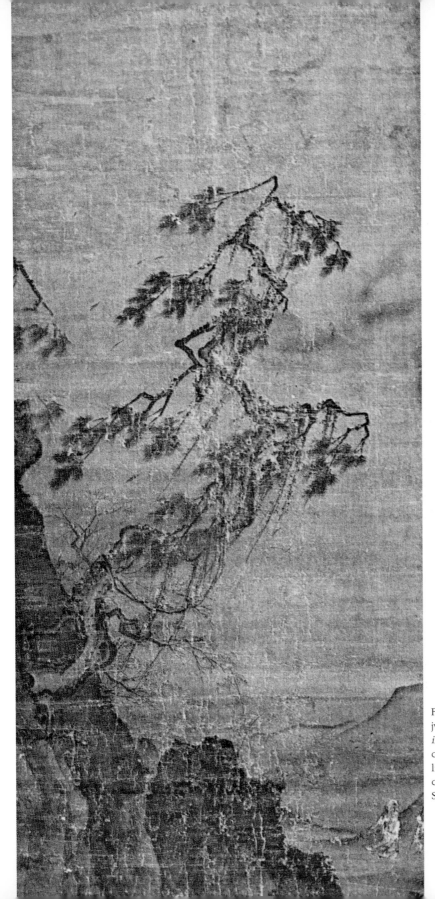

Fig. 27) Attributed to Yi Sang-jwa, *Walking under a Pine Tree in Moonlight*, 1st half of 16th century. Hanging scroll, ink and light color on silk, 197 × 82.2 cm. National Museum of Korea, Seoul

Fig. 28) Gang Hui-an, "Scholar Gazing at Water," 15th century. Album leaf ink on paper, 23.5×15.7 cm. National Museum of Korea, Seoul

dark ink applied to the left edge of the cliff as well as to the underside of the rock supporting the scholar forms a stark contrast to the unpainted void on the left half of the composition. The abbreviated brushstrokes depicting the figure of the scholar are quite simple, recalling the Chan (Jap. Zen) Buddhist ink painting of the Southern Song period. The only soft elements here are the vines that hang down from the cliff and the water reeds in the lower left corner.

Gang Hui-an visited China in 1462 as an envoy to the Ming court where he apparently observed paintings of the then active Zhe School. However, there is one reservation in accepting the seal of Gang on this painting as authentic. Compared to the landscape attributed to Yi Sang-jwa discussed above, the style of this painting reflects a later version of the Zhe School manner, yet Gang's dates of activity are about 80 years earlier than Yi's. In his lifetime, Gang was praised not only for his painting but also for his poetry and calligraphy, especially in the seal, clerical, and *bafen* styles. (The latter is a variant of clerical script that was developed during the Han dynasty.) Gang mastered the Three Excellences (of painting, poetry and calligraphy), but he did not wish to be remembered by posterity for his skill in painting. In scholarly circles, skill in painting was looked down upon as a lowly "mean skill," or *cheongi*. This is the traditional explanation for the scarcity of paintings by Gang. However rare, his

landscape and figure painting impressed his contemporaries and his painting style was followed by sixteenth-century painters such as Kim Si [formerly read "Je"] and Yi Gyeong-yun. Besides "Scholar Gazing at Water," only a few other small and fragmentary paintings are credited to Gang.

The third style, the Yuan interpretation of the Mi Fu tradition, can be seen in the "Landscape" (fig. 29) attributed to Seo Mun-bo, a court painter during the reign of King Seongjong (r. 1470-1494). The album leaf is one of three stylistically similar landscapes now kept in the collection of the Yamato Bunkagan in Nara, Japan. The landscape shows mountain peaks textured with Mi ink-dots rising above an undulating band of clouds drifting across the picture plane. The other two landscapes have traditional attributions to Choe Suk-chang and Yi Jang-son. All three painters are believed to have been active during the second half of the fifteenth century. The stylistic similarity of the three leaves is such that a recent study has convincingly argued that they once formed one continuous handscroll.

Fig. 29) Attributed to Seo Mun-bo, "Landscape", 15th-16th century. Album leaf, ink and light color on silk, 39.7×60.1 cm. The Museum Yamato Bunkakan, Nara

All three landscapes show the basic Mi convention of mist-laden hills textured profusely with ink-dots to represent vegetation. However, they deviate from the style of Mi in showing a greater degree of three-dimensionality and heaviness in the mountain masses. In this sense, they are closer to the landscape manner of the Yuan scholar-official and painter, Gao Kegong, who combined the Northern Song style of Mi with that of the two Five Dynasties masters Dong Yuan and Juran. It seems quite natural that, with the scarcity of surviving landscape paintings by Mi Fu, and the difficulty of gaining access to both Northern and Southern Song landscapes painted in his style, Joseon painters of the fifteenth century relied on Yuan versions of the Mi style as models.

These early Joseon painters embraced not only the monochrome ink style of Mi Fu but also those of other Chinese painters of the Song and Yuan. Furthermore, they transmitted all those Chinese monochrome ink styles to Japan in the fifteenth century. Ink painting of the Muromachi period (1336-1573) in Japan flourished under the influence of Korea in the early fifteenth century through diplomatic contacts between the Joseon court and the Ashikaga shogunate. Evidence of such contacts is documented in the *Veritable Records*

Fig. 30) Unidentified artist, *Evening Rain on Plantain Leaves*, colophon dated to 1410. Hanging scroll, ink on paper, 96 × 31.4 cm. Private collection, Japan

of the Joseon Dynasty as well as in inscriptions on paintings produced in both Japan and Korea.

Such is the case with the *Evening Rain on Plantain Leaves* (fig. 30), now in a Japanese private collection. Although we do not know the name of the painter, it is assumed that he was a Korean court painter who accompanied the envoy Yang Su (act. early 15th century), a high official of the Board of Rites, to Japan. Yang wrote a poetic inscription on the painting in rhyme following a preceding poem. The title of his inscription begins with a phrase saying that he is enjoying his stay in the Ryuzan monks' dwelling. Yang's poetic inscription is followed by a date, the eighth month of the eighth year of Yongle (the reign title of the third emperor of Ming), or 1410. In his long title, Yang identifies himself as "The Joseon dynasty's emissary," followed by his many titles including Vice Minister of the Board of Rites and member of the *Jiphyeon-jeon*, the highest honor given to a scholar during the early Joseon period. So we can surmise that the painting was done in 1410 or thereabouts. The other inscriptions on the painting are poems penned by monks of the Gozan or "Five Mountains." This refers to two groups of Zen temples, five each in Kamakura and Kyoto. Besides Yang's, the other notable inscription on the painting is that of the famous Zen monk-painter, Gyokuen Bompo (1348-1424?), who left several ink orchid paintings.

Evening Rain on Plantain Leaves depicts a humble cottage in the foreground buried under plantain and pine trees in a misty mountainous landscape. The mountains in the middle ground are rendered in dark ink washes and dots. Distant mountain peaks are depicted with light ink washes, reminiscent of landscapes in the Ma-Xia style of Southern Song. The basic diagonal division of the composition and the use of mist to obliterate the bases of the mountains also hark back to the Southern Song. The contour of the large plantain leaves in the foreground is rendered with a fine brush, and even finer lines were employed to depict their veins. Members of literary circles in traditional East Asia often planted plantain near their studios so that they may enjoy the poetic sound of raindrops on the leaves.

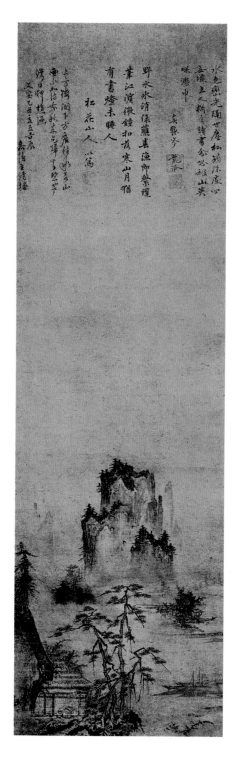

Another recorded contact between the art circles of Korea and Japan in the early fifteenth century is the visit to Korea by the Zen monk-painter Shūbun. In 1423, Shūbun accompanied the emissary of Ashikaga Yoshimochi to the Joseon court, and returned to Japan the following year. He was then already affiliated with the Shōkoku-ji temple, one of the five Gozan Zen temples in Kyoto, and an official painter to the Ashikaga shogunate. *Mountain Peaks and Water Bathed in Light* (fig. 31), a landscape with three inscriptions penned by Zen monks active in the fifteenth century is attributed to Shūbun. This interesting painting combines stylistic features we have seen in An Gyeon's *Dream Journey* of 1447 (fig.3) with those of *Walking under the Moonlight* (fig. 27) attributed to Yi Sang-jwa. The distant mountain peaks rising above the mist are quite similar to An Gyeon's peaks in the Li-Guo manner, only more two-dimensional in feeling. On the left side of the landscape, the rocky cliff by the cottage under a cluster of pine trees, one of which bends sharply to the right, echo elements found in *Walking under the Moonlight.*

Shūbun's influence on Muromachi painters working primarily in ink monochrome, especially ones active at the Shōkoku-ji temple, such as Jōsetsu and Sesshū (1420-1506) is well known. This means that early fifteenth century contact between Korea and Japan was instrumental in the development of Muromachi monochrome ink landscape painting. Among recorded instances of Korean-Japanese

Fig. 31) Attributed to Shūbun, *Mountain Peaks and Water Bathed in Light*, dated 1445. Hanging scroll, ink and light color on paper, 107.9 × 32.7 cm. Okayama Prefectural Museum of Art, Japan

contacts, perhaps the most notable is that of the Korean painter Su Mun who visited Japan in 1423 and left an album of ink bamboo with landscapes dated to that year. Since the pronunciation of Su Mun's name in Japanese is "Shūbun," he is often confused with his Japanese contemporary of the same name and the two painters have often been identified as one. But it is now clear that Su Mun was a Korean painter.

Another painter deserving of mention in this context is Mun Cheong (act. mid-15th to late 15th century). A number of paintings, both in Korea and in Japan are assigned to Mun and current scholarship accepts him as a Korean, who, some time in the mid-fifteenth century, settled in Japan. Ahn Hwi-joon identifies a small painting, the *Landscape with Pavilions* (fig. 32), in the collection of National Museum, Seoul, as a possible painting by Mun before his move to Japan. It is a typical early fifteenth-century Li-Guo derived An Gyeon-style landscape. Upon closer examination, however, we find that Mun has used short parallel brushstrokes to texture the earthen hills. Ahn Hwi-joon calls these short

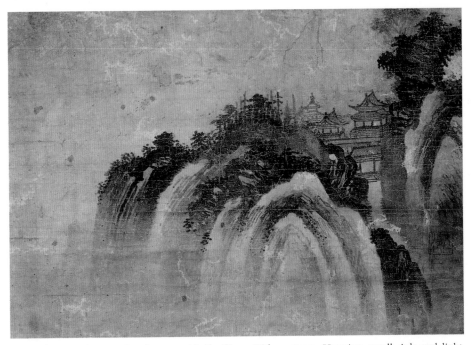

Fig. 32) Mun Cheong, *Landscape with Pavilions*, 15th century. Hanging scroll, ink and light color on paper, 31.5 × 42.7 cm. National Museum of Korea, Seoul

texture strokes "*danseonjeom-jun*" or short-line texture strokes. Other sixteenth-century Korean landscape paintings also show this texturing technique, making it a unique Korean contribution to East Asian landscape painting. A few other paintings bearing Mun Cheong's seals now kept in Japan have more Japanese character in their busy compositions.

In this chapter, we took the unprecedented step of considering painting of the Goryeo period together with that of the early Joseon period. This was done because we must rely on literary evidence to reconstruct a history of Goryeo painting, and because there seems to have been considerable continuity in subject matter and styles into the earliest phase of Joseon painting. We have seen that there was a very active period of artistic exchange between Korea and China in the fifteenth century. From Korea many of the Chinese monochrome ink landscape styles were transmitted to Japan. In the sixteenth century Korea and Japan parted ways and developed independent ink painting traditions. In Japan, ink painting was practiced primarily in Zen circles, while in Korea it was a major form of expression for both court and literati painters. In Korea, both the An Gyeon School and the Korean Zhe School had an equally strong presence in landscape art up to the second half of the seventeenth century, while the Mi tradition survived as a minor tradition, in both court and literati circles. The artists of these two stylistic camps would in the mid-Joseon period further modify Chinese landscape styles into even more Koreanized forms, paving the way for the native true-view landscape painting that developed in the eighteenth century.

IV. Koreanization of Chinese Landscape Styles : The Mid-Joseon Period

Historical Overview

As we have noted in the previous chapter, the mid-Joseon period spans some 150 years from about 1550 to 1700. This is also the time when the Japanese invasions of 1592 and 1597, and the Manchu Qing invasions of 1627 and 1636 took place. Also as noted, a humiliating condition of surrender to the Qing after the 1636 invasion was that the crown prince and his brothers, the second and third sons of King Injo, along with scholars and their sons were sent as hostages to Shenyang, the then capital of the Qing. Crown Prince Sohyeon and the second in line, Prince Bongnim (later, King Hyojong; r. 1649-1659) were sent to Shenyang immediately after the surrender in 1636, and lived there for ten years. Prince Bongnim's bitter experiences in the Qing capital prompted him to consider revenge on the Manchus. During his short reign as king, he actively planned the "Northern Conquest," or the invasion of the Qing Empire. But the military superiority of the Qing was such that he could not fulfill his dream. The third in line, Prince Inpyeong (1622-1658), the most talented of the three princes in painting and calligraphy, spent a year in China from 1640 to 1641. Later, after 1650, his brother, as King Hyojong, sent him to China four times as emissary.

By the time of King Sukjong (r. 1674-1720), Korea had recovered from the four invasions and was able to focus on domestic welfare, culture and the arts. King Sukjong's reign was characterized internally by severe partisan politics, but at least there were no new invasions. Chief among the achievements of his reign was the initiation of public use of coinage by minting the *sangpyeong tongbo* or "ever constant circulating treasure." Another notable achievement was the publication

of the National Code (*Jeonnok tonggo*) in 1708. This new code was a major revision of the first National Code (*Gyeongguk daejeon*).

Under this relative peace and stability, direct contact with the Chinese scholarly world continued, resulting in new cultural developments in Korea. During this period Korea was exposed for the first time to Chinese painting manuals of the late sixteenth and early seventeenth centuries. Through these painting manuals as well as through direct access to paintings, Chinese literati painting in the so-called "Southern School" manner gradually made inroads into Korea.

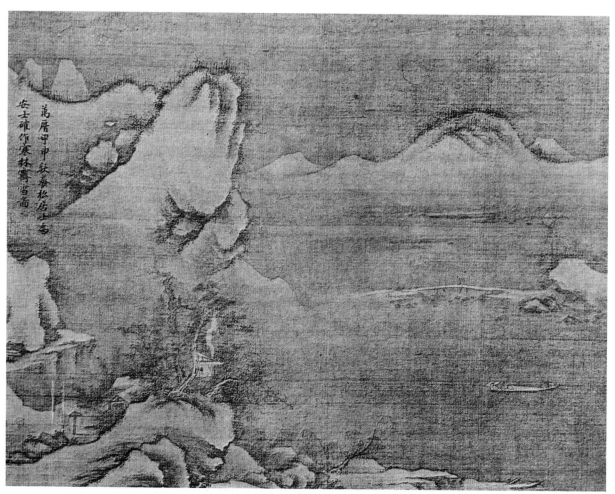

Fig. 33) Kim Si, *Clearing after Snow in Wintry Forest*, dated 1584. Hanging scroll, ink and light color on silk, 53.0×67.2 cm. The Cleveland Museum of Art, Ohio

Transformation of the Zhe and the Li-Guo School Styles

Grounded in landscape painting of the early Joseon period, mid-Joseon landscape art became even more distinctively Korean in style. The An Gyeon School style continued to have a strong following up to the mid-seventeenth century and the Korean Zhe School flourished until the end of that century.

The most prominent heir to the An Gyeon tradition was Kim Si (formerly read "Je" 1524-1593), who not only mastered that tradition, but also painted in the Zhe School manner. It is not uncommon for Korean painters of the Joseon period to work in more than one style. Kim was the son of the famous scholar-official Kim An-ro (1481-1537), but he chose to lead a reclusive life after the death of his father in a political struggle. Kim Si's most representative work is *Clearing after Snow in Wintry Forest* (fig. 33) now in the collection of the Cleveland Museum of Art, Ohio. The composition shows a solid mass on the left half of the painting while the right half of the picture plane is left empty with only a distant hill and other small landscape

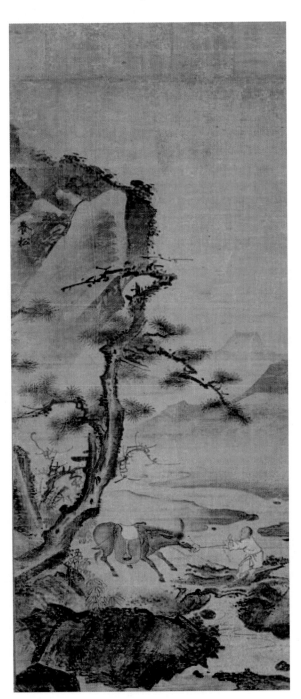

Fig. 34) Kim Si, *Boy Pulling a Donkey*, late 16th century. Hanging scroll, ink and color on silk, 111 × 46 cm. Ho-Am Art Museum, Seoul

elements scattered over a wide expanse of water. If we compare this painting with the "Late Winter" (fig. 25) attributed to An Gyeon we see compositional similarities such as solid masses placed to one side on the left. Other similar elements in the landscape are the hills, the trees and the cottages tucked under the trees. However, Kim's painting has more landscape depth than the one attributed to An Gyeon. Korean landscape paintings of the mid to late sixteenth century tend to show more spatial depth and greater expanses of space than earlier ones. The artist's inscription along the left edge of the painting dates to 1584 (*gapsin* [*jiashen*] year of the Wanli reign).

Kim's other well-known painting, *Boy Pulling a Donkey* in the collection of the Ho-Am Art Museum (fig. 34), is a charming scene of a boy trying very hard to get a donkey across the stream under a pine tree set against a background of mountains and waters. The vertical division of the composition as well as the use of large axe-cut texture strokes in depicting foreground rocks and mountain peaks indicates Kim is working in the Zhe School style. Of special note is the use of green pigments on the rocks and on the mountain peaks which reinforces the liveliness of the scene. The tension between the boy and the donkey is such that the boy's body creates the shape of a reverse "C" toward the donkey while the donkey's legs, firmly planted on the ground form an opposing "C" shape. The use of humor in a landscape painting makes this a unique work of art.

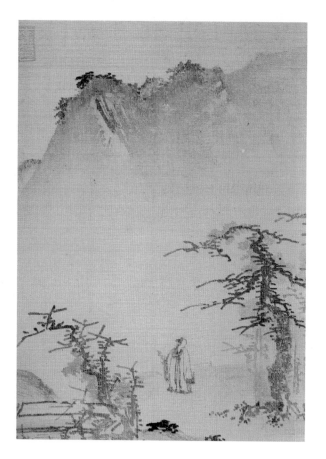

Fig. 35) Yi Bul-hae, *Walking with a Staff*, 2nd half of 16th century. Hanging scroll, ink on silk, 18.6 × 13.5 cm. National Museum of Korea, Seoul

In China, the Zhe School style had been practiced mostly by professional painters, who were not part of the ruling elite. In Korea, however, there was no strict class differentiation among those who painted in the style. As we saw earlier, scholar-painters such as Gang Hui-an of the early Joseon period practiced the Zhe School style after he visited the Ming capital as an envoy and presumably saw court paintings done in the style. This tradition of the literati elite painting in the Zhe style continued into the sixteenth century as we have also seen in the scholar Kim Si's painting.

Another scholar-painter who mostly painted in the Zhe School style is Yi Bul-hae (act. late sixteenth century). Not much is known

about his life, but he was cited as one of the three best scholar-painters of the late sixteenth century in nineteenth-century sources. His best-known work, *Walking with a Staff* (fig. 35) in the collection of the National Museum, Seoul, is a small painting showing a scholar with a staff in his right hand standing between two groups of wintry trees. Above him, separated by thin layers of mist, is a ridge of mountain tops spread across the entire width of the picture. The peak on the left is done in large axe-cut texture strokes, a hallmark of the Ma-Xia and Zhe School styles while the rendering of the trees shows affinity with the Li-Guo manner. The theme of a human figure enjoying nature in a landscape setting is

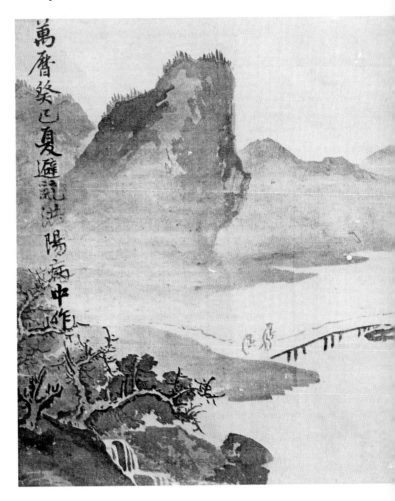

Fig. 36) Yi Heung-hyo, *Landscape*, dated 1593. Hanging scroll, ink on silk, 29.3 × 24.9 cm. Private collection, Korea

frequently used in paintings done in the Ma-Xia and Zhe School styles. The size of the figure in relation to the landscape is larger than that found in paintings of the Li-Guo/An Gyeon style, where the awesome grandeur of nature is emphasized by tiny figures in landscape. Several other extant paintings by Yi also take similar themes as subject matter.

The combining of several styles in one painting by Yi Bul-hae can also be seen in the works of other artists of the late sixteenth century, and seems characteristic of Korean painting of the mid-Joseon period. Paintings by the two sons of Yi Sang-jwa, Yi Sung-hyo (ca. 1534-?) and Yi Heung-hyo (1537-1593), by Yi Jeong (1578-1607), and also by the scholar-official painter Yun Ui-rip (1568-1643), all share in this eclecticism. The small *Landscape* (fig. 36) by Yi Heung-hyo, inscribed along the left edge with "painted while sick in Hongyang whereto [I] fled from turmoil in the *kyesa [guisi]* year of the Wanli reign (1593)," exemplifies the eclectic trend of combining several styles even to the point of employing the abbreviated brush manner of Chan painting from the Southern Song period.

At the end of the sixteenth and the beginning of the seventeenth century, there were three painters of the royal Yi line who played a leading role in the dissemination of the Zhe School style. They are: chronologically, Yi Gyeong-yun (1545-1611); Yi Yeong-yun (1561-1611), his younger brother; and Yi Jing (1581-after 1643), his son. Yi Gyeong-yun's best known painting is the *Landscape* (fig. 37) now in the collection of the National Museum, Seoul. This painting, which is relatively large (91.1 x 59.5 cm) compared to other paintings by him, depicts two lofty scholars enjoying leisure in the company a crane amidst autumn mountains. A boy servant holding a staff is seen behind the standing scholar, while another boy to the right of the crane is seen brewing tea. The mountainous setting unfolds from rocky boulders at the lower right into the spacious clearing where the figures converse against screen of rocky outcroppings which provide an enclosed shelter for the figures. To the left is an expanse of water, the source of which is the meandering stream that flows from the distant mountains. Yi applied light and dark ink on the rocks and mountains using large "axe-cut" texture strokes.

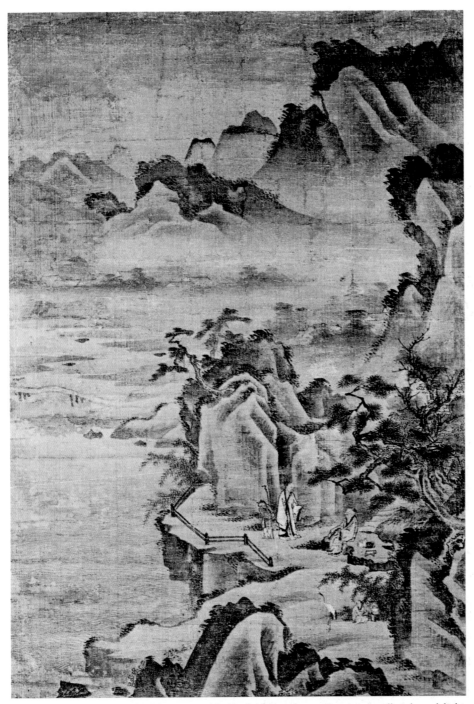

Fig. 37) Yi Gyeong-yun, *Landscape*, 2nd half of 16th century. Hanging scroll, ink and light color on silk, 91.1×59.5 cm. National Museum of Korea, Seoul

But here, there is not much "flying white," making the surface textures smoother than is usual in the Zhe School style. Also unusual in this painting is the use of color; green on the bamboo and pines, blue and pink on the robes of the scholars, and, finally, brown to indicate autumn foliage on the trees at the right edge of the painting.

Other paintings attributed to Yi Gyeong-yun are mostly small works that depict the leisurely life of scholars in landscape settings, such as the "Viewing the Moon" (fig. 38), a leaf from an *Album of Figures in Landscape*, in the collection of the Korea University Art Museum, Seoul. Another leaf from the same album shows a scholar cooling off from the summer heat by submerging his feet in water. Strictly speaking, these small leaves fall into the sub-genre called "figures in landscape" (*sansu inmul*).

Fig. 38) Attributed to Yi Gyeong-yun, "Viewing the Moon," one leaf from *Album of Figures in Landscape*, 2nd half of 16th century. Album of 10 leaves, ink on silk, 31.2 × 24.9 cm. Korea University Art Museum, Seoul

Despite his royal ancestry, Yi Jing was the son of a concubine and thus had to follow a different path in life than his highborn father, Yi Gyeong-yun. Yi Jing was a professional painter in the Bureau of Painting (*Dohwa-seo*) at court and participated in the repair of King Taejo's portrait in 1628. As a reward for his portrait work, he was promoted to the sixth rank, the highest level a court painter can reach according to the National Code. However, most of his existing works are landscapes, some painted on a large scale. He is recorded to have excelled in many styles including the Zhe School manner like his father. Many of his landscapes also show an inclination toward the more conservative Li-Guo/An Gyeon tradition.

Yi Jing's representative Zhe School style painting is the *Evening Bell from Mist-shrouded Temple* (fig. 39) in the collection of the National Museum, Seoul. This is one of the Eight Scenes of the Xiao and Xiang Rivers, which depict eight famous spots along two scenic rivers of Hunan province in southern China. This traditional Chinese landscape theme came to Korea sometime in the fifteenth century, and remained a favored subject in landscape

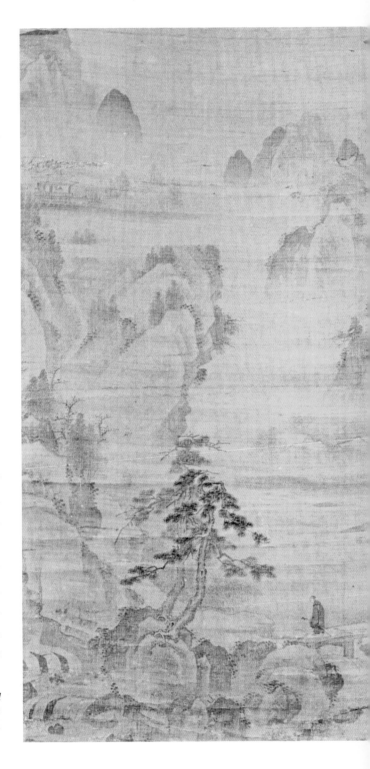

Fig. 39) Yi Jing, *Evening Bell from Mist-shrouded Temple*, first half of 17th century. Hanging scroll, ink and light color on silk, 103.9×55.1 cm. National Museum of Korea, Seoul

Fig. 40) Yi Jing, *Gold-painted Landscape*, 1st half of 17th century. Hanging scroll, gold pigment on silk, 87.8×61.2 cm. National Museum of Korea, Seoul

art until the end of the Joseon dynasty. The basic compositional scheme here is the vertical division of the picture plane into two, much like Yi Gyeong-yun's *Landscape* (fig. 37), except that the voids and solids in two paintings have been reversed. We have to look very hard to find the temple that is tucked under the top of the distant peaks shrouded in a band of mist on the upper left. In the lower right corner, a monk with a staff is making his way across a bridge to the temple.

Yi Jing also painted many landscapes in gold ink on dark silk. *Gold-painted Landscape* (fig. 40) in the collection of the National Museum, Seoul, is representative of his painting in the Li-Guo/An Gyeon style. Compared to An Gyeon, Yi seems to have indulged much more in fantastic landscape and mountain formations. The foreground landmass and the trees growing on it seem to fuse into one convoluting form and the mountains in the distance look like clouds rising in the sky. The only straight lines are the architectural contours of the pavilions and boats. On the left, there is an expanse of water receding into the horizon. The recession creates a sense of great distance. This water also flows toward the lower right where it breaks into several small cascades at the lower edge of the painting.

If the two paintings above represent Yi Jing's Zhe School and Li-Guo/An Gyeon styles, *Old Villa in the Hwagae District* (fig. 41), in the collection of the National Museum, Seoul shows little of those two traditions. It is dated by inscription to the year 1643, and in his old age, Yi seems to have created a more personal style. We will return to this painting in the next section.

It was in the mid-Joseon period that Korean Zhe School painting reached its height in the works of Kim Myeong-guk, a court painter active during the mid-seventeenth century. Although Kim's dates are unknown, we know that he went to Japan twice, first in 1636, and then again in 1643, with the official Korean mission to Edo. He was highly praised by the eighteenth-century art critic Nam Tae-eung who commented that "there is no one like Kim Myeong-guk either before or after." Kim is one of the few Korean painters to portray the Zen monk Bodhidarma, doing so in the abbreviated manner of Southern Song

Fig. 41) Yi Jing, *Old Villa in the Hwagae District*, dated 1643. Hanging scroll, ink and light color on silk, 89.3 × 56 cm. National Museum of Korea, Seoul

monk paintings. Kim also painted landscapes in the An Gyeon manner, but he is best known for large-scale works of relatively big figures in landscape done in the Zhe School style.

The most widely-known painting by Kim is *Snow Landscape* (fig. 42) in the collection of the National Museum, Seoul. All the stylistic traits basic to the Zhe School of the mid-Joseon period are present here. However, there is much more drama both in the relationship between the landscape setting and the figures and in Kim's use of the brush. The scholar on the donkey and the boy servant in the lower left corner appear to be running away from an imminent avalanche of the steep, snow-covered peak on the upper right. They both look upward at the peak while heading in the opposite direction. Their anxious gestures and movement elicit empathy and concern from the viewer. Kim's dark staccato-like brushstrokes in the fore and middle distance seem to accelerate the feeling of danger in the scene.

Kim Myeong-guk is one of the few painters who left behind large-scale paintings. In that sense, he is much like professional painters of the

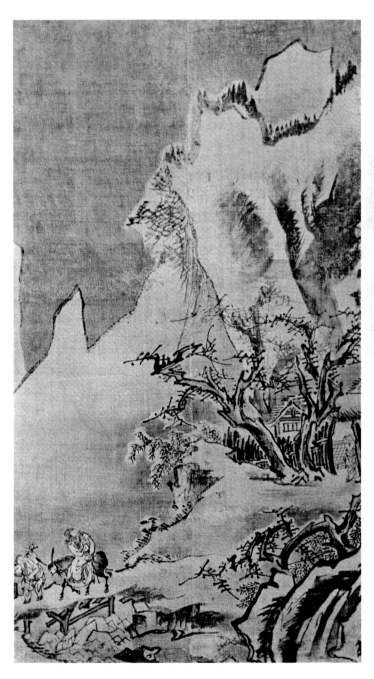

Fig. 42) Kim Myeong-guk, *Snow Landscape*, mid-17th century. Hanging scroll, ink and light color on silk, 101.7×55 cm. National Museum of Korea, Seoul

Zhe School in sixteenth-century China, especially Wu Wei (1459-1508), Wang E (act. ca. 1462- ca. 1541) and Zhang Lu (1464-1538) who were criticized for being "deranged and unorthodox" in their brushwork. Like his Ming counterparts, Kim wielded a "wild" brush in a painting such as *Viewing the Waterfall* (fig. 43), also in the collection of the National Museum, Seoul, which measures 176.6 x 100.2 cm. Kim's brushstrokes are broad and coarse, and compared to smaller paintings of the time, the contrast between light and dark is strong. Kim's painting follows the general Zhe School composition of vertical division, but here, the solid on the left side and the void on the right side loom equally large. The "void" is occupied by the waterfall, which fills nearly the entire height of the painting, exerting a strong visual presence. The two figures stand against a backdrop of dramatic scenery, with a waterfall on the right, a cliff on the left, and an old tree in the middle. It is hard to read any spatial depth into this scene. Although the space to the right of the cliff should recede into the distance, the angularity of the rocky boulders and the strong light and dark contrast contribute to flattening both the space and the mass into two dimensions. It is tempting to think that Kim, during his two trips to Edo Japan, saw contemporaneous Muromachi landscape paintings which are similarly characterized by bold contrasts and strong brushwork, and above all, the lack of three-dimensionality in landscape space.

Roots of True-view Landscape Painting

Up to this point, the subject matter of many of the Korean landscape paintings was primarily derived from China, focusing on famous Chinese literary themes such as the "Red Cliff" or "Peach Blossom Spring," or famous scenic Chinese sites such as the "Eight Scenes of the Xiao and Xiang Rivers." But there is documentary evidence that from the beginning of the Joseon dynasty, Korean painters also made native Korean scenery the subject of their works. The records speak of paintings capturing the scenery of Mount Geumgang, or

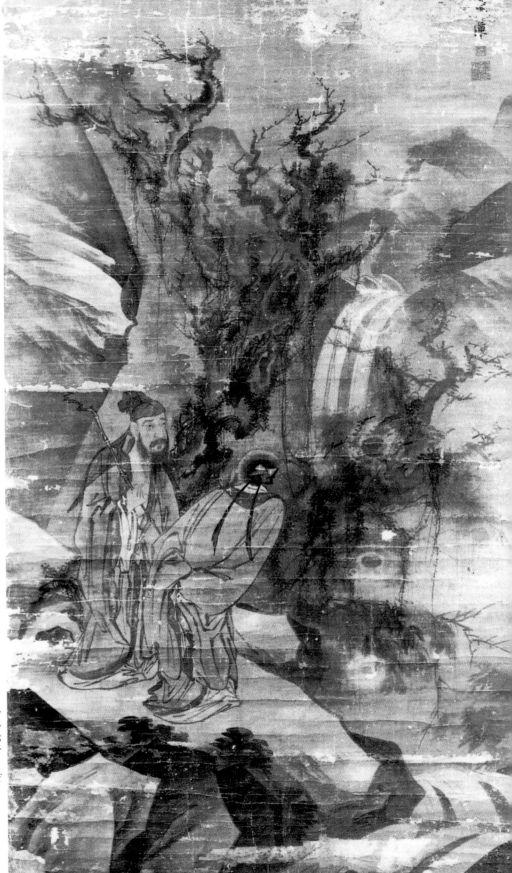

Fig. 43) Kim Myeong-guk, *Viewing the Waterfall*, mid-17th century. Hanging scroll, ink and light color on silk, 176.6×100.2 cm. National Museum of Korea, Seoul

scenes of the new capital, Hanyang. Up to the late Joseon period, however, these paintings of actual Korean scenes were not referred to as "true-view" landscape, or *jingyeong sansu*.

The term "true-view" is a translation of the Korean word

jingyeong (Ch. *zhenjing*, Jap. *shinkei*), meaning "real scenery." In Korea today, the term designates paintings of landscapes that depict actual Korean scenery which are executed with techniques developed during the eighteenth century specifically to represent Korean scenery. So it may not be appropriate to apply the term to paintings of Korean scenery prior to the eighteenth century. Yet we sometimes apply the term to paintings from the mid-Joseon period depicting actual Korean scenery. These paintings do not depict full "landscapes" in their own right as they were meant to serve as documentary paintings for the purpose of recording a social event. However, since they depict social events that took place at specific sites, the landscape background of these documentary paintings should be considered real scenery or "true-view."

Fig. 44) Unidentified artist, *Gathering of Scholars at the Dokseo-dang Reading Hall*, ca. 1570. Hanging scroll, ink on silk, 102×57.5 cm. Seoul National University Museum

One of the best examples of this narrow category of true-view paintings is the *Gathering of Scholars at the Dokseo-dang Reading Hall* (fig. 44), which can be dated to about 1570. Around this time, many paintings depicting elegant gatherings of scholars or officials to commemorate their gatherings were commissioned. Some of them show the actual scenery of the place where the gathering took place, while others simply show the gathering within a pavilion set in an unspecified landscape. Most of these commemorative paintings were done on a wide hanging-scroll format. The wide scroll is horizontally divided into two: the upper portion containing the painting proper, and the lower, reserved for inscriptions and colophons. In this case the lower portion of the painting contains a list of names of the scholars who spent their officially granted period of reading recess all together in the Dokseo-dang Reading Hall. The Sino-Korean title of the painting is written across the top from the right to the left in decorative seal-script.

In the case of *Gathering of Scholars at the Dokseo-dang Reading Hall*, we know that the hall during the Joseon period existed in an area called Dumopo along the Han-gang river from 1517 to 1592. This hall was built for the elite young scholars of the *Jiphyeon-jeon* who were granted a period of "reading recess" to recharge themselves. This Joseon-period sabbatical system was initiated during the reign of King Sejong the Great. It is possible today to identify the exact location of the hall and to point to aspects of the mountain setting surrounding the hall. The mountain and the river are still the same, but, sadly, in place of the Reading Hall, there is an apartment complex of high-rise buildings which almost obliterates the whole mountain behind it. Only a stele that tells the history of the hall stands at the entrance to the complex.

The date of the painting can be deduced from the dates of the scholars whose names appear in the lower portion. Altogether, there are ten names listed along with personal data such as family place of origin, sobriquets, dates of birth, years of success in state examinations, et cetera. The names of some of the participants included Yun Geun-su (1537-1616) who spent his recess in 1567, Jeong Yu-il (1533-1576) who

spent his recess in 1570, and Jeong Cheol (1536-1593) who spent his recess with Yi I (1536-1584) in 1569. Other notable participants at the gathering were Go Bong-ryeong (1526-1586), and Yu Seong-ryong (1542-1607). Judging from these dates, we surmise that the date of the gathering was sometime in 1569/70, most likely in 1569 when Yi I wrote the *Discourses at Dongho* (*Dongho mundap*) during his stay in the hall. The hall was also called Dongho (East Lake) Dokseo-dang as the Han-gang river forms a lake-like pool at this spot where it turns southward from its easterly flow out to the Yellow Sea. Therefore, this painting must have been commissioned very soon after 1569 to commemorate the time the participants spent together at the Reading Hall.

The painting proper (fig. 45) begins with leisurely boats floating around the river's edge in the foreground at the lower right, which gives way to an expanse of water (the Han-gang river) in both directions. The sandy shoals in the river and the low hills lined with trees above are partially shrouded in mist. The Reading Hall is a structure with a central courtyard surrounded by trees under soft earthen hills that rise high on the left but form a protective screen behind the Reading Hall. The screen of hills extends rightward almost to the edge of the painting. The muted tones of ink and the soft brushstrokes used for the shading of the hills successfully bring out the tactile as well as the three-dimensionality of the ridge. The elaborate rendering of the Reading Hall with figures of scholars visible inside, and perhaps a servant outside the east wall of the compound adds visual interest. Two other figures can be seen climbing up the mountain path to the peak behind the building. The compound is depicted in the so-called "parallel perspective" technique where the two sides of a building are drawn nearly parallel to each other as they recede into the distance. This is quite different from one-point vanishing perspective of the Italian Renaissance. The main purpose of using parallel perspective is to give equal importance to all parts of the structure depicted and to ensure that everything in it can be accounted for as is befitting a visual document. Documentary paintings were produced in multiple copies so that each participant in the event could keep a copy.

The painter of *Gathering of Scholars at the Dokseo-dang Reading Hall* remains unknown, but it is obvious that he tried to depict the scenery as he saw it, and not worried about whether his style conformed to Zhe or to Li-Guo School conventions of the time. The anonymous

Fig. 45) Detail of *Gathering of Scholars at the Dokseo-dang Reading Hall* (Fig. 44)

Fig. 46) Han Si-gak, *Special National Examination for Applicants from the Northeastern Provinces*, dated 1664. Right half of handscroll, ink and color on silk, 57.9×674.1 cm (whole scroll). National Museum of Korea, Seoul

painter worked much like eighteenth-century painters of true-view landscapes, who depicted specific scenery with the most appropriate ink and brush techniques they had at their disposal, often creating new ones in the process. Paintings like this one and the two that follow serve as a bridge between the Chinese-oriented landscapes of earlier periods and the full-fledged "true-view" landscapes of the late Joseon.

The *Old Villa in the Hwagae District* (fig. 41) by Yi Jing, which we introduced earlier, dated by inscription to the year 1643, also qualifies as a landscape depicting real scenery. We learn from the inscription below the painting that Yi painted this without visiting the site. He

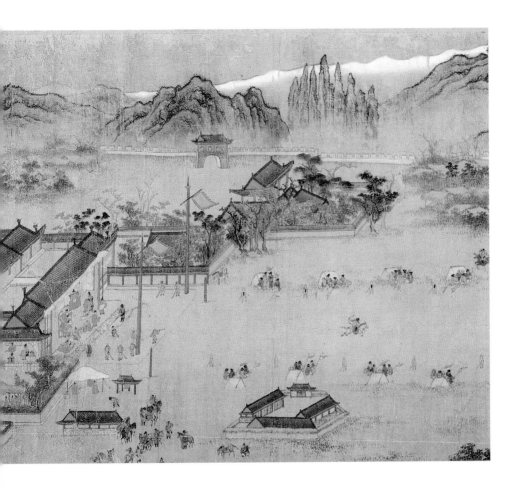

worked from documentary evidence and from looking at other Joseon-period paintings of villas. The scene depicted is that of a villa once owned by Jeong Yeo-chang (1450-1504), a famous Neo-Confucian scholar of the early Joseon period. The composition of the painting is characterized by multiple focal points, with soft hills scattered all around, making it hard to find the villa tucked into a grove of trees in the middle distance. The scene as a whole seems very far from the viewer and appears quite spacious, with some of the hills in the background receding dimly into the distance. The overall impression of this painting is that of mellowness, created by an artist in his maturity. Yi felt no need to invoke either the Zhe or Li-Guo styles he had used earlier in life.

Another documentary painting with a famous site as its setting is the *Special Examinations for Applicants of the Northern Frontier* (fig. 46). Painted by the court painter Han Si-gak (1621-?), the site depicted is Mount Chilbo (Seven-Jewel Mountain) in Gilju, Hamgyeongbuk-do province. Due to the mountain's unusual rock formations and beautiful ridges on either side of the main peak, Mount Chilbo is considered one of the eight scenic spots of Hamgyeong-do province. The site is also known as the "Mount Geumgang of Hamgyeong-do province." Mount Geumgang, or the Diamond Mountains, is the standard evoked when expressing the highest praise for beautiful scenery. (Its importance in Korean landscape painting will be explored in the next chapter.) The examination scenes unfold under a backdrop of mountains rendered in the archaic blue-and-green landscape style. In the right half of the scroll, we find the distinctive needle-like peaks of Mount Chilbo. Although the primary purpose of this late seventeenth-century painting lies in its documentary function, it marks an early milestone in the development of true-view landscape painting that we will be exploring.

Beginning of Southern School Literati Painting

The concept of the Southern School or literati painting needs to be explained in some depth to understand Korean painting after the mid-seventeenth century.

Up to now, we have mainly discussed Korean painters who adopted the stylistic conventions of the Li-Guo, Zhe, or Ma-Xia schools. In China however, by the early seventeenth century, all three styles and the masters whose names are associated with them were relegated to the "professional camp" of painters for hire as opposed to the "amateur camp" of scholars or scholar-officials who painted for pleasure or leisure. This latter camp of amateurs came to be known as practitioners of the "Southern School" of painting while their professional counterparts became known as painters of the "Northern School." The term "literati painting" in Korea refers to paintings that reflect both the

doctrine and formal techniques of the Southern School in China. Primarily used, as the term suggests, for art produced by men of learning, the ideals of scholar painting were first proposed by Su Shi (1037-1101) and his circle of friends during the Northern Song dynasty in China. This was a time when the term "literati" (*wenren*) was synonymous with "government-officials" (*shidaifu*). Su Shi and his cohorts formulated a theory of painting based on the idea that the paintings of scholar-officials are inherently better than those by professional artists because they were produced by men of superior social status, education, and upbringing. They coined the term *shidaifu hua* or "paintings by scholar-officials" to denote works "dabbled" by themselves and their fellow scholar-officials in their leisure time solely for the purpose of expressing their innermost thoughts and feelings.

It was Dong Qichang (1555-1636) and Mo Shilong (d. 1587) who at the end of the Ming dynasty (1368-1644), first classified the tradition of Chinese landscape painting into the two genealogies of Southern and Northern schools of painting. At this time, however, the social situation had changed so that a man of letters did not necessarily hold a government position. The categorization of Chinese landscape painting in the *Huashuo* (Discourses on Painting), traditionally attributed to Mo Shilong, into Northern and Southern schools parallels the Tang dynasty division of Chan Buddhism (Kor. Seon, Jap. Zen) into Northern and Southern schools. In Mo's scheme, the founder of Southern School of landscape painting was the much-revered Wang Wei (699-759) of the Tang dynasty. In the following Five Dynasties period, Guo Zhongshu (ca. 910 - 977), Dong Yuan (d. 962), Juran (act. ca. 960-985), Jing Hao (ca. 855-915), and Guan Tong (act. 10th century) continued this lineage. In the Northern and Southern Song periods, Mi Fu (1051-1107) and his son Mi Youren (1075-1151) inherited the mantle. The Southern lineage continued in the Yuan dynasty with the Four Great Masters, namely Huang Gongwang (1269-1354), Wu Zhen (1280-1354), Ni Zan (1301-1374), and Wang Meng (ca. 1308-1385). In his *Huayan* (Painter's Eye), Dong Qichang expanded the lineage into the Ming period to include the Wu School painters Shen Zhou (1427-1509) and Wen Zhengming (1470-

Fig. 47) Detail showing example of hemp-fiber texture strokes. From the *Wintry Groves and Layered Banks*, attributed to Dong Yuan, ca. 950. Handscroll, ink and color on silk, 181.5×116.5 cm. Kurokawa Institute of Ancient Cultures Gallery, Japan

Fig. 48) Detail showing example of moss dots. From the *Seeking Truth in Autumn Mountains,* attributed to Juran, ca. 960-980. Hanging scroll, ink and light color on silk, 156.2×77.2 cm. National Palace Museum, Taipei.

Fig. 49) Detail showing crab's claw texture strokes. From the *Fishing on a Wintry River*, attributed to Li Cheng, 1st half of 10th century. Hanging scroll, ink on silk, 170×101.9 cm. National Palace Museum, Taipei

Fig. 50) Detail showing example of raindrop texture strokes. From the *Travelers by Streams and Mountains* by Fan Kuan, ca. 1000. Hanging scroll, ink on silk, 206.3×103.3 cm. National Palace Museum, Taipei

Fig. 51) Detail showing example of Mi ink-dots. From the *Spring Mountains Ringed with Pines* by Mi Fu (1051-1107), but possibly later copy. Hanging scroll, ink and color on paper, 35×44.1 cm. National Palace Museum, Taipei

Fig. 52) Detail showing example of hemp- fiber texture strokes. From the *Dwelling in the Fuchun Mountains* by Huang Gongwang, dated 1350. Handscroll, ink on paper, 33×636.9 cm. National Palace Museum, Taipei

Fig. 53) Detail showing example of folded-ribbon texture strokes. From the *Rongxi Studio* by Ni Zan, dated 1372. Hanging scroll, ink on paper, 74.7×35.5 cm. National Palace Museum, Taipei

Fig. 54) Detail showing example of ox-hair texture strokes. From the *Autumn Mountains with a Solitary Temple* by Wang Meng, mid-14th century. Hanging scroll, ink on paper, 142×38.5 cm. National Palace Museum, Taipei

1559), who were influenced by the Four Great Masters of the Yuan. Dong Quichang also entered certain Northern Song painters such as Li Cheng (919-967), Fan Kuan (ca. 960-ca. 1030), Li Gonglin (ca. 1041-1106), and Wang Shen (ca. 1048-1103) into the Southern lineage. In another line up, Ma Hezhi (act. ca. 1130-1180) and Kao Kegong (1248-1310) were also placed into the Southern School.

Many of these painters, including Wang Wei, were scholar-officials, but the Four Great Masters of the Yuan were not government officials although they were of the literati class. Because of this, Dong Qichang used the term "literati painting" (*wenren zhi hua*) instead of the old term, "scholar-official painting" (*shidaifu hua*), in his writings. After Dong, there was a strong tendency to equate Southern School painting with literati painting.

According to Dong Qichang and his fellow theorists, the Northern School style had its origin during the Tang dynasty with the eighth-century artist Li Sixun (651-716), founder of the blue-and-green style of landscape painting and his son Li Zhaodao (ca. 675-741). It continued in the Five Dynasties period with Zhao Gan (act. mid-10th century), and was followed by Zhao Boju (act. early 12th century) and Zhao Bosu (1124-1182) in the Northern Song. Later, Ma Yuan (act. before 1189-after 1225), Xia Gui (act. early 13th century), Li Tang (ca. 1050-after 1130), and Liu Songnian (ca. 1050-after 1130) carried the Northern

School mantle into the Southern Song. Also included in this Northern succession were the painters of the Zhe School in the Ming dynasty, who drew upon the landscape tradition practiced in the Song Academy. Many of the painters placed into the Northern School were professional court painters.

After the late Ming period, the division between the two schools was clearly fixed. Southern School paintings were understood to be ones painted exclusively in the style or styles practiced by artists listed in the Southern School genealogy. In other words, the simple ink landscapes of Wang Wei constituted the archetype of the Southern School. To this paradigm later elements such as *cun* (texture strokes), used to depict the surface of rocks and mountains, and special ink techniques and compositions were gradually added, culminating in the orthodox Southern School style.

Examples of Southern School elements from the Five Dynasties period include "hemp-fiber" texture strokes (long, wavy and nearly parallel brushstrokes used to describe earthen hills) (fig. 47) and "moss" dots (fig. 48) of Dong Yuan and Juran. Southern school elements from the Northern Song period are the gaunt wintry tree branches resembling crab claws of Li Cheng (fig. 49) and the "raindrop" texture strokes of Fan Kuan (fig. 50). Also from the Northern Song are the moist atmosphere and soft horizontal ink-dots of varying tonality and size to represent vegetation on mountains of Mi Fu and his son, Mi Yuren (fig. 51). These classical Southern School elements were later amended and popularized by the work of the Four Great Masters of the Yuan dynasty. Huang Gongwang (fig. 52) and Wu Zhen reinterpreted the styles of Dong Yuan and Juran. Ni Zan re-worked the brush techniques of Jing Hao and Guan Tong creating the "folded-ribbon" texture strokes (fig. 53), that is, dry, light strokes formed by dragging the brush sideways and turning it downward at a ninety degree angle to depict rocky surfaces. The contribution of Wang Meng, the youngest of the four, was the "ox-hair" texture strokes (fig. 54) to describe sinuous "dragon-veined" mountains.

In the following Ming period, the painters of the Wu School, Shen Zhou (1427-1509), Wen Zhengming (1470-1559), and others who

worked in Wu county, Jiangsu province (today's Suzhou and its environs) in turn reinterpreted the styles of the Four Great Masters of the Yuan to create their personal styles. Dong Qichang designated this Southern School stylistic lineage as the *zhengtong* (Kor. *jeong-tong*) or "orthodox tradition" of landscape painting.

In Ming China, during the Jiajing (r. 1522-1566) and (1572-1615) reigns, the rapid expansion of the printing industry into all areas of China resulted in the publication of large numbers of painting manuals. Among the manuals which reached Korea relatively early are *Master Gu's Painting Manual* (*Gushi huapu*, pub. 1603) by Gu Bing, the *Book of Illustrated Tang Poems* (*Tangshi huapu*, Wanli era), and the *Ten Bamboo Studio Manual of Painting and Calligraphy* (*Shizhuzhai shuhuapu*, pub. 1627). Later arrivals include the *Ten Bamboo Studio Notepaper Manual* (*Shizhuzhai qianpu*, pub. 1644) and the *Mustard Seed Garden Manual of Painting* (*Jieziyuan huachuan*) published in two stages in 1679 and 1701. It was through the importation of *Master Gu's Painting Manual* and the *Mustard Seed Garden Manual of Painting* that Southern School or literati painting styles were introduced to Korea in the seventeenth century.

These painting manuals and other new Chinese ideas and artifacts arrived in Korea through renewed diplomatic and cultural interchanges between the Joseon court and the new Qing dynasty. As also mentioned earlier, exchanges between Korea and Qing China began when the two eldest sons of King Injo, Crown Prince Sohyeon and Prince Bongnim (later, King Hyojong) were sent as hostages to China. As also mentioned earlier, their younger brother, Prince Inpyeong (personal name Yi Yo, 1622-1658), who was the most talented of the three princes in painting and calligraphy, was held hostage in China from 1640 to 1641. After 1650, he traveled there again four times as emissary for his brother, King Hyojong. Like his scholar-official fellow countrymen, Yi might have been reluctant to accept the fall of the Ming, a Han Chinese dynasty, and slow to recognize the legitimacy of the ruling Qing Manchus, but he nonetheless welcomed cultural contacts with China. It was under such circumstances that the Southern School literati painting took root in Korea.

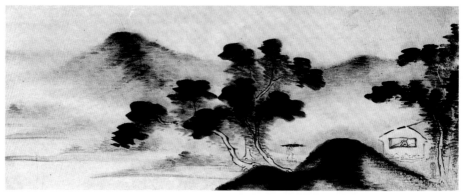

Fig. 55) Yi Jeong-geun, *Mi-style Landscape*, 1st half of 16th century. Right half of handscroll, ink on paper, 23.4 × 119.4 cm (whole scroll). National Museum of Korea, Seoul

However, before the arrival of painting manuals with Southern School styles and direct knowledge of the new painting orthodoxy through cultural exchange, some Korean artists were already working successfully in the exalted literati styles.

In the previous chapter, we examined landscape paintings now in the collection of the Yamato Bunkakan attributed to Seo Mun-bo, Choe Suk-chang, and Yi Jang-son. These three Yuan interpretations of the literati Mi Fu style and the sixteenth-century *Mi-style Landscape* (fig. 55) with the signature of Yi Jeong-geun, a professional court painter, exemplify the early works of Joseon painters in the Southern School manner. The overall impression of Yi's painting is softer than the three Mi-style works in the Yamato Bunkakan, especially as it recedes into the distance at the left. However, the soft horizontal Mi ink-dots in the foreground and on the hills in the middle ground, as well as on the trees in Yi's handscroll are unmistakable hallmarks of the scholarly Mi style.

Turning to the seventeenth century, we find a Korean work in the style of one of the most important painters in the Southern School lineage, Huang Gongwang of the Yuan dynasty. In Korea, one of the earliest landscapes inspired by Huang's style is the *Landscape after Huang Gongwang* (fig. 56) which has the inscription and seal of Yi Yeong-yun (1561-1611), the previously mentioned younger brother of Yi Gyeong-yun and uncle of Yi Jing. In the inscription, the artist reveals that he is painting in the early style of Huang Gongwang. Although Yi's

brushstrokes lack the characteristic calligraphic power of the Yuan master, he managed to capture some of Huang's hemp-fiber texture stokes and method of rendering trees. As a legitimate relative of the royal family, and a person of high learning, Yi surely fits the original Song ideal of the literati painter.

Another Korean painter who worked in a Southern School style is [Naong] Yi Jeong (1578-1607). His life story, which has been preserved in a memorial composed by the famous literary figure Heo Gyun (1569-1618), illustrates a typical Korean phenomenon. According to Ho, Yi was the son of Yi Sung-hyo and the nephew of Yi Heung-hyo, both well-known painters at the early Joseon court. When his father died, his uncle took in the orphaned Jeong and taught him how to paint. Although his talent was exceptional, he was not disciplined. He died at the age of thirty, and did not leave behind many paintings. The *Album of Landscapes* which consists of 12 leaves now in the collection of the National Museum in Seoul shows many aspects of his styles. "Leaf No. 4" (fig. 57) of this album shows him attempting to follow the Wu School style as practiced by Shen Zhou of the early Ming. The simple linear rendering of the trees and rooftops in the foreground, and the scattering of dark dots on the mountain peak

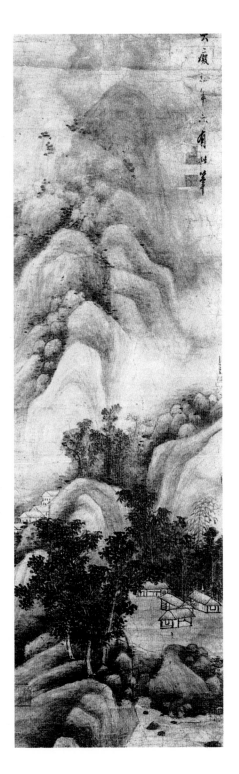

Fig. 56) Yi Yeong-yun, *Landscape after Huang Gongwang*, late 16th-early 17th century. Hanging scroll, ink on paper, 97 × 28.8 cm. National Museum of Korea, Seoul

Fig. 57) Yi Jeong, "Leaf No. 4" from *Album of Landscapes*, early 17th century. Album of 12 leaves, ink on paper, 19.1×23.5 cm. National Museum of Korea, Seoul

in the middle ground seem all very similar to elements found in Shen's landscapes. However, the texture strokes Yi used on the central mountain are not quite like the hemp-fiber texture strokes used by Shen in his paintings.

There are several leaves in the same album, such as "Leaf No. 2" (fig. 58) with even more unusual brushstrokes. The brushwork is akin to that practiced by artists of the *yipin*, or "untrammeled class" of painters in China. *Yipin*-style painting came into being in the tenth century among Chan Buddhist painters, and was later adopted by literati painters. In fact, it is difficult to call the chaotic strokes used to depict trees in the foreground of Yi Jeong's landscape "brushstrokes." The painter might as well have dipped the tip of a broken sugar cane into ink, and dragged it across the paper to draw the trees. It is unknown

Fig. 58) Yi Jeong, "Leaf No. 2" from *Album of Landscapes*, early 17th century. Album of 12 leaves, ink on paper, 19.1×23.5 cm. National Museum of Korea, Seoul

which channels Yi Jeong used to gain access to the inspiration for his paintings. His works also bear close comparison to the works of the Ming period by Zhe School painters such as Zhang Lu (act. mid-sixteenth century), who was labelled "deranged" by late Ming critics.

Prince Inpyeong [Yi Yo] whom we have mentioned as a frequent traveler to China also dabbled in skillful ink play. His fan-shaped painting, *A Solitary Fishing Boat* (fig. 59), displays a simple composition of foreground hillocks with trees and mountains in the distance separated by an expanse of water. The artist's inscription tells us that the figure in the lone fishing boat is rowing home. Yi employs several brush conventions of the Southern School such as hemp-fiber texture strokes and soft, broad foliage strokes similar to those found in Ming versions of the Mi Fu style. Above all, the calm and bland feeling

Fig. 59) Yi Yo, *A Solitary Fishing Boat*, first half of 17th century. Fan, ink and light color on silk, 15.6 × 28.8 cm. Seoul National University Museum

conveyed by the painting achieves the ideal of literati art valued by its practitioners.

The 106 models of painting compositions by Chinese masters contained in *Master Gu's Painting Manual*, which was introduced to Korea as early as 1608, offered fresh stimuli to scholar-painters in Korea searching for new ideas. An undated album leaf by Jo Sok (1595-1668), "Gathering Mist in the Village by the Lake" (Fig. 60), in the collection of the Kansong Art Museum in Seoul, is based on a composition by Gao Kegong in vol. 3 of the *Manual*. The same composition also appears in the *Book of Illustrated Tang Poems* on a page entitled "After Gao Kegong's Brush Idea." However, instead of following the Chinese model exactly, Jo took the right half of Gao's composition and enlarged it to fill the entire picture plane. He also added a few houses at the foot of the hill across the river.

In the next generation, the scholar-painter Yun Du-seo (1668-1715) also made good use of painting manuals by teaching himself how to paint various types of Chinese compositions from them. His dependence on Chinese models can clearly be seen when comparing his paintings with the contents of a manual in his possession which survives in the collection of the Yun Du-seo Memorial Museum,

established by his descendants in his hometown of Haenam, Jeollanam-do province. His small "Thatched Pavilion by the Water's Edge" (Fig. 61), a leaf from an album of paintings also in the Yun Du-seo Memorial Museum, draws from two works by Ni Zan to create his own landscape. From *Master Gu's Painting Manual,* Yun adopted Ni Zan's characteristic composition of foreground trees and distant mountains separated by an expanse of water and the linear depiction of the hills. From the Ni Zan work reproduced in the *Book of Illustrated Tang Poems,* Yun borrowed the motif of a small pavilion. Also from the latter, Yun took the "folded-ribbon" texture strokes of Ni and used them to texture his rocks on the lower left corner. In the lower right corner, however, Yun added a small fisherman walking toward the pavilion, a human element that Ni Zan seldom used.

Fig. 60) Jo Sok, "Gathering Mist in the Village by the Lake," mid-17th century. Album leaf, ink and light color on paper, 38.5×27.6 cm. Kansong Art Museum, Seoul

The mid-Joseon period thus saw three important developments: an increasing Koreanization of a wide range of Chinese painting styles that had reached Korea in earlier periods; the emergence of the early stage of true-view landscapes in the form of documentary painting; and the acceptance of Chinese literati painting as a new trend. Korean painters' reliance on model compositions illustrated in Chinese painting manuals continued into the late Joseon period, even as their self-

awareness as a people and their pride in things Korean reached new heights. However, as we have seen in the case of Jo Sok and Yun Du-seo, Korean painters modified the Chinese models to make landscape compositions that were uniquely their own. In the late Joseon period, painting manuals came to be even more widely circulated and utilized by literati painters as well as by professional painters in the Bureau of Painting (*Dohwa-seo*) at court. We will return to these developments in the next chapter.

Fig. 61) Yun Du-seo, "Thatched Pavilion by the Water's Edge," one leaf from *Album of Paintings,* late 17th - early 18th century. Ink on paper, 16.8×16 cm. Yun Memorial Museum, Haenam, Jeollanam-do province

V. Korean Inspiration: True-view Landscape Painting of the Late Joseon Period

Historical and Intellectual Background

The golden eighteenth century in Korean history opened with the second half of the reign of Sukjong (r. 1674-1720). This was followed by the short reign of Gyeongjong (r. 1720-1724) and with the enlightened rule of Yeongjo (r. 1724-1776) and Jeongjo (r. 1777-1800). The latter two monarchs promoted scholarship and culture throughout Korea to levels unprecedented since the time of King Sejong the Great in the fifteenth century. The entire period was also blessed with a long peace free from devastating foreign invasions that lasted until the middle of the nineteenth century.

The 1644 overthrow of the 'Han' Chinese dynasty of Ming by the nomadic Manchus and their subsequent establishment of the Qing dynasty in China had an important effect on Korea's cultural awareness. The Joseon maintained cordial diplomatic relations with the Qing, but the court and the majority of high-ranking Joseon scholar-officials were at heart loyal to the fallen Ming. Culturally, Koreans felt superior to the Manchus. They looked down on Manchus as "barbarians" (horo) lacking in Confucian civilization, culture, and scholarship. Furthermore, in the absence of a rightful inheritor to the centuries old Confucian tradition in China, Koreans came to regard themselves as the legitimate heirs to that grand lineage. This Korean attitude was promoted mainly by the Neo-Confucian scholar Song Si-yeol (1607-1689) and his followers, and by a group of scholars known as the Old Doctrine (Noron) faction.

One way of pledging loyalty to the fallen Ming was the continued use of the last Ming reign title, Chongzhen (r. 1628-1644), in most of their routine documents. Although official documents at the

Joseon court had to be dated in accordance with the new Qing reign titles, Korean Neo-Confucian scholar-officials kept using the old Chongzhen reign title for dating private documents for as long as 100 years into the Qing.

Joseon scholar-officials' desire to assume the mantle of China's Confucian tradition could be understood as a duty to faithfully keep the cultural and intellectual traditions of China's past. However, the situation was somewhat different. Joseon scholar-officials increasingly began to feel new confidence and pride in their own culture, history, and land. This new attitude manifested itself in two important ways. One was the development of the native landscape tradition of "true-view" painting in the late seventeenth and early eighteenth centuries. The other was that Korea's intellectual class now felt free to take the incentive and examine their own history and affairs. At this time, for instance, the Joseon court refurbished the tombs of Korean kings going back to the Silla and beyond to the legendary founder of Korea, King Dangun.

A more important and certainly more formidable intellectual force from the late seventeenth century was the School of Practical Learning (*Sil-hak*). The scholars of this school advocated political, economic, social, and educational reform. They took practical affairs as their point of departure, emphasizing not only traditional humanistic disciplines derived from China, but also social and natural sciences and technology. Their interest in promoting a new understanding of Korea's history and culture led to a surge of publications about various aspects of Korean history, literature, language, and geography.

The birth of the Practical Learning movement in Korea actually traces back to the early seventeenth century, when a pioneering work by [Jibong] Yi Su-gwang (1563-1628), the *Topical Discourses of Jibong* (*Jibong yuseol*) was published in 1614. This first *Silhak* publication dealt with a wide range of subjects including astronomy, geography, Confucianism and botany as well as Yi's own views on Korean society and dynastic government. Yi Su-gwang, who visited Yanjing three times (in 1590, 1597, and 1611) as an emissary to the Ming court, was strongly influenced by the philosophy of Wang Shouren [Yangming] (1472-1529),

the leader of the Chinese philosophical school of the mind, who developed the theory that knowledge and action are one. Yi was also exposed to the new Western learning that was brought to China by Jesuit priests starting in the sixteenth century.

Yi Su-gwang's work was followed in 1670 by the *Treatise by Bangye* (*Bangye surok*) written by [Bangye] Yu Hyeong-won (1622-1673). The text was an assessment and a critique of Joseon institutions, including its land system, educational policies, government structure, and military service. Besides the *Bangye surok*, Yu also left a sizable body of writings on history, geography, linguistics, and literature.

The scholar who further expanded Yu Hyeong-won's ideas was [Seongho] Yi Ik (1681-1763) who published a modestly titled, but truly encyclopedic work in 30 volumes, the *Insignificant Explanations by Seongho* (*Seongho saseol*). Although Yi Ik had never visited China, he benefited from his father's vast collection of books among which were maps of the world and works on astronomy, Catholicism, Western painting, science, and technology. The importance of Yi Ik in relation to the development of true-view landscape painting has been pointed out by several scholars. His notations on Western painting reveal a familiarity with paintings brought back to Korea from Qing China by Joseon emissaries. Yi Ik's idea that a painting should reflect reality and be a "true-view" of a scene is expressed in his recorded colophon to a painting entitled *Nine-bend [Stream] of Mount Wuyi*:

> When I look at landscape paintings of the past and present, I am stunned by their strangeness and falsehood. I am sure that there is no such scenery on earth. They were painted only to please the viewers. Even if ghosts and demons were to roam the entire universe, where in the world would they find the true-view (*jingyeong*) [as rendered in such paintings]? These strange paintings can be compared to those who tell lies and embellish words to cheat others. What can one take from them?

His view that paintings of landscape should resemble the scenery depicted was without doubt influenced by Western paintings of

landscapes that looked more "real" to him. Yi Ik himself was not a painter, and his interest in Western realism remained restricted to criticism and theory. His general view of Western approach to painting, or at least its emphasis on actual observation, seems to have been shared by many *Silhak* scholars. A self-portrait by the well-known painter, Yun Du-seo (1668-1715), one of the members of Yi Ik's circle of scholars, is further evidence of the growing Korean interest in painting based on actual observation. Yun's realistic self-portrayal, painted with painstaking detail, is now kept in the Yun Du-seo Memorial Museum in Haenam, Jeollanam-do province.

This period is also marked by the flourishing of works of historical geography, which can be more directly associated with the development of true-view landscape painting. Han Baek-gyeom's (1552-1615) pioneering work, the *Treatise on Korean Geography* (*Dongguk jiri-ji*) of the early seventeenth century was followed by Yi Jung-hwan (1690-?) *Ecological Guide to Korea* (*Taengni-ji*), which can be characterized as a cultural geography, as it includes local customs and community values. Added to the above are the *Routes and Roads* (*Doro go*) and *Mountains and Rivers* (*Sansu go*) by Sin Gyeong-jun (1712-1781), and the Map of Korea (*Dongguk jido*) by Jeong Sang-gi (1678-1752), produced at the command of King Yeongjo. The latter, printed in nine sheets (one showing the entire peninsula, and the others showing each of the eight provinces), could be folded into one album and was an epoch-making work in its precise marking of the distances between one place and another. When the eight sheets depicting each province separately were spread out and put together, they formed a complete map of the peninsula the size of a large carpet. The map was made on a scale of 1:420,000. The original map no longer exists, but copies of it under the names "Dongguk jido" or "Paldo jido" are proudly preserved in Korean collections today.

The School of Practical Learning in the late eighteenth and the early nineteenth century was also termed the School of Northern Learning (*Bukhak-pa*), as their proponents openly accepted the advanced *Silhak* scholarship of Qing China. The leading scholars of Northern

Learning include Hong Dae-yong (1731-1783), Bak Ji-won (1737-1805), the author of the famous *Jehol Diary,* and Bak Je-ga (1750-1805), whose text, the *Discourses on Northern Learning (Bukhak-ui),* gave the school its name. Two younger scholars of this persuasion, Jeong Yak-yong (1762-1836) and Seo Yu-gu (1764-1845), had careers which extended into the first half of the nineteenth century. Of the five, Bak Je-ga and Jeong Yak-yong left a few paintings that reflected their intellectual interests. One of Bak's paintings is strongly influenced by the techniques of Western painting. Seo Yu-gu contributed to our knowledge of East Asian art history by putting together the *Painting Basket (Hwajeon),* a compilation of writings on the theories and techniques of painting written by Chinese as well as Korean scholars of the past.

The interest in history and geography in the second half of the Joseon dynasty also manifested itself in widespread travel to scenic spots, not only to the Diamond Mountain region but also to other parts of Korea. Scholars tended to travel widely, sometimes accompanied by their favorite court painters, and most of them left voluminous travel diaries describing what they saw on their journeys. Much can be learned from comparing their descriptions with true-view landscape paintings of the same sites.

Whether the scholars belonged to the conservative Old Doctrine faction or to the more progressive School of Practical Learning, the intellectual spirit of the age converged on an intense study of Korean history, geography, culture, and natural environment. This common effort in defining Korea's historical and cultural identity led in turn to a renewed interest in depicting the topography of Korea, and to the rise of true-view landscape painting.

Jeong Seon (1676-1759)

The artist traditionally credited as the leading exponent of the new "true-view" trend in landscape painting in the early eighteenth century is Jeong Seon (1676-1759). Jeong is also known by the name

with which he signed most of his paintings, Gyeomjae, or "Studio of Modesty." He came from an impoverished *yangban* family, but was recommended by the well-known scholar Kim Chang-heup (1653-1722) to the Royal Bureau of Painting. It was unusual for a descendant of a *yangban* family to become a member of the Royal Bureau of Painting as the job had been traditionally relegated to men of the lowly *jungin* ("middle people") class. Throughout Jeong's long career as a painter, he served mostly in the capital except for a few provincial postings he held from time to time. Late in life, he was honored by King Yeongjo, who bestowed upon him an official position of the fourth rank in 1754 and of the second rank in 1756. This royal action met with stiff opposition from other court officials who considered Jeong's lowly status (a mere painter) as unbefitting an office of the second rank. But the painter also had influential supporters and emerged victorious.

There was a coterie of scholar-officials whom Jeong Seon befriended and were instrumental in forming his art and thought, especially the development of true-view landscape painting. Foremost among his supporters were six brothers of the powerful Andong Kim family, particularly Kim Chang-jip (1648-1722), Kim Chang-hyeop (1651-1708) and Kim Chang-heup. Other scholars in Jeong's circle include Yi Ha-gon (1677-1724), who left interesting views on painting in his *Duta-cho* (*Draft Writing of Duta*) and [Sacheon] Yi Byeong-yeon (1671-1751), one of the most accomplished poets of the time. The other artist in this elite circle was Jo Yeong-seok (1686-1761), a scholar-painter who left a well-known album of genre paintings.

As has been pointed out by many scholars, the basic elements of Jeong's true-view (*jingyeong*) style, which began to develop in the 1730s, were derived from the Southern School painting styles of China. A look at the true-view landscapes of Jeong Seon and his contemporaries will reveal that three Southern School elements prevail in their works, hemp-fiber texture strokes, Mi ink-dots, and folded-ribbon texture strokes. Of the three elements, Mi ink-dots appear most frequently throughout Jeong Seon's works.

The majority of the true-view landscapes of the late Joseon period depict aspects of Mount Geumgang, a mountain range replete with symbolism and bearing various names. Located in the northern part of Gangwon-do province along the coast of the East Sea (Donghae), the range occupies a large area (map 5), with peaks said to number as many as 12,000. The area is customarily divided into three main parts: Outer Geumgang (Oegeumgang); Inner Geumgang (Naegeumgang); and Coastal Geumgang (Haegeumgang). The dividing line between Outer and Inner Geumgang is Biro-bong peak. Sometimes the whole Geumgang area is simply referred to as Sea and Mountains (Haeak or

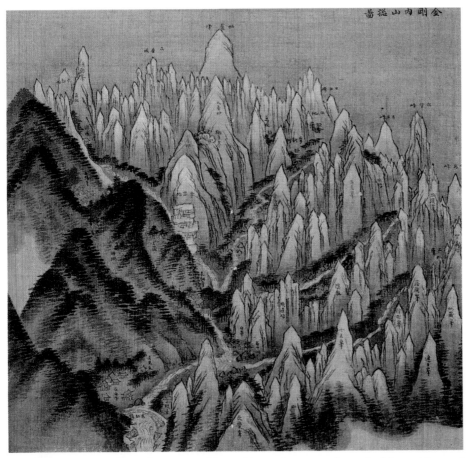

Fig. 62) Jeong Seon, "Complete View of Inner Mount Geumgang," one leaf from *Album of Paintings of Pungak Mountain in the Sinmyo Year [1711]*. Album of 13 leaves, ink and light color on silk, 36×37.4 cm. National Museum of Korea, Seoul

Haesan), and painting albums containing a series of Geumgang views are frequently called *Album of Sea and Mountains* (*Haesan-do cheop*). Since the area is located to the east of the capital, Hanyang (present-day Seoul), these albums were also called *Albums of Travel to the East* (*Dongyu-cheop*). In winter, when its rocky peaks are all exposed, Mount Geumgang is called All Bones Mountain (Gaegol-san). In the fall, when colorful leaves cover the mountain, it is called Autumn Foliage Mountain (Pungak-san).

Although Jeong Seon lived to the age of eighty-four and left behind an enormous body of work, his dated paintings, which fall between the years 1711 to 1751, are relatively few. The 1711 date apparently marks Jeong Seon's first visit to Mount Geumgang when he painted the so-called *Album of Paintings of Pungak [Autumn Foliage] Mountain in the Sinmyo Year [1711]* (fig. 62). This album contains 13 leaves of paintings to which is attached a colophon written in 1867 by a descendant of a certain Baekseok who is identified as Bak Tae-yu (1648-1746), a high official during the reigns of King Sukjong and King Yeongjo. According to the colophon, Jeong Seon accompanied Bak on the latter's second trip to Mount Geumgang, and produced a painting album of the site. Although the reliability of the colophon to the album can be questioned, the paintings in the album all show Jeong Seon's early hand, one that is still lacking in stylistic confidence and individuality.

Jeong's second trip to Mount Geumgang the following year (1712), and his third trip in 1747 are well documented in the two albums he made of the trips, both entitled *Album of Realistic Representations of Sea and Mountains*, to which contemporaneous scholars attached colophons and dates. The 1712 album is not extant today, only the colophons have survived. It is not clear whether he made more trips to the area between 1712 and 1747. However, a recent study shows that Jeong painted many images of Mount Geumgang based on his earlier sketches.

Jeong's favorite composition was the type known as the "Complete View of Mount Geumgang" (*Geumgang jeondo*), which he

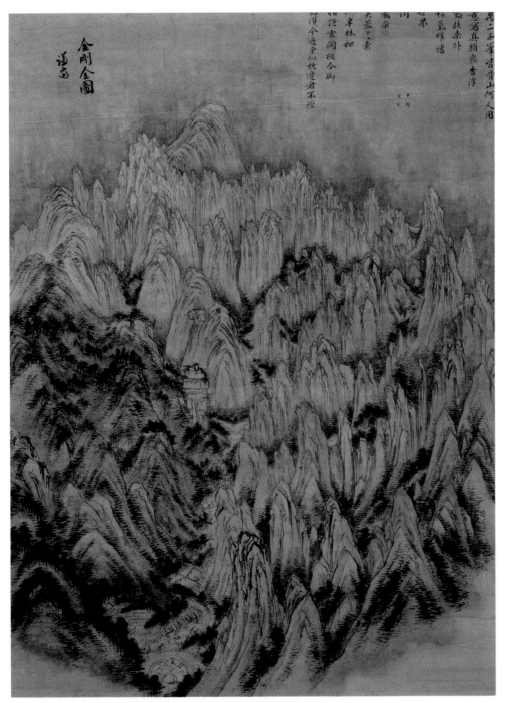

Fig. 63) Jeong Seon, *Complete View of Mount Geumgang*, dated 1734. Hanging scroll, ink and light color on paper, 130.8×94 cm. Ho-Am Art Museum, Seoul

painted many times after 1711. Two versions of this composition, the *General View of Inner Mount Pungak [Geumgang]*, an undated late work in the collection of the Kansong Art Museum, Seoul; and the *Complete View of Mount Geumgang*, dated 1734 (fig. 63); display his painting styles during two different periods. The basic composition in both works is characterized by organizing and texturing the mountain into distinctive rocky or earthen structures. The foreground and the left edge of the painting is organized into an area of low, densely-vegetated earthen peaks which serve to embrace and emphasize the imposing presence of the steep, barren rocky peaks in the distance. Even for someone seeing these paintings for the first time, it is possible to recognize the concept of *yin* and *yang* revealed in this composition. Jeong Seon was known to have studied the *Book of Changes* (*Yijing*) and applied its principles in making his paintings. A recent article has gone so far as to interpret everything in the 1734 painting in terms of *yin* and *yang* as well as the eight diagrams of the *Yijing*. Two features in the painting that might lend support to this interpretation are the arched bridge in the lower left, which exists in cosmic opposition to the prominent Biro-bong peak in the far distance. Curiously, Jeong Seon's inscription also forms a semicircle, at the center are four characters reading, "Inscribed in the winter of the cylical year *gapsin* [1734]." It is more instructive to read the artist's poetic inscription:

> Twelve-thousand peaks of All Bones Mountain
> Who would even try to portray their true image?
> Their layers of fragrance float beyond the East Sea
> Their accumulated *chi* swells expansively throughout the world.
> Rocky peaks like lotus blossoms, emitting whiteness.
> Pine and juniper forest obscures the entrance to the profound.
> This careful sojourn, on foot through Mount Geumgang,
> How can it be compared with the view from one's pillow?

The poem at once describes the scene painted and alludes to the profundity associated with Mount Geumgang. The last line is a

reference to Zhong Bing, the fourth-century Chinese painter-theorist whom we cited in chapter II for covering the walls of his room with images of mountains for the purpose of roaming around them with his eyes while lying in bed in old age.

This painting and similar works by Jeong Seon and his followers are meant to be true-view landscapes, faithful to reality. But a good look at the *Complete View of Mount Geumgang* reveals that it is more of a conceptualized view of the entire mountain. In fact it is conceived in the same tradition as the *Nine-bend [stream] of Mount Wuyi*, which was painted both as a complete view and as nine separate compositions. In his composition, Jeong combined the age-old tradition of the "complete view" (*jeondo*) with his own visual encounter of the peaks of Mount Geumgang, creating a memorable image to which he added a poem expressing his thoughts and feelings about the mountain.

Even though the *Complete View of Mount Geumgang* is traditional and conceptual, a comparison of this painting with a contemporary travel description of travel to the site reveals Jeong's power of realism. The following is a passage from the *Traveling on Land* (*Jihaeng-rok*), a travelog by the literatus Yi Man-bu (1664-1732):

Before me rise twelve thousand peaks winding sinuously into the distance. Looking at these jagged, craggy peaks soaring into the sky, I am seized with such awe and exhilaration that I feel as if I am immersed in fresh water.

The needle-like twelve thousand peaks (fig. 64) of Mount Geumgang were depicted by Jeong with the distinctive downward strokes called Gyeomjae vertical strokes (*Gyeomjae sujik-jun*) that he developed during the course of painting Mount Geumgang many times. As seen in a recent photograph of the peaks (fig. 65), Jeong masterfully captured the essence of their reality.

Besides these "complete views," Jeong Seon painted individual scenes of particular sites on Mount Geumgang as components of albums or screens. The number of the scenes in each set varies—sometimes only eight, in other cases 30 or more. He also painted

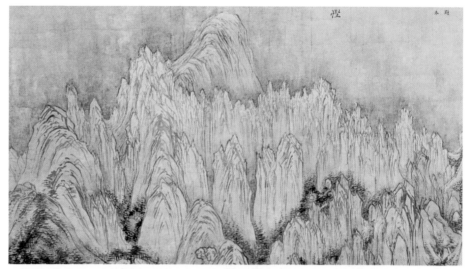

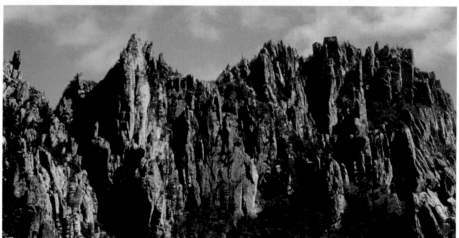

Fig. 64) Detail of *Complete View of Mount Geumgang* (Fig. 63)
Fig. 65) Mount Geumgang, Gangwon-do province. Photograph by Yi Song-mi, 1999.

small-scale works depicting one peak or one temple from his *Complete View* paintings. Two undated album leaves, the "Jeongyang-sa Temple" (fig. 66) and "View-Hole Peak" (fig. 67) both show sites that appear in the *Complete View* paintings. The Jeongyang-sa temple complex is barely visible toward the upper left portion of the Complete View, and the prominent peak on the upper right portion is the View-Hole Peak. This peak, called "Hyeolmang-bong" in Korean, is so named because it has a hole through which one can see the view beyond. Though undated, this

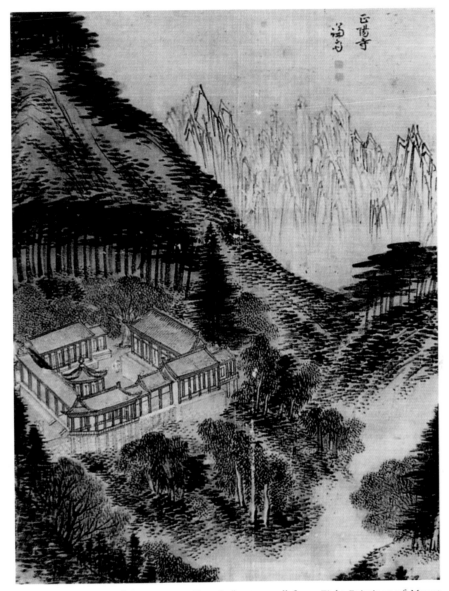

Fig. 66) Jeong Seon, "Jeongyang-sa Temple," one scroll from *Eight Paintings of Mount Geumgang*, first half of 18th century. Set of eight hanging scrolls, ink and light color on paper, 56×42.8 cm. Kansong Art Museum, Seoul

leaf is considered a late work by Jeong Seon as it displays relaxed and masterful brushstrokes throughout.

Jeong Seon's trip to the Mount Geumgang area must have included visits along the East Coast, the site of a very unusual

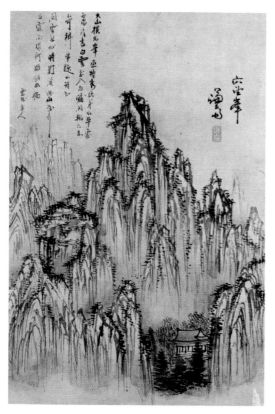

fig. 67) Jeong Seon, "View-Hole Peak," first half of 18th century. Album leaf, ink and light color on silk, 33 × 22 cm. Seoul National University Museum

formation: two enormous rock monoliths that form the appearance of a massive gate. Jeong painted the scene in both small and large format, the most impressive of which is a huge hanging scroll, the *Rock Gate at Tongcheon* (fig. 68). In this monochrome work, Jeong focused on the severity of the scene which he conveyed through contrasts of horizontal and vertical brushstrokes as well as light and dark ink. He modeled the faces of the columnar rocks in his distinctive vertical texture strokes of dark ink. Perhaps more striking than the depiction of the rocks is the linear rendering of the billowing waves, which seem to engulf the rocks. A man, carrying a staff and dressed in a typical Korean costume with a broad-brimmed horsehair hat, is passing through the gate, looking backward in fear of being overtaken by the surging tide. His boy servant follows him. In the foreground is another group of figures. The man on horseback, accompanied by two servants, seems unafraid to confront the waves. The unusual treatment of the waves makes this work one of the most arresting depictions of the sea in East Asian painting.

Jeong Seon's true-view landscape paintings also cover a wide range of scenes in and around Seoul, where he spent much of his life. *Clearing after Rain on Mount Inwang,* painted in 1751 (fig. 4) which we introduced in chapter I, is the last dated work by Jeong Seon. It depicts the rocky mountain situated to the west of Gyeongbok-gung palace in Seoul. A photograph of Mount Inwang (fig. 5) taken from the 37th floor of the modern Lotte Hotel in the center of Seoul, approximates the view depicted by Jeong. In this painting Jeong emerges as the most daring and original painter of true-view landscape. An unusually large

Fig. 68) Jeong Seon, *Rock Gate at Tongcheon*, first half of 18th century. Hanging scroll, ink on paper, 131.6×53.4 cm. Kansong Art Museum, Seoul

horizontal hanging scroll, the painting shows a well-structured composition of mountain peaks and forest separated by large areas of mist. Mount Inwang rises above thick clouds after a rain, exposing its rocky surfaces against the sky. The clearing clouds still obscure houses and rows of pines and other deciduous trees. Jeong Seon has used rapidly executed bold strokes of saturated ink to define the rounded peaks of the mountain covered with enormous boulders of yellowish white granite. A dotted line along the far ridge of the mountain represents the north-western portion of the fortress wall that encircled the capital. Much of this fortress still stands today.

In the middle distance, just below the massive central peak, smaller rocky outcroppings alternate with soft white earthen mounds covered with rows of pine trees, each depicted with a simple vertical trunk and a few horizontal branches. This stylized rendering of landscape is one of the hallmarks of Jeong Seon's late style. In order to enliven the earthen mounds, Jeong applied Mi ink-dots to indicate clusters of vegetation. The range of tones, from saturated dark ink to the white of the paper, along with the range of brushstrokes, from traditional Mi ink-dots to self-invented sweeping strokes, enrich the visual effect of the painting. The viewer is left with an unforgettable impression of Mount Inwang.

Jeong Seon's Contemporaries and Followers

All artists of the eighteenth century painted true-view landscapes in some form. Although Jeong's presence in the capital was preeminent in the second quarter of the eighteenth century, there were other literati painters such as Heo Pil (1709-1761), Yi In-sang (1710-1760) and Yi Yun-yeong (1714-1759) who maintained relative independence from Jeong even when they painted true-view landscapes. Yi In-sang and Yi Yun-yeong were particularly close to each other and left paintings with inscriptions in which their friendship and time spent together at certain locations were celebrated.

Fig. 69) Yi Yun-yeong, "Goran-sa Temple," dated 1748. Album leaf, ink and color on paper, 29.5 × 43.5 cm. Private collection, Seoul

Both were highly regarded men of letters. Yi In-sang could not advance to high office due to his ancestry as his great-grandfather was an illegitimate son. His last position in office was that of a magistrate of a small district, an office of the sixth rank in a bureaucracy of nine ranks. Yi Yun-yeong did not have Yi In-sang's problem. He was a high-born son, but simply stayed away from an official career, and instead, pursued his own interest in writing, calligraphy and painting.

The two friends who shared the same surname are considered supreme models of literati who painted in the early eighteenth century. In true amateur spirit, they painted not for money, but for themselves or for close friends who appreciated their works. Also they tended to paint subject matter with high symbolic content such as landscapes or pine trees in styles based on the Chinese Southern School but with their own personalities clearly discernible in their brushwork.

Yi Yun-yeong's "Goran-sa Temple" (fig. 69) in a private collection in Seoul shows the scenery of the "Cliff of Falling Flowers" (Nakhwa-

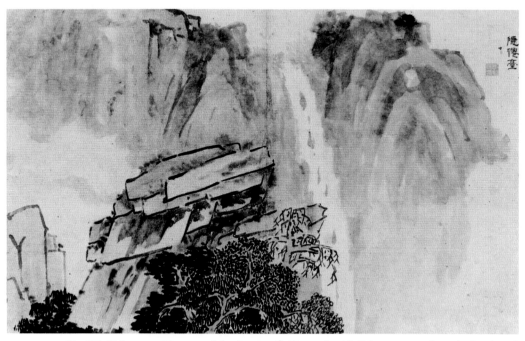

Fig. 70) Yi In-sang, "Terrace of the Immortal's Retreat," mid-18th century. Album leaf, ink and light color on paper, 34×55 cm. Kansong Art Museum, Seoul

am), a historically famous spot along the White Horse River (Baengma-gang river) in Buyeo. It is said that when the Baekje Kingdom fell, three thousand Buyeo court ladies plunged themselves into the river to avoid being subjugated to the combined forces of the Silla and Tang China. The painting is a low-key work typical of literati ink painting with light colors and a dated inscription. The artist tells us that he and Yi In-sang were together in 1748 on Mount Jiri where they shared their thoughts on the beautiful scenery of Goran-sa temple. However, he felt that words were inadequate to express the beauty of the scenery, and decided to sketch it with dry brushstrokes. The temple is perched on top of the cliff overlooking the ever-flowing river. Yi's scene is a poignant reminder of both the history of the site and passage of time. His sensitive use of dry brush and soft colors transforms tragic history into visual elegance and grace.

Yi In-sang similarly uses dry brushstrokes in many of his paintings, and until recently, the "Goran-sa Temple" was mistakenly attributed to Yi In-sang. In his "Terrace of the Immortal's Retreat" (Eunseon-dae) (fig. 70), one of the scenic spots in the Outer Geumgang

area, however, Yi opted for a more relaxed "wet" brush. In this abbreviated scene, Yi depicts a background cliff and waterfall against which the Eunseon-dae rock terrace, surrounded by a few trees, is firmly anchored. His use of sharp outlines for the angular contours of the terrace also contrasts with the soft, broad strokes employed on the surface of the cliff, particularly to the left. Clouds obscure much of the lower portion of the cliff on either side of the terrace, giving a sense of distance between them. The tree foliage under the terrace, rendered in dark ink and in greater detail, not only gives a strong accent to the painting, but also adds distance between the foreground and the background. The overall impression of this small true-view landscape painted on a double-album leaf is one of freshness and purity. This is also true of Yi In-sang's other paintings. Although undated, due to the relaxed brushwork, this painting likely belongs to the late years of Yi's life and concisely reveals the literati philosophy of pursuing the cultured life of art and leisure.

Unlike the literati painters above, most other younger contemporaries of Jeong Seon inevitably fell under his stylistic influence. His long and prolific career around the capital and his association with the most learned, sophisticated, and powerful figures of the time attracted many younger artists to his style. Modern scholars speak of a group of "Followers of Gyeomjae" (*Gyeomjae ilpa*) or of a "School of Jeong Seon" (*Jeong Seon pa*), but these designations were not current in the eighteenth or nineteenth centuries. The master's followers can be divided into two groups primarily by age.

The first group includes those born before the 1740s, represented by Kim Yun-gyeom (1711-1775), Choe Buk (ca. 1720-ca. 1768), Gang Hui-eon (1738-before 1784) and Jeong Hwang (1735-?), the grandson of Jeong Seon. Most of these painters had a direct master-pupil relationship with Jeong Seon. One artist who is sometimes considered a disciple of Jeong Seon, but usually not included in his "school" is Sim Sa-jeong (1707-1769). Sim came from the *yangban* class, but could not hold office due to his grandfather's participation in an attempted coup against the crown prince (later, King Yeongjo). An artist who is

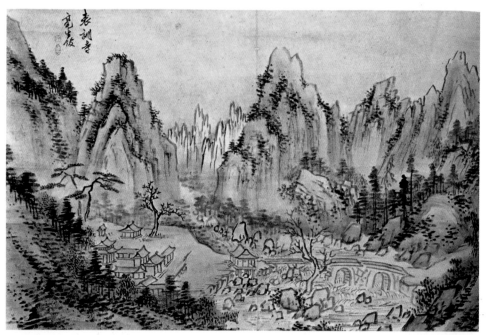

Fig. 71) Choe Buk, "Pyohun-sa Temple," 18th century. Album leaf, ink and light color on paper, 38.5×57.3 cm. Private collection, Korea

Fig. 72) Pyohun-sa Temple. Photograph taken from Colonial period (1910-1945) black-and-white photo album of Mount Geumgang (n.p. and n.d.)

sometimes included in this first group is the court painter Kim Yu-seong (b. 1725), who went to Japan in 1763. But Kim is usually discussed in the context of the Korean role in transmitting Southern School painting styles to Japan.

The second group is composed of artists born after the 1740s and thus active during the late eighteenth and early nineteenth centuries: Kim Eung-hwan (1742-1789), Kim Deuk-sin (1754-1822), and Kim Seok-sin (1754-?) among others. While the earlier group were men of different social status, the painters in the later group, who were too young to have had direct contact with Jeong, were members of the Royal Bureau of Painting and belonged to the *jungin* ("middle people") class.

As a term, the "School of Jeong Seon" could be misleading. His style of painting was not formally transmitted in a master-pupil setting, but was adopted and emulated by the generation of painters that followed. However, it has by now become firmly established as a term in Korean art history to refer to a wide range of artists whose paintings show traces of direct or indirect stylistic influence from Jeong Seon.

In the earlier group of Jeong Seon's "school" the legacy of the master is readily seen in the works of his only professional follower, Choe Buk, who left a number of paintings depicting Mount Geumgang. Although Choe was from the *jungin* class, his exceptional talent in poetry, painting, and calligraphy brought him into close contact with contemporary *yangban* literati. The "Pyohun-sa Temple" (fig. 71) is a leaf from an album. This temple can easily be spotted in Jeong Seon's previously mentioned undated *General View of Inner Mount Pungak* in the collection of the Kansong Art Museum. Together with Jangan-sa temple, it is one of the most frequently painted sites of Mount Geumgang. In his composition, Choe Buk has placed the temple compound, seen in an old photograph (fig. 72), on the far left so that it sits just beyond the earthen hills. He has reserved the center space for the stone bridge and the stream, behind which rises a screen of rocky peaks. The needle-like peaks, the identifying feature of Mount Geumgang, add distance and space. No one doubts that this painting falls within the stylistic sphere of Jeong Seon, but a more relaxed

Fig. 73) Sim Sa-jeong, "Bodeok-gul Dwelling," second half of 18th century. Album of four leaves, ink and light color on paper, 27.6×19.1 cm. Kansong Art Museum, Seoul

brushwork and the updated composition are indicative of Choe Buk's distinct handling and a later interpretation of the great master's style.

Despite his *yangban* heritage, Sim Sa-jeong was a de facto professional painter and practiced a wide range of styles. He is considered by many the most conservative painter of the eighteenth century for displaying in his work the strong influence of Chinese painting manuals. Nevertheless, he is one of the most prolific painters of the late Joseon period; there is almost no subject matter that he did not touch. He left a fair amount of true-view landscapes, many of them depictions of Mount Geumgang. Some of these depictions, such as "Samilpo Lake," presumably a leaf from an undated album of paintings of the Inner Diamond Mountain area in the collection of the Kansong Art Museum, display the strong influence of Jeong Seon in composition and brush method. However, in his depiction of a small temple used by monks built on stilts, "Bodeok-gul Dwelling" (fig. 73), another album leaf also in the Kansong Art Museum, he displays Southern School brush idioms such as Mi ink-dots and folded-ribbon texture strokes. Also, unlike Jeong Seon, Sim depicts small areas of the mountain up close as if seen through the macro lens of a camera. With his relaxed brushstrokes in the Southern School manner, Sim was able to reach yet another dimension in painting true-view landscapes.

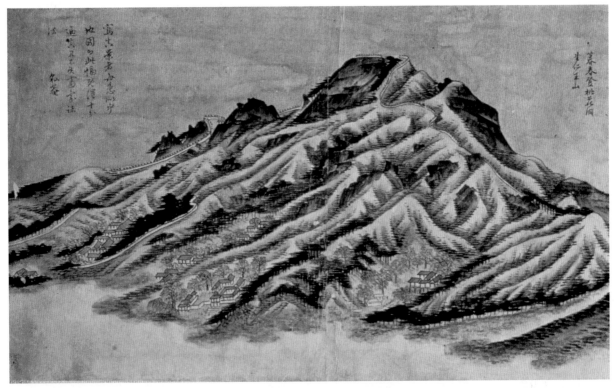

Fig. 74) Gang Hui-eon, "Mount Inwang Seen from Dohwa-dong," second half of 18th cendury. Album leaf, ink and light color on paper, 24.6×42.6 cm. Private collection, Korea

Another true-view artist who belongs to the first group of Jeong Seon followers is Gang Hui-eon who worked as a court meteorologist and painted the album leaf "Mount Inwang Seen from Dohwa-dong" (fig. 74). The leaf depicts the scenery on the opposite side of the same mountain as shown in Jeong Seon's *Clearing after Rain on Mount Inwang* (fig. 4). The sweeping strokes of dark ink resembling axe-cut texture strokes but applied more densely, the lavish use of Mi ink-dots, and the simplified rendering of the pine trees are all evidence of Jeong Seon's influence. Gang Se-hwang (1713-1791), a noted painter and critic, wrote this inscription on the painting:

Painters of true-view landscapes [*jingyeong*] are always worried that their painting might look like maps. However, this painting successfully captures resemblance [to real scenery] while not sacrificing the [old] masters' methods.

Fig. 75) Kim Eung-hwan, "Complete View of Mount Geumgang," dated 1772. Album leaf, ink and light color on paper, 22.3×35.2 cm. Private collection, Korea

In Gang's inscription, Gang Hui-eon's not "sacrificing the [old] masters' method" includes indebtedness to Jeong Seon. More surprising in this painting is Gang's use of light blue to define the empty space in the upper part of the painting as sky. Although Jeong Seon's *Complete View of Mount Geumgang* (fig. 63) shows some blue color around the rocky peaks, the master did not treat the space above the mountain peaks as true sky, as Gang has done. Gang's use of modulated blue here makes this perhaps the most "natural" depiction of the sky in eighteenth-century Korean painting. The title of the painting written on the upper right and Gang Se-hwang's inscription on the upper left both seem to be suspended in the blue sky. Gang Hui-

eon's naturalistic treatment of the sky suggests that he might have seen Western paintings brought back to Korea from China by officials of the Joseon court.

In the later group of Jeong Seon's followers, [Damjol-dang] Kim Eung-hwan can be singled out as the most devoted painter of true-view landscapes. However, Kim's style, unlike that of other followers of the master, reveals fewer personal characteristics. He was a painter in the Royal Bureau of Paintings at the same time as Kim Hong-do (1745-1806), the leading court painter during the reigns of Yeongjo and Jeongjo. Among Kim Eung-hwan paintings of Mount Geumgang, the one displaying the most affinity with Jeong Seon's style is the album leaf he painted for Kim Hong-do in 1772 (fig. 75), the "Complete View of Mount Geumgang." Kim Eung-hwan inscription on the upper right corner reads: "In the year *imjin* [1772], Damjol-dang painted [this] for Seoho [Kim Hong-do] in imitation of the *Complete View of Mount Geumgang*." Although it is not specified in the inscription whose "complete view" is being imitated, there are obvious similarities to Jeong Seon's work. As in the Complete View paintings by the master of Mount Geumgang, Kim's painting depicts both rocky and earthen peaks. Here the earthen peaks appear in the left corner of the composition, sheltering in ascending order the three famous temples of Jangan-sa, Pyohun-sa, and Jeongyang-sa. Also like Jeong Seon, Kim has made liberal use of Mi ink-dots combined with light blue washes to cover the earthen peaks and applied blue washes to the rocky peaks which are drawn in outline.

These similarities are rather superficial, as the landscape conveys nothing of the majestic effect of the mountain as evoked by Jeong Seon in his paintings. Instead, there is a great deal of mannerism and stylization, suggesting that Kim Eung-hwan copied this scene "in imitation" of Jeong Seon's painting, not from life. This imitative quality is particularly evident in the rigid repetition of the V-shaped valleys. But at the same time, this painting serves the important precedent of being a work produced by a Korean court painter "in imitation" of a Korean, not a Chinese master.

The Second Phase of True-View Landscape Painting:
Gang Se-hwang and Kim Hong-do and his Contemporaries

The title of this section might appear somewhat unorthodox to those knowledgeable about true-view landscape painting of the late Joseon period, as it combines the name of a scholar painter (Gang Se-hwang), by definition an amateur, with that of a professional painter (Kim Hong-do). In modern scholarly writings, it has been customary to treat separately the true-view landscapes of literati and professional painters. However, there are three good reasons for breaking with this practice. First of all, Gang Se-hwang, besides being the leading scholar-painter and art critic of the eighteenth century, exerted influence on the artistic development of the younger Kim Hong-do. Second, while both men painted many subjects, they reached new heights in the field of true-view landscape painting in the post-Jeong Seon era. Third, the artistic milieu of the eighteenth century was so fluid that it becomes artificial to draw a distinction between literati "amateur" painters and the professionals. This is especially important when it comes to true-view landscape.

Being a scholar-painter and a promoter of Southern School literati painting in Korea, Gang Se-hwang (1713-1791) was inclined, even when painting true-view landscapes, to adhere to "traditional methods of painting" as expressed in his inscription on Gang Hui-eon's painting of Mount Inwang. He seems, however, to have been equally interested in the depiction of scenery as the eye

Fig. 76) Gang Se-hwang, *Self-portrait*, second half of 18th century. Hanging scroll, ink and light color on paper, diam. 14.9 cm. Collection of Gang Ju-jin, Korea

saw it. Like many contemporary painters, he also took a trip to Mount Geumgang. This was in 1788, and he recorded it in a travel diary and in an album of paintings. During this trip he met by chance Kim Hong-do and Kim Eung-hwan. The two younger artists were sketching the scenery of the famous mountain by the order of King Jeongjo. In a preface he wrote bidding farewell to Kim Hong-do and Kim Eung-hwan, he praised the two for their skillful and beautiful rendering of Mount Geumgang:

> Some say that if mountains and waters had spirits, they would abhor being portrayed in such minute detail. But I don't think so. When people want to have their portraits painted, they invite the best painter and treat him with propriety. They will be satisfied if their portraits finally resemble them closely without missing a hair. Therefore, I think the mountain spirits would not abhor this utmost likeness of their images.

Since Gang was himself a portrait painter who left several self-portraits (fig. 76), his analogy between portraits and true-view landscapes is natural and understandable. On one occasion, comparing the paintings of Mount Geumgang by Jeong Seon and Sim Sa-jeong, he complained that Jeong Seon's paintings did not achieve the true likeness of the mountain because he painted them in a disorderly manner using hemp-fiber texture strokes.

Gang's twofold interest in realistic depiction of the landscape and adherence to traditional methods of painting can best be seen in his *Album of a Journey to Songdo*. Although the album itself does not bear a date, there is convincing evidence that the paintings were done in 1757, at the age of forty-five, when he made a trip to Songdo (present-day Gaeseong). The album is a truly novel work in that the artist expressed his firsthand impression of the unusual scenery he saw on the journey with such fresh feeling. The seventh leaf, "Approach to Yeongtong-dong" (Yeongtong-donggu) (fig. 77), perhaps epitomizes the spirit of this album. Gang's own inscription aptly describes the wondrous scene:

Fig. 77) Gang Se-hwang, "Approach to Yeongtong-dong," one leaf from *Album of Journey to Songdo*, ca. 1757. Album of 16 leaves, ink and light color on paper, 32.8×53.4 cm. National Museum of Korea, Seoul

The stones at the approach to Yeongtong-dong are as big as houses. They are even more surprising because they are covered with green moss. It is said that a dragon rose out of the pool here, but that is rather incredible. Nonetheless, this is a rare sight to behold.

Enormous boulders occupy most of the foreground, their imposing size punctuated by the tiny figure of a traveler astride a donkey followed by the even smaller figure of a servant as the pair heads toward the narrow gorge on the right. The rocks are outlined with sharp ink and colored in light blue and green mixed with ink and earth colors. The effect is fresh and transparent, very similar to a Western watercolor. Beyond these rocks and to the right of the gorge, earthen peaks seem to arise softly, the effect of Gang's use of Mi inkdots, which give the impression of shading. The rocks diminish in size

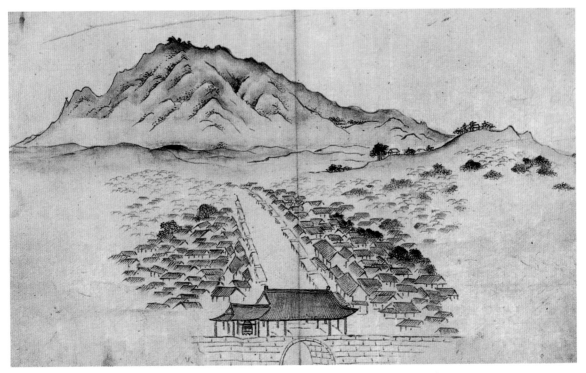

Fig. 78) Gang Se-hwang, "View of Songdo," one leaf from *Album of Journey to Songdo*, ca. 1757. Album of 16 leaves, ink and light color on paper, 32.8×53.4 cm. National Museum of Korea, Seoul

as they become more distant, and the gorge narrows as it winds into the mountains. This careful attention to scale gives the viewer an unambiguous sense of depth and distance.

Adherence to proper scale is also evident in the first leaf, "View of Songdo" (fig. 78), where the wide avenue leading away from the city gate narrows as it recedes into the distance, and the houses on either side gradually diminish in size accordingly. Spatial recession is also achieved by the use of lighter tones to depict the mountains in the back distance. Many other leaves in the album reveal a similar interest in rendering the actual appearance of topography. Following traditional conventions of landscape painting, Gang left the sky unpainted. Yet there is no doubt that without the influence of Western painting, in particular the use of spatial recession and the recognition of relative scale in compositional elements, the *Journey to Songdo* might not have been possible.

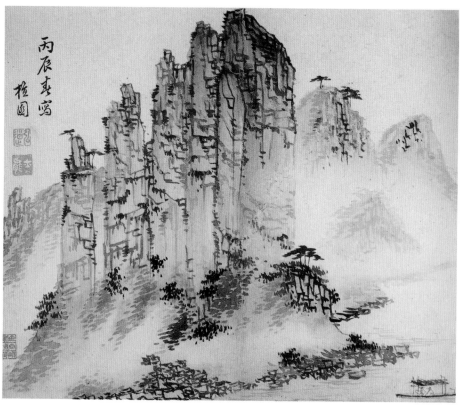

Fig. 79) Kim Hong-do, "Oksun-bong Peaks," one leaf from *Album of the Byeongjin Year [1796].*
Album of 20 leaves, ink and light color on paper, 26.7×31.6 cm. Ho-Am Art Museum, Seoul

Gang Se-hwang's relationship with Kim Hong-do (1745-1806) began when the latter was a young boy. Gang later reminisced about this lifelong acquaintance:

> At first when Saneung [Kim Hong-do] was young, I used to praise his talent and taught him the secrets of painting. Later, we served in the same office together, seeing each other morning and evening. In the end, seeking distraction in the world of the arts together, I felt as if we were friends.

Kim Hong-do entered the Royal Bureau of Painting sometime before 1765 as deduced by the earliest citation of his activity as a court painter in records of that year. His career as a court painter is well documented in various sources.

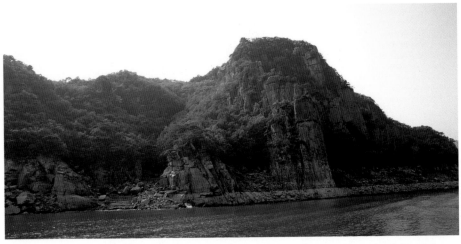

Fig. 80) Oksun-bong Peaks, Danyang, Chungcheongbuk-do province. Photograph by Yi Song-mi, 2001

According to Gang Se-hwang, Kim made more than 100 sketches of various aspects of Mount Geumgang during his 1788 trip there. Some scholars have linked this trip with a set of five albums, each containing 12 leaves now known as *Album of the Four Districts of Geumgang* (*Geumgang saguncheop*). Each of the 60 leaves in this set bears Kim's seals. It is generally agreed that the two intaglio seals reading "Danwon" (the artist's sobriquet) and "Hong-do" on the upper part of each leaf as well as the calligraphy of the inscribed titles that identifies the sites on each leaf are spurious. We will return to this issue at length in chapter VI.

The best examples of Kim Hong-do's true-view style are found on the album leaves depicting the Danyang area in Chungcheongbuk-do province, from the *Album of the Byeongjin Year [1796]*, painted when he was fifty-one years old. A leaf from this album, "Oksun-bong Peaks" (Bamboo Shoot Pinnacles) (fig. 79), which bears the cyclical date as well as the artist's signature and seals, features a group of rocky columns emerging from an earthen mound. The angular facets of the columns as seen in a recent photograph (fig. 80), are modeled in Kim's painting with a variety of lotus-vein texture strokes and straight choppy lines applied with great ease of brush movement. The tallest pinnacle or "peak" on the right displays the darkest brushstrokes, perhaps to

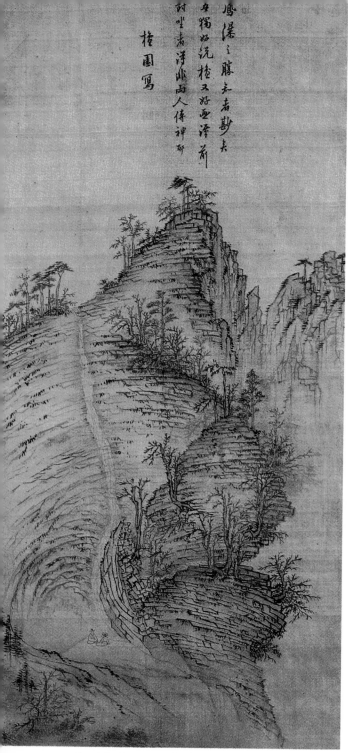

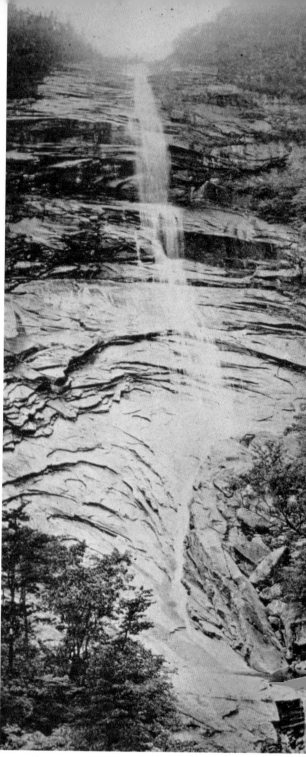

Fig. 81) Kim Hong-do, "Flying Phoenix Waterfall," one scroll from *Paintings of Sea and Mountains*, late 18th century. Set of eight hanging scrolls, ink on silk, 91.4× 41 cm. Kansong Art Museum, Seoul

Fig. 82) Flying Phoenix Waterfall. Photograph taken from Colonial period (1910-1945) black-and-white photo album of Mount Geumgang (n.p. and n.d.)

emphasize it as the apex of the curious rock formation. The gradually receding shoreline of the river and the mountain peaks in the far distance create a hazy, but cozy sense of space. A small boat, at the lower right, accentuates the imposing scale of the overhead landscape.

An undated set of eight hanging scrolls of scenes of Mount Geumgang provides further evidence of Kim's adherence to tradition while keeping a close observation of nature. In the second scroll of the set, "Flying Phoenix Waterfall" (*Bibong-pok*) (fig. 81), Kim used lotus-vein and horse-tooth texture strokes to convey the unusual surface of a cliff more than 100 meters high, from the top of which "flies" the narrow streaks of a waterfall. A comparison of this painting with an old photograph of the waterfall (fig. 82) shows how Kim transformed nature while remaining faithful to the natural features of the site. Painted on silk, this painting reveals more deliberate, less relaxed brushwork than that of Kim's 1796 *Byeongjin Year* album, pointing to an earlier date of production.

Two of Kim Hong-do's contemporaries, Yi In-mun (1745-1821), who served with Kim at court as a professional painter, and Jeong Su-yeong (1743-1831), a literati painter, deserve mention for their contribution to the later phase of true-view landscape painting. In his *Mount Geumgang Viewed from Danbal-ryeong Ridge* (fig. 83), Yi In-mun gives us a dramatic view of the mountain emerging in the distance from a dense fog. A recent photograph of the rocky peaks of Mount Geumgang (fig. 84) shrouded in clouds approximates the upper view of Yi's painting. Again we quote from the scholar Yi Man-bu, who wrote a century earlier in his travel diary, the *Jihaeng-rok*, a description of precisely this setting:

After following the trail for thirty *ri* (approx. 12 km) miles, I reached the summit of a hill called Danbal-ryeong, a ridge of Mount Cheonma. . .[Mount] Geumgang rose to the east. Everywhere I turned, its peaks soared, looking like jewels, silver, snowflakes, and ice, stacked one atop another, until they reached heaven and there was no more sky to behold in the east and beyond. . . The monk Hyemil said, "People who come here to view Mount Geumgang regret [seeing] the dense clouds that always obscure the mountaintop, but today the sky is absolutely clear,

Fig. 83) Yi In-mun, "Mount Geumgang Viewed from Danbal-ryeong Ridge," late 18th century. Album leaf, ink and light color on paper, 23×45 cm. Private collection, Korea

Fig. 84) Mount Geumgang, Gangwon-do province. Photograph courtesy of JoongAng Daily

allowing a clear view of the summit. How lucky you are to have such a rare opportunity.

In other paintings, Yi In-mun reveals a remarkable range of styles demonstrating his knowledge of various schools of Chinese painting. However, in this painting, the scenery is depicted in his uniquely personal style, characterized by a composition consisting of discrete yet interrelated elements and a heavy reliance on ink wash to impart volume and rhythm to the icicle-like distant peaks. The painting is completely comprehensible and without reference to either Jeong Seon or Kim Hong-do.

The literati painter Jeong Su-yeong, the great-grandson of Jeong Sang-gi, the maker of the great map of Korea mentioned earlier, traveled widely throughout the peninsula. Several of the paintings and travel diaries recording his trip to the Mount Geumgang area survive. The *Album of Sea and Mountains* (*Haesan-do cheop*), painted in 1799, two years after his trip, displays his unique painting style. Four leaves of this album when put together form a vast landscape entitled "Mount Geumgang Seen from the Cheonil-dae Terrace" (fig. 85). Many of the topographical features of the landscape are identified by name. The sense of space is enhanced by the pronounced recession of the mountains in the left half of the scene. Jeong Su-yeong's characteristic brushwork, hesitant and blunt, reveals his cautious, almost scientific attempt to depict the peaks as they actually appear in nature. At the same time, his arbitrary use of blue and red seems amateurish, a trait of authentic scholar painting.

In another leaf of the same album, "Snow Spewing [Cataract] Pond" (Bunseol-dam) (fig. 86), which is painted as a single leaf, Jeong rendered the angular rock forms with sharp, straight lines and the gushing water of the cataract with fast, elliptical lines. Another set of lines drawn with equal speed intersects the cataract enhancing the effect of water spewing into space. In the rock-strewn pond below, the bubbling water is rendered in blunt strokes distinctive to Jeong. Although Jeong is said to have drawn his style from many earlier

Fig. 85) Jeong Su-yeong, "Mount Geumgang Seen from Cheonil-dae Terrace," four leaves from *Album of Sea and Mountains*, dated 1799. Album of 46 leaves, ink and light color on paper, 37.2 × 123.8 cm. National Museum of Korea, Seoul

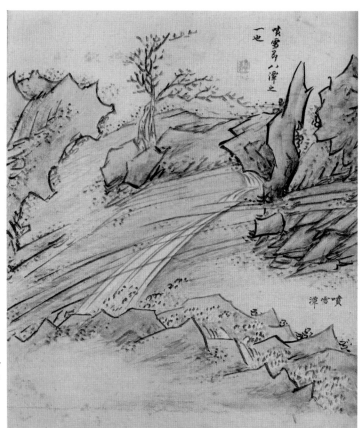

Fig. 86) Jeong Su-yeong, "Snow-Spewing [Cataract] Pond," one leaf from *Album of Sea and Mountains*, dated 1799. Album of 46 leaves, ink and light color on paper, 37.2 × 31 cm. National Museum of Korea, Seoul

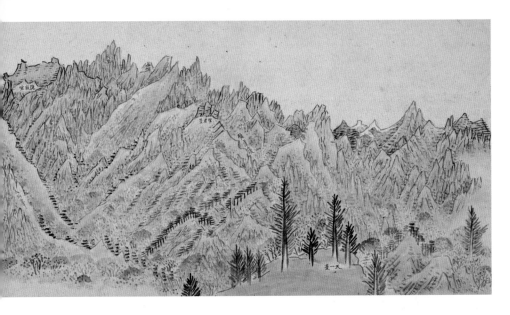

sources, both Korean and Chinese, his true-view landscape paintings are unique in not revealing any contemporary or historical influence.

The eighteenth century was an era of peace and prosperity in Korea ruled by the enlightened kings Yeongjo and Jeongjo. It was a golden age in which great intellectual and cultural advancements were made in Neo-Confucianism, history, geography, language, and literature. It was also a time when Western learning and new books and ideas from China entered Korea, to be avidly studied and utilized. All these developments contributed to a new self-awareness and national pride among the Korean people. Korean artists were particularly aware of the country's great history and beautiful land. Along with countless scholars and poets, they delighted in traversing the country's scenic and historic spots. Their travels gave birth to a uniquely Korean tradition of true-view landscape painting. Perhaps the most creative achievement in the history of Korean art, these true-view paintings depicted the spirit and natural beauty of the peninsula. Jeong Seon's leading role was crucial at the beginning, but at each successive stage of development, his contemporaries and followers also made significant contributions. Each of them not only captured the basic ethos of the time but also left their own personalities and ideas in these memorable landscape paintings. Korean landscape art never achieved again the high general level or universal scale of the eighteenth century.

VI. Waning of the Korean Tradition:
The Late Nineteenth to the Early Twentieth Century

Historical Overview

After the death of King Jeongjo in 1800, the Joseon throne was occupied by a series of lesser kings, most of them young boys at the time of their accession. King Sunjo (r. 1800-1835) was eleven years old, and King Heonjong (r. 1834-1849), grandson of King Sunjo, only eight years old when they were enthroned. It was during this time that rule by "in-law government" (*sedo jeongchi*) became prevalent in Korea. The two most powerful in-law families of the late Joseon were the Kims of Andong and the Jos of Pungyang.

The Kim family of Andong was headed by Kim Jo-sun, whose political power stemmed from his daughter, Queen Sunwon, wife of King Sunjo. Queen Sunwon took charge of state affairs at court sessions after her husband's death by sitting behind a bamboo curtain (*suryeom cheongjeong*). The Jo family of Pungyang, headed by Jo Man-yeong, gained access to power through Jo's daughter, Queen Sinjeong (Dowager Queen Jo), mother of King Heonjong.

The Dowager Jo was perhaps the most powerful woman in nineteenth-century Joseon, and her family's grip on power was challenged only by the Andong Kims. When her son Heonjong died without producing an heir apparent, a royal prince was brought in from a side line by Queen Sunwon (Kim). This prince ascended the throne at the age of nineteen as King Cheoljong (r. 1849-1863) without prior training for kingship. King Gojong (r. 1863-1907), who succeeded Cheoljong, was also brought in from a side line, and ascended the throne at the age of twelve. The power behind Gojong's ascension was the Dowager Jo who was determined to put an end to the power of the Andong Kim family by forming an alliance with Gojong's father, Yi Ha-

eung (1820-1898). Known in Korean history as the Heungseon Daewongun, Yi practically ruled the country as regent to his son until 1873.

Under such power politics the country suffered a great deal both internally and externally, and political order rapidly deteriorated. Rebellions and uprisings such as that of 1812 in Pyeongan-do province and that of Jinju in 1862, became rampant. Roman Catholicism, which had been introduced to Korea in the late eighteenth century, and had devotees among the scholars of the School of Practical Learning, such as Jeong Yak-yong and his brother, Yak-jeon, became the target of persecution by the Daewongun. The regent conducted a series of bloody purges from 1864 to 1866, causing the deaths of over 7,500 converts. Nine French Catholic priests were also persecuted during that time. In retaliation, the French government sent a naval ship to Ganghwado island at the mouth of the Han-gang river near Seoul.

Although the French were defeated, the Outer Gyujang-gak Royal Library (Oegyujang-gak) on the island was sacked and burned. This incident is known in Korean history as *Byeongin yangyo* (Disturbance by Westerners in the cyclical year *byeongin*, 1866). Among the items taken to France at that time were several hundred volumes of valuable court documents called *uigwe* (book of court rites). These texts contained detailed records and illustrations of important court rituals and events such as royal weddings, banquets for special occasions, royal funerals, the painting and copying of royal portraits, and so forth. Since 1993, the governments of Korea and France have been engaged in negotiating the return of these documents to Korea.

It was also in 1866 that crew members of the American schooner, the *General Sherman*, were killed by Koreans in Pyeongyang. The United States navy returned in 1871 to retaliate by invading Ganghwado island, causing much more damage than did the French. This invasion is called the *Sinmi yangyo* (Disturbance by Westerners in the cyclical year *sinmi*, 1871). Such threats from Western powers led the Daewongun to declare a policy of isolation in 1871. However, this move was clearly against the rising tide of internationalism in East Asia. Qing

China was being pried open in the wake of conflicts with Western powers, and Meiji Japan had instituted an open-door policy. Needless to say, there were progressive young scholar-officials who opposed Korea's isolation policy. Gradually, Japan and the Western powers forced Korea to sign diplomatic and commercial treaties; with Japan in 1876, and with the United States in 1882.

The national and international affairs that affected the ailing kingdom of Joseon at the turn of the century are too complicated to be discussed here. Some of the major incidents include the Military Mutiny of 1882 (*Imo gullan*); the Donghak Rebellion/Movement of 1893-1894; the Sino-Japanese War of 1894, which was mostly fought in Korea; the Reform of the cyclical year *gabo* or 1894 (*Gabo gyeongjang*); the assassination of Queen Min, who was the pro-Chinese and pro-Russian wife of King Gojong; King Gojong's flight to the Russian Legation in 1896; and the birth of the Independence Club (*Dongnip hyeophoe*) in 1896. The Club was headed by Dr. Seo Jae-pil, who urged Gojong to declare himself emperor after his return from the Russian Legation. Gojong did this in 1897, declaring himself Emperor of Korea and changing the name of the dynasty from Joseon to Daehan jeguk (The Great Empire of Han). The name of South Korea today, Daehan minguk (The Republic of the Great Han [People]) is derived from that.

Meanwhile, the conflict between Japan and Russia culminated in the Russo-Japanese War of 1905 which ended with Japan's victory. After the war, Japan forced Korea to sign the Protectorate Treaty of 1905 (*Eulsa boho joyak*), and gradually extended its dominance over all of Korea. This naturally triggered patriotic Koreans to fight against Japanese imperialism and call for independence. They formed righteous armies (*uibyeong*) to fight against the Japanese. Emperor Gojong was forced to abdicate in 1907, and his son Sunjong succeeded him as emperor for the final three years of the empire until Japan annexed Korea in 1910, putting an end to 512 years of Joseon rule.

Korea remained a colony of Japan for thirty-five years (1910-1945) until the end of World War II. Even before liberation, Koreans continued to resist colonization, with the March First Independence

Movement of 1919 as the most noble and memorable expression of Korean patriotism in the face of Japanese oppression. It was during the Colonial Period that the Japanese destroyed many royal palace buildings and other important historical monuments to erase Korea's cultural past, and to make way for new structures deemed necessary to legitimize the colonial government. Additionally, innumerable treasures such as paintings and Buddhist ritual items were taken to Japan by Japanese officials and collectors.

At the end of World War II in 1945, against the will of the Korean people, the nation was divided into two along the 38th parallel by the armed forces of the United States and the Soviet Union that had helped liberate Korea from Japan. In the South, the democratic Republic of Korea and in the North, the communist People's Republic of Korea, were established in 1948. In 1950, North Korean troops invaded the South across the 38th parallel, launching the most devastating war in Korean history, the Korean War (1950-1953), which involved the forces of China and the United Nations under United States command. During this three-year period, over five-million Koreans (2.3 million from the South, and about 2.92 million from the North) lost their lives. In 1953, despite South Korean opposition, the Chinese, the North Koreans, and representatives from the United Nations Command signed an armistice, which still remains in effect today.

Southern School Literati Landscape Painting

Although we discussed the development of literati painting styles and its early beginnings in Korea at length in chapter IV, we did not examine the full range of the genre in chapter V to give prominence to the position of true-view landscapes and to highlight the fluid milieu in eighteenth-century art where both amateur literati and professional painters worked in the same styles. By that time, the term "Southern School painting" (*namjong-hwa* Ch. *nanzhong-hua*) was not exclusively used the same way it, and its related term, "literati painting" (*sadaebu-*

Fig. 87) Gang Se-hwang, "In Imitation of Shen Shitian's Clear Summer Day under a Paulownia Tree," second half of 18th century. Album leaf, ink and light color on paper, 30×35.8 cm. Private collection, Korea

Fig. 88) *Shen Shitian's Clear Summer Day under a Paulownia Tree.* Woodblock print, from the *Mustard Seed Garden Manual of Painting* (First complete edition pub. 1701)

hwa or *munin-hwa,* Ch. *Shidaifu hua* or *wenren[zhi] hua),* were first used when both were coined in China.

Chinese painting manuals introduced to Korea from the early seventeenth century continued to exert strong influence in the eighteenth and nineteenth centuries. The *Mustard Seed Garden Painting Manual* contains instructions on how to draw the miniature figures that populate landscape painting, and gives advice on formal elements and their combinations, on the delineation of trees and boulders, and on the models of traditional compositions. The cumulative effect of this educational tool is visible in the works of innumerable Joseon-period artists. Painters who drew upon the manual for motifs and compositions,

however, did so without acknowledging their source. There were exceptions, such as when a composition is copied in its entirety or when the artist identifies his source by inscription. An example is Gang Se-hwang's inscription on his "Clear Summer Day under a Paulownia Tree" (*Byeogo cheongseo-do*) (fig. 87), reading "In Imitation of Shen Shitian's Clear Summer Day under a Paulownia Tree." Gang was referring to a composition by the Ming-dynasty literati master Shen Zhou, which appears in volume five of the manual (fig. 88). The differences between Gang's painting and the model from the manual stem from differences in format — vertical versus horizontal — which necessitated a slight modification in composition by Gang. However, Gang's painting preserves a great deal of the Chinese master's original composition and the affinity between the two is immediately recognizable.

Grounded in eighteenth-century practices, Korean Southern School literati painting of the nineteenth century reached its apex with Kim Jeong-hui (1786-1856). Kim was a high official and a leading scholar of epigraphy (*geumseok-hak*) and textual criticism (*gojeung-hak*) in addition to being one of the most original calligraphers of the Joseon period. He and his followers developed Korean literati painting into a lively artistic movement. Although Korean literati assume the lead in this autonomous movement, professional court painters kept up with the new trends. Moreover, artists of the growing *jungin* class also occupied prominent positions in the movement.

Important artists working in the literati style active between the late eighteenth century and the first half of the nineteenth century include Jeong Su-yeong, whose paintings of Mount Geumgang were discussed earlier, Yi Jae-gwan (1783-1837), and Kim Su-cheol (act. mid-19th century). However, the leading role was played by Kim Jeong-hui, assisted by artists of his circle, including Jo Hui-ryong (1789-1866), Jeon Gi (1825-1854) and Heo Ryeon (1809-1892). The latter group of artists did not restrict themselves to painting landscapes, but also explored the theme of the Four Gentlemen (bamboo, plum, orchid, and chrysanthemum); to which their calligraphic training was applicable, especially in bamboo and orchid.

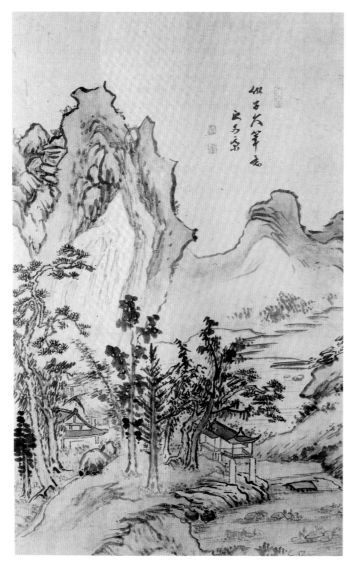

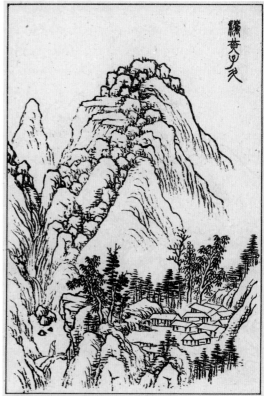

Fig. 89) Jeong Su-yeong, *Landscape in the Style of Huang Gongwang*, early 19th century. Hanging scroll, ink and light color on paper, 101×61.3 cm. Korea University Art Museum, Seoul

Fig. 90) *Landscape in the Manner of Huang Gongwang.* Woodblock print, from the *Mustard Seed Garden Manual of Painting* (First complete edition pub. 1701)

The painting of this period did not reflect, as in earlier times, the styles of many Chinese artists. It focused almost exclusively on Huang Gongwang and Ni Zan of the Yuan dynasty, and on the Mi Fu and his son Mi Youren of the Song dynasty. The sketch-like qualities of the works of these Chinese masters served to emphasize the Korean literati's interest in calligraphy and the style was referred to as "Ye-Hwang" (the Korean pronunciation of Ni-Huang). The inclination to

choose Ni Zan and Huang Gongwang as models is also a phenomenon observed in Chinese literati painting of the late Qing period. The renewed Chinese emphasis on calligraphic qualities in painting is attributable to the rising interest of the Qing in epigraphy (the study of stone and bronze inscriptions). Such similarities in cultural development reflect the closeness of Korean and Chinese artistic circles at the time.

However, as Korean artists developed their individuality, even when claiming to be working in the brush style or ideas of a particular Chinese master, we find only vague similarities in composition or in rendering certain motifs like trees, between the Chinese models found in painting manuals and the Korean imitation. The imitations are usually more expressive, displaying uniquely individual brushwork, composition, and color scheme. Jeong Su-yeong's *Landscape in the Style of Huang Gongwang* (fig. 89) is ostensively a tribute to Huang Gongwang as indicated by his inscription which says "in imitation of Zijiu [Huang Gongwang]'s brush ideas." Yet when compared to the *Landscape in the Manner of Huang Gongwang* in the *Mustard Seed Garden Manual of Painting* (fig. 90), there are few points of similarity except for the high mountain on the left. It should be noted here that the Sino-Korean character translated here as "in imitation of" (*bang*, Ch. *fang*) has more of an implication of "following," or "in the spirit of" rather than an exact copy. Therefore, it is no surprise to not find an exact parallel between the painting and the model it is "imitating." The overwhelming impression of Jeong Su-yeong's painting is his unique, seemingly hesitant brush and his naive and artless quality which make this work a good example of literati painting.

Jeon Gi followed the model compositions in the *Mustard Seed Garden Manual of Painting* more faithfully in many of his paintings. His *Streams and Mountains with Abundant Reeds* (fig. 91) dated to 1849 is an adoption of a Ni Zan composition taken from the manual (fig. 92). However, Jeon has improvised on Ni's basic composition, using a rough brush whose tip has been worn down to a rounded stump. With it he produced a painting that amply displays his expansive personality. This is quite different from Ni Zan's scrupulous, almost timid brush style.

Fig. 91) Jeon Gi, "Streams and Mountains with Abundant Reeds," dated 1849. Album leaf, ink on paper, 24.5×41.5 cm. National Museum of Korea, Seoul

Other painters of the nineteenth century such as Heo Ryeon, also adhered faithfully to both Ni Zan's compositions and brushwork. Bolder departures from the Ni model resulted in far more unorthodox landscapes painted by Kim Su-cheol (act. mid-19th century), Kim Chang-su (act. 19th century), and Hong Se-seop (1832-1884).

Kim Jeong-hui, whose sobriquets were Chusa and Wandang, expounded on the cardinal points of his theory of art, especially of literati art, in his *Winterscape* (*Sehan-do*) (fig. 93). This painting can be considered a quintessential literati painting. The highly symbolic, yet simple pictorial elements and the inscription deftly convey the artist's purpose, while uniting calligraphy and painting, which is the basis of literati painting. The title of the painting is from a passage in the *Analects of Confucius* that says: "When the year grows cold, we see that the pine and cypress are the last to fade." Kim's disciple, [Useon] Yi Sang-jeok (1804-1860), acquired precious books for him during an official trip to Beijing in 1843 and again in 1844. At the time, the master himself was living in exile on Jejudo

Fig. 92) *Landscape in the Manner of Ni Zan.* Woodblock print, from the *Mustard Seed Garden Manual of Painting* (First complete edition pub. 1701)

island off the southwest coast of Korea. This painting, with its allusions to pine and cypress trees, old symbols of constancy in the face of hardship and danger, is Kim's offer of thanks and praise for Yi Sang-jeok's steadfast respect, friendship, and support. The simple trees and dwelling (fig. 94) are economically drawn with highly-charged, dry brushwork. The calligraphic inscription is written in his signature quirky style.

The circumstance that enabled Kim to construct this refined expression of literati ideals was the world of high scholarship to which he was born. At the age of twenty-four, he accompanied his father, Kim No-gyeong (1766-1838), to Yanjing, China. There he met prominent Qing scholars of epigraphy such as Weng Fanggang (1733-1818) and Ruan Yuan (1764-1849) and had opportunities to study contemporary Chinese scholarship and painting. Having absorbed all the historically significant calligraphy styles — seal, clerical, cursive, and running scripts — he created a new calligraphy style that came to be called "Chusa-style script" (*Chusa che*).

Fig. 93) Kim Jeong-hui, *Winterscape* (Sehan-do), dated 1844. Handscroll, ink on paper, 27.2 × 70.2 cm. Private collection, Korea

Fig. 94) Detail of *Winterscape*

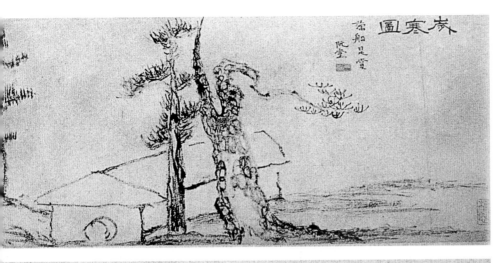

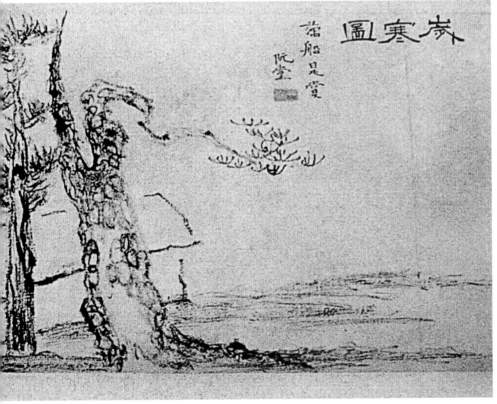

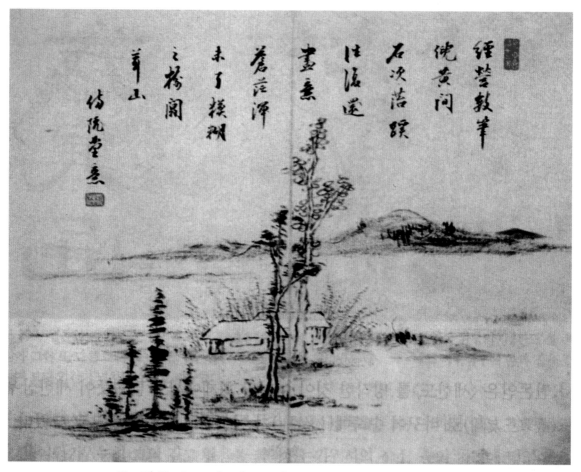

Fig. 95) Heo Ryeon, "Landscape after Wandang," second half of 19th century. Album leaf, ink on paper, 37×31 cm. Private collection, Korea

Kim's achievement in bringing Southern School painting in Korea to such an erudite level was in great part to due his high caliber, talent, and life experiences. But we must also bear in mind that many previous stages of development in the literati art of both Korea and China by the mid-nineteenth century had given him a most pristine and supportive basis from which to achieve.

The exalted position enjoyed by Kim Jeong-hui's led Heo Ryeon to paint the "Landscape after Wandang" (fig. 95), an album leaf in the master's style, thereby establishing a new horizon in Joseon-period literati painting. The compositional elements in Heo's painting are trees

and cottages, not unlike those in Kim's *Winterscape*, and the brushwork also comes close to the master's. But it is obvious that no one can really imitate Kim's brush style. Earlier, we have seen Kim Eung-hwan in his "Complete View of Mount Geumgang" which he painted for Kim Hong-do in 1772 (fig. 75), inscribed his work as being "in imitation of a *Complete View of Mount Geumgang.*" But Kim did not specify which Korean master's work was being imitated. Now in the nineteenth century, Heo Ryeon took it one step further to specifically state that he is imitating Kim Jeong-hui, a Korean master. Heo's action is significant in that it departs from the prior custom of Korean artists to imitate only the works of the great Chinese masters. It shows that in the late Joseon period, Korean painters had the confidence to recognize the achievements of their own countrymen who painted in literati styles as an integral part of the orthodox Southern School tradition. After decades of transformation, the literati tradition in Korea that had been imported from China became ripe enough and important enough to make this epochal shift.

The importance of the literati style was such that court painters at the end of the nineteenth century also felt compelled to learn it. For the professionals, however, the Southern School style was just another artistic option in an open field of many styles. They employed its conventions to suit the demands of the work at hand. In many paintings produced by such court artists as Yu Suk (1827-1873), Yi Han-cheol (1808-1880), Jang Seung-eop (1843-1897), and An Jung-sik (1861-1919), the literati style was just a style, no more no less. This led to the practice, which became quite popular, of imitating the appearance of literati painting without a thorough understanding of its original purpose, history, or ideology. A handscroll painted by Jang Seung-eop in 1884 entitled *Village Dwelling in Luxuriant Forest* (fig. 96) now in the collection of the Sunmun University Art Museum in Asan, Chungcheongnam-do province, carries an inscription on the upper left (not shown). In his inscription, the artist says that the painting was done in the brush idea of Fanghu, or Fang Congyi (ca. 1301-after 1380), a Yuan painter who worked in the Mi Fu tradition. Jang's painting, however, has almost

Fig. 96) Jang Seung-eop, *Village Dwelling in the Luxuriant Forest*, dated 1884. Handscroll, ink on paper, 26.8×160.5 cm. Sunmun University Art Museum, Asan, Chungcheongnam-do province

Fig. 97) An Jung-sik, "Autumn Thoughts among Streams and Mountains," dated 1917. Album leaf, ink on paper, 25.8×28.3 cm. Seoul National University Museum

nothing to do with any known painting by the Chinese master. Instead, Jang employed brushstrokes vaguely reminiscent of hemp-fiber texture strokes. Another case of a mistaken notion of Southern School ideals is an album leaf painted by An Jung-sik, the "Autumn Thoughts among Streams and Mountains" (Fig. 97) in the collection of Seoul National University Museum. In his inscription, An declares that he painted it in the "general [brush] idea of the Yuan master Huang Gongwang." However, the painting more closely resembles a typical Ni Zan composition than the work of Huang Gongwang.

The Last Phase of True-View Landscape Painting

As discussed in the previous chapter, true-view landscape as a genre of painting was well-established by the end of the eighteenth century. With Jeong Seon as the leader in the first half of the century and Gang Se-hwang and Kim Hong-do separately creating another

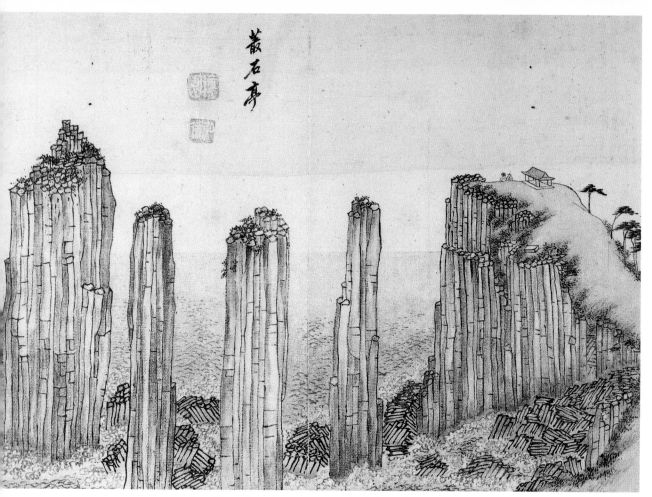

Fig. 98) Attributed to Kim Hong-do, "Chongseok-jeong Pavilion," one leaf from *Album of the Four Districts of Geumgang*, date undetermined. Set of five albums with 60 leaves, ink and light color on silk, 30.4×43.7 cm. Private collection, Korea

phase of the tradition later part of the century, the road was paved for further diversification of the genre as well as for mass production. By far the most popular subject of true-view landscape painting in its last phase in the nineteenth century was Mount Geumgang.

In recent years, several extant sets of album leaves depicting comprehensive scenes of famous spots on Mount Geumgang with slightly different titles, but the same basic content, have come into public light. They all must have been based on a single prototype. Perhaps the most well-known is the set assigned to Kim Hong-do that we mentioned in our discussion of his true-view landscapes in Chapter V. This set of five albums of 12 leaves each (60 leave total) has been on public display

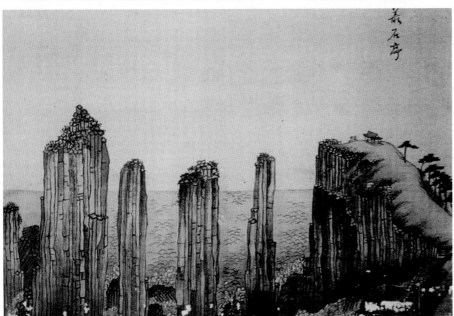

Fig. 99) Kim Hong-do, "Chongseok-jeong Pavilion," one leaf from *Album of the Eulmyo Year, [1795]*. Album of three leaves, ink and light color on paper, 23.2×27.7 cm. Private collection, Korea

Fig. 100) Attributed to Kim Hong-do, "Chongseok-jeong Pavilion," one leaf from *Album of Sea and Mountains*, date undetermined. Set of albums with 40 leaves, ink and light color on paper, dimensions unknown. Private collection, Korea

in the past decade at the National Museum of Korea in Seoul. Although Kim's seals on each of the 60 leaves are spurious and the colophons accompanying the paintings give inconsistent information, they are considered to be genuine works painted by Kim in 1788. The albums in the set are inscribed with the title *Complete Scenes of Mount Geumgang* (*Geumgang jeondo*), but they were introduced to the public in recent years under the title of *Album of the Four Districts of Geumgang* (*Geumgang saguncheop*). We want to avoid confusion with Jeon Seon's "complete views" of the mountain, so we will use the newly-minted title instead of the inscribed title in our discussion of the album.

We have reservations about accepting the album leaves in the entire set of *Album of the Four Distircts of Geumgang* as authentic works by Kim Hong-do. A comparison of a leaf depicting the "Chongseok-jeong Pavilion" (fig. 98) with a leaf of the same scene from Kim's more

Fig. 101) Attributed to Kim Hong-do, "Pearl [Cataract] Pond," one leaf from *Album of the Four Districts of Geumgang*, date undetermined. Set of five albums with 60 leaves, ink and light color on silk, 30.4 × 43.7 cm. Private collection, Korea

securely dated and signed *Album of the Eulmyo Year [1795]* (fig. 99) shows that the two works could not have been painted by the same hand. The two leaves differ vastly both in the use of the brush and the handling of space. It is possible but unlikely that the passage of seven years is the cause for two executions of the same subject by the same artist to be so different. The tense delineation of the rocks and pavilion in the *Four Districts* leaf as well as the poor choice of an artificial horizon line for the seascape seem alien to the treatment of the same elements in the 1795 leaf. The 1795 leaf is Kim at his best, revealing confident, casual brushwork in the formation of the rocky columns and pavilion, and in the evocation of the gradually fading waves out to the distant sea.

The importance of the attribution of the *Four Districts* albums to Kim Hong-do, however, can not be overlooked as there are three

Fig. 102) Unindentified artist, "Pearl [Cataract] Pond," one leaf from *Album of Travel to the East*, ca. 1825. Set of albums with 22 leaves, ink and light color on paper, 26.7 × 19.8 cm. Sungkyunkwan University Museum, Seoul

other known sets of albums that share identical compositions. One set is the *Album of Sea and Mountains* (*Haesan-do cheop*) which is now in an undisclosed private collection. The set contains 40 leaves and is also attributed to Kim Hong-do. In composition and modeling techniques, the paintings in the *Sea and Mountains* set are almost identical with those in the *Four Districts* set, though they contain stronger contrasts of light and dark and are extremely mannered in execution. The harsher qualities of the former set are evident as seem in the "Chongseok-jeong Pavilion" (fig. 100), a representative leaf from one of the albums in the set.

The second set is an album of 30 leaves. It is entitled *Album of a Geumgang Journey While at Rest* (*Geumgang wayucheop*) and also attributed to Kim Hong-do. This thirty-leaf set includes some scenes that are not in the sixty-leaf *Four Districts* set. Its motifs and compositions also display more similarity to known works by Kim Hong-do, but the execution still lacks all the subtle qualities we associate with Kim's authentic landscape paintings.

The third set, entitled *Album of Travel to the East* (*Dongu cheop*), contains 28 leaves painted by an unidentified artist, along with the poems and travel diary of the well-known scholar-official, Yi Pung-ik (1804-1887). In 1825 Yi apparently took a twenty-nine day trip to all the scenic sites of the Inner, Outer, and Coastal Geumgang region. The *Travel to the East* set has 22 leaves with compositions in common with the leaves in the *Four Districts* set attributed to Kim Hong-do. A comparison of any two leaves of identical composition from these two albums reveals both similarities and differences. A study of the scene depicted in the "Pearl [Cataract] Pond" (Jinju-dam) (fig. 101) from the *Four Districts* set with the same scene depicted in the *Travel to the East* set (fig. 102) offers us many points of comparison, but neither leaf is a work by Kim Hong-do.

The fact that these album sets contain identical compositions argues for the existence of manuals of "model compositions" used by painters for depicting the scenery of Mount Geumgang by the end of the eighteenth century. In this connection, we should recall Gang Se-

hwang's remark that Kim Hong-do and Kim Eung-hwan had made more than 100 sketches of Mount Geumgang during their trip there by the order of King Jeongjo. Kim Hong-do and Kim Eung-hwan, being the most prominent court painters at the time, could have used those sketches to assemble a kind of Mount Geumgang composition bank, from which they and also other court painters could draw when producing scenery of that mountainous region in large quantity.

Although none has survived, some albums of "model compositions" of Mount Geumgang scenery produced by the Royal Bureau of Painting might have been reproduced as woodblock prints for circulation. The possible existence of such prints is supported by the publication of the court record of King Jeongjo's 1795 trip to his father's tomb in Hwaseong. This type of document known as *uigwe* (book of court rites) contains many pages of woodblock illustrations, including some in landscape settings. We have a great number of these *uigwe* on court banquets with woodblock illustrations of banquet scenes in palace sites published by the Joseon court since 1795. It was also a widespread practice during the late Ming and early Qing periods to produce sets of woodblock prints of well-known sites in China such as Mount Huang, Mount Lu, the West Lake in Hangzhou, and the Yuanming yuan garden. The landscape prints were either included in local gazetteers and

Fig. 103) *Mount Geumgang and its Old Temples*, undetermined date. Woodblock print, 61.6×37.2 cm. Toyama Museum of Fine Arts, Japan

Fig. 104) Yi Ui-seong, "Front View of Coastal Geumgang," one leaf from *Album of Sea and Mountains*, early 19th century. Set of albums with 20 leaves, ink and light color on paper, 32× 48 cm. Private collection, Korea

encyclopedic compilations or published independently. Some of these Chinese prints were known in Korea, as evidenced by Jeong Seon's painting of Mount Lu now in the collection of the Kansong Art Museum, presumably done after a printed illustration of the mountain published in China in 1726.

Illuminating in this connection is an album of eight woodblock prints entitled *Mount Geumgang and its Old Temples* (fig. 103), now in a Japanese collection. Many of the leaves in this undated album have both Korean and Chinese inscriptions identifying the sites illustrated. Although the inscriptions on the reproductions are not easy to read, some of the legible ones indicate Chinese mountains, such as Mount Lu and Mount Heng. None of the eight prints illustrates the scenery of Mount Geumgang, as the album title indicates, but the possibility of its existence cannot be doubted.

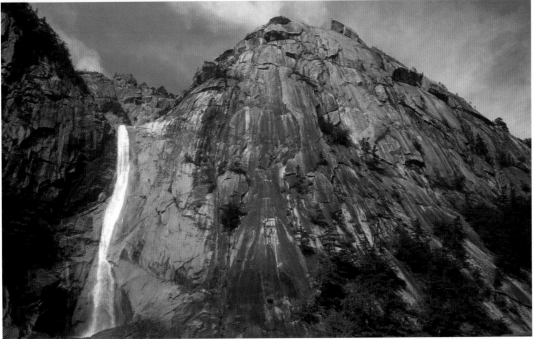

Fig. 105) Kim Ha-jong, "Nine Dragons [Waterfall] Pond," one leaf from *Album of Sea and Mountains*, dated 1815. Set of albums with 25 leaves, ink and light color on silk, 29.7×43.3 cm. National Museum of Korea, Seoul

Fig. 106) Nine Dragons [Waterfall] Pond. Photograph by Yi Song-mi, 1999

Fig. 107) Kim Ha-jong, "Clear Mirror Terrace," one leaf from *Album of Sea and Mountains*, dated 1815. Set of albums with 25 leaves, ink and light color on silk, 29.7×43.3 cm. National Museum of Korea, Seoul

A case could be made for the likelihood that print illustrations of Mount Geumgang served as the models for many of the early nineteenth century depictions of Mount Geumgang by the literati painter Yi Ui-seong (1775-1833). This suspicion becomes apparent when we examine Yi's "Front View of Costal Geumgang" (fig. 104), a leaf from his *Album of Sea and Mountains* (*Haesando-cheop*), now in a private collection in Korea. In Yi's rendering of the site, the brushstrokes that delineate the rock formations are all of uniform thickness, with only a slight variation in ink tone, and there is a complete absence of any further texturing of the rock surfaces. These qualities of line and ink indicate an origin in printing, not painting. Additionally, the sea waves are also delineated in short lines of uniform thickness, very different

Fig. 108) Kim Ha-jong, "Clear Mirror Terrace," one leaf from *Album of Autumn Foliage Mountain*, dated 1865. Set of four albums with 58 leaves, ink and light color on paper, 49.3× 61.6 cm. Private collection, Korea

from the billowing sea waves executed with swift, modulated brushstrokes seen in Jeong Seon's *Rock Gate at Tongcheon* (fig. 68).

Perhaps the most noteworthy painter of true-view landscape painting in the nineteenth century is Kim Ha-jong (1793-after 1875), the third son of the court painter Kim Deuk-sin, and grandnephew of Kim Eung-hwan. The younger Kim's activities as a court painter are well documented. Two sets of paintings of Mount Geumgang credited to him are important in understanding nineteenth-century true-view landscape painting. The first set is the *Album of Sea and Mountains* dated 1815. Some of its 25 leaves such as the "Clear Mirror Terrace" (Myeonggyeong-dae) (fig. 107), or the "Nine-Dragons [Waterfall] Pond" (Guryong-yeon) (fig. 105), display similarities with those of the *Four*

Fig. 109) Jo Jeong-gyu, *Nine Dragons [Waterfall] Pond*, dated 1860. Hanging scroll, ink and light color on paper, 108×48 cm. Kansong Art Museum, Seoul

Districts set attributed to Kim Hong-do, but are not identical to them. However, they show enough similarity to suggest that the artist was well aware of those compositions. The younger Kim's brushstrokes are broader and bolder, with less use of texture strokes than the work in the *Four Districts* set. Moreover, a comparison of his "Nine-Dragons [Waterfall] Pond (fig. 105)" with a recent photograph of the site (fig. 106) reveals that Kim's composition is closely based on observation of the scene.

The second set of Mount Geumgang landscapes by Kim Ha-jong, entitled *Paintings of Autumn Foliage Mountain* (*Pungak-kwon*), dated 1865, contains 58 leaves bound into four albums. Though Kim's compositions still show affinity with those in the *Four Disticts* and the *Sea and Mountains* sets attributed to Kim Hong-do, the viewpoints in each of the younger artist's paintings are somewhat different. Additionally, the painting in this second set, when compared scene by scene with those in the artist's earlier album of 1815, reveal how far Kim Ha-jong has come in his mastery of the brush. The 1865 rendering of the "Clear Mirror Terrace" (fig. 108), for instance, displays a mature Southern School style with softer, more relaxed brushwork when compared to his earlier 1815 version (fig. 107).

Other professional true-view painters of this period include, among others, Jo Jeong-gyu (b. 1791) and Yu Suk (1827-1873). Jo's paintings of Mount Geumgang are characterized by bold touches of personal brushwork and simplified forms. The *Nine-Dragons [Waterfall] Pond* (fig. 109), a hanging scroll painting from a set of eight in the collection of Kansong Art Museum, Seoul, shows an idiosyncratic composition that is very different from earlier renditions of the subject. The strong contrast between the dark ink on the right side of the cliff and the lighter linear treatment of the waterfall and the peak above it, is also unique. Yu Suk is better known for his figures and genre paintings, but he also left some true-view landscapes. They tend to fall within the style of Jeong Seon.

In addition to the scholar-amateur painters and professional painters at the Court Bureau of Painting, there were a considerable

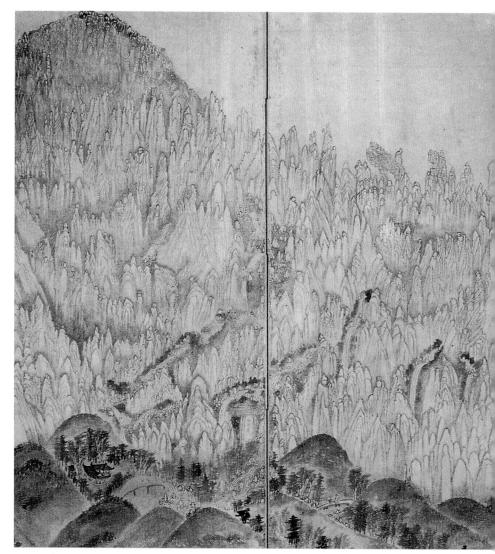

Fig. 110) Unidentified artist, *Mount Geumgang*, 19th century. Ten-panel screen (four panels), ink and light color on paper, 123×597 cm. Private collection, Korea

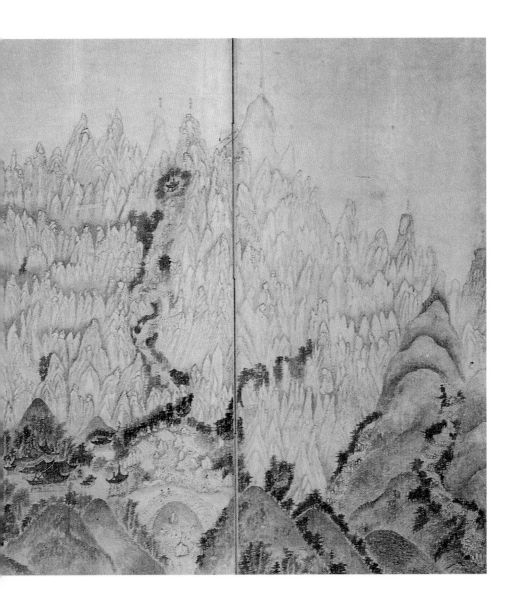

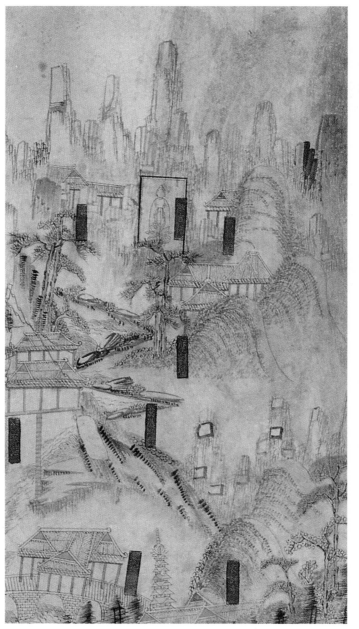

Fig. 111) Unidentified artist, *Mount Geumgang*, late 19th century. Eight-panel screen (three panels), ink and light color on paper, 82.5×44.5 cm (each panel). Ho-Am Art Museum, Seoul

Fig. 112) An Jung-sik, *Chehwa-jeong Pavilion*, dated 1915. Ten-panel screen (five panels), ink and light color on silk, 170×473 cm. Ho-Am Art Museum, Seoul

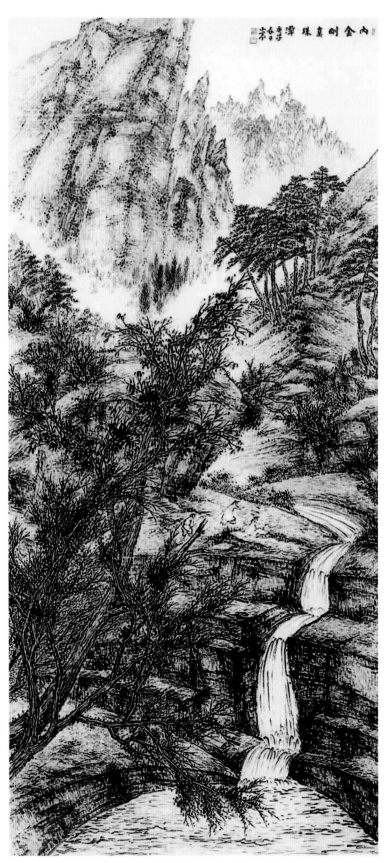

Fig. 113) Byeon Gwan-sik, *Pearl [Cataract] Pond in Inner Geumgang*, dated 1960. Hanging scroll, ink and light color on paper, 263×121 cm. Ho-Am Art Museum, Seoul

number of landscape artists who produced paintings to meet the demand of the general population. We now term paintings produced for ordinary people "folk paintings" (*minhwa*). Typically, the artists of *minhwa* did not have any formal training in painting, and their works tended to be conservative both in style and subject matter. There remains a large body of late Joseon folk paintings of landscapes that features Mount Geumgang. Some of the Mount Geumgang folk paintings show similarities to mainstream Mount Geumgang paintings while others deviate considerably from them. Two examples from the collection of Ho-Am Art Museum serve to illustrate this point. The *Ten-panel screen of Mount Geumgang* (fig. 110) belongs to the former category as we can discern the style of Jeong Seon's in the treatment of needle-like rocky peaks and the use of Mi ink-dots on the earthen mounds. However, in the *Eight-panel screen of Mount Geumgang* (fig. 111), the style is quite different. It has the typical charm and naiveté of an untrained hand, and displays only faint knowledge of mainstream Mount Geumgang painting. Yet the standard rocky peaks and earthen mounds are here, and even the practice of putting labels on important sites.

True-view Landscape Painting into the Twentieth Century

Amid the dominance of Southern School literati painting, the tradition of true-view landscape continued into the late nineteenth century, but was not pursued with the same degree of zeal and creativity as in the eighteenth century. Among those who worked in the tradition in the late nineteenth century, which in turn became the basis of early twentieth-century true-view landscape, we can single out An Jung-sik (1861-1919). A member of the last generation of court painters, An left the impressive ten-panel screen entitled *Chehwa-jeong Pavilion* (fig. 112), now in the collection of the Ho-Am Art Museum. Dated 1915, the screen depicts a village in Yeonggwang, Jeollanam-do province. Without such turn-of-the-century production of true-view landscape by

Fig. 114) Yun Suk-nam [Yun Seong-nam], *Nine Dragons [Waterfall] Pond*, dated 1999. Beads, oil and acrylic on white pine panels, 250×400×70 cm. Collection of the artist

Fig. 115) Nine Dragons
[Waterfall] Pond.
Photograph by Yi Song-
mi, 1999

artist like An, the art of modern Korean landscape painters such as Byeon Gwan-sik (1899-1976) and Yi Sang-beom (1897-1972) might not have been possible.

Byeon Gwans-sik's *Pearl [Cataract] Pond in Inner Geumgang* (fig. 113), dated to 1960, is a monumental painting of about 2.6 meters in height that attempts to synthesize all past landscape traditions. It is impossible to single out what brush conventions Byeon had in mind when he executed this true-view of a popular spot on Mount Geumgang. He challenges us not to think in those terms as we look at this unique depiction of a scene that had been repeatedly painted in the past. Both Yi Sang-beom and Byeon Gwan-sik lived through the Japanese colonial period and the Korean War. Their renewed interest and love of Korean landscape is in no sense less fervent than the true-view landscape painters of the eighteenth century.

Since 1998, there has been another wave of interest in true-view landscapes of Mount Geumgang after the area was opened on a limited basis to South Koreans. South Korean artists who visited the mountain have produced many modern versions of "true-views" of the site in all possible media and format. The *Nine Dragons [Waterfall] Pond* (fig. 114) by Yun Suk-nam [Yun Seong-nam], still owned by the artist, is as monumental in size as Byeon Gwan-sik's painting. Yun's choice of oil, acrylic, wood, and glass beads, not uncommon in contemporary installation art, seems foreign to traditional painting medium. But in capturing a memorable impression of the waterfall (fig. 115), it seems equally effective. Thus, the practice of traveling in order to sketch scenery of exceptional beauty or uncommon character continues to be a living tradition amid the influx of the latest means of artistic expression, whether it be installation, performance, digital, or video art.

The modern and contemporary art scene in Korea today is as lively, innovative, and viable as any in the world's leading art centers of New York, Paris or Berlin. Many Korean artists go abroad, and some stay and work overseas while others come back to infuse new trends into Korean art. Korean artists actively participate in well-established

art venues such as the Venice Biennale. It is exciting to see our artists do something totally novel and yet still rooted in the spirit of traditional Korean art. Many museums and galleries in Korea also compete to provide venues for the exhibition of works by renowned world artists, as well as to mount avant-garde shows like the Whitney Biennale. The whole story of these later chapters in Korean art, including landscape art, has been told by Kim Youngna in *Modern and Contemporary Art in Korea*, the first volume in our Korean Culture Series.

REFERENCE MATERIALS

Maps

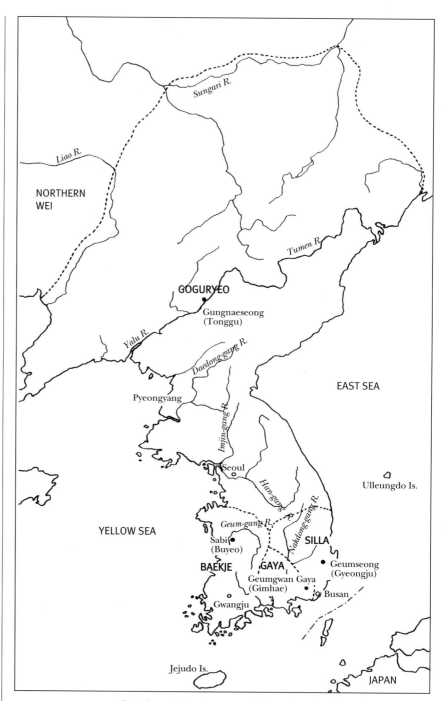

1. The Three Kingdoms and Gaya (ca. 600)

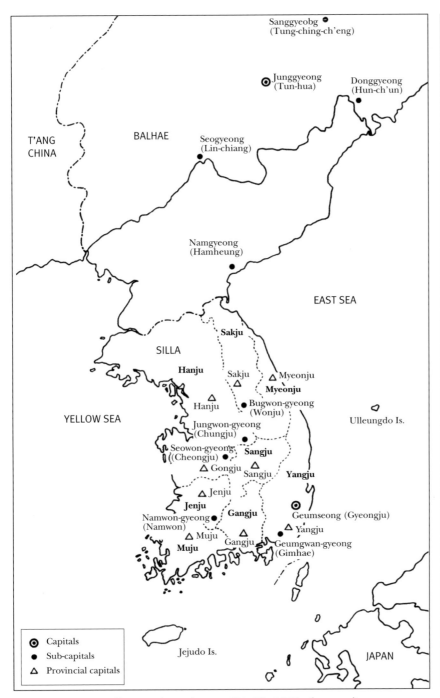

Sanggyeobg
(Tung-ching-ch'eng)

Junggyeong
(Tun-hua)

Donggyeong
(Hun-ch'un)

T'ANG
CHINA

BALHAE

Seogyeong
(Lin-chiang)

Namgyeong
(Hamheung)

EAST SEA

Sakju

SILLA

Hanju

Sakju

Myeonju

Myeonju

Hanju

Bugwon-gyeong
(Wonju)

YELLOW SEA

Jungwon-gyeong
(Chungju)

Ulleungdo Is.

Seowon-gyeong
((Cheongju)

Sangju

Gongju

Sangju

Yangju

Jenju

Jenju

Gangju

Geumseong (Gyeongju)

Namwon-gyeong
(Namwon)

Yangju

Muju

Gangju

Geumgwan-gyeong
(Gimhae)

Muju

Capitals
Sub-capitals
Provincial capitals

Jejudo Is.

JAPAN

2. Balhae and Provinces of Unified Silla (ca. 750)

Legend:
- ● Capitals
- ● Garrisons
- ○ District administrative headquarters

KHITANS

JURCHEDS

Bukgye
Anbuk-bu

EAST SEA

Seongyeong

Anbyeon-bu

Hwangju-mok

Gyoju-mok

Seohae

Gyoju

Gyeonggi

Donggye

Anseo-bu

Gaegyeong

Myeongju

Namgyeong

Gawangju-mok

Chungju-mok

Ulleungdo Is.

YELLOW SEA

Yanggwang

Cheongju

Andong-bu

Sangju-mok

Gyeongsang

Jenju-mok

Annam-bu

Donggyeong

Jeolla

Jinju-mok

Naju-mok

Jejudo Is.

JAPAN

3. Territory of Goryeo in the Late Tenth to Early Twelfth Century

Legend:
- ○ Gamyeong (Provincial capital)
- ⚑ Army barracks
- ⚓ Navy barracks

CHINA

Gyeongseong

Hamgil
(Hamgyeong)

Pyeongan

Bukcheong

Anju

Hamheung

Pyeongyang

EAST SEA

Hwangju

Hwanghae

Haeju

Gangwon

Ongjin

Gyodong

Hanyang
(Seoul)

Gyeonggi

Ulleungdo Is.

Wonju

Cheongju

Chungcheong

Gonju

Gyeongsang

Boryeong

Jeonju

Daegu

YELLOW SEA

Jeolla

Jinju

Ulsan

Gangjin

Dongnae

Goseong

Suncheon

Tsushima

Haenam

Jejudo Is.

JAPAN

4. Territory of Joseon Showing the Eight Provinces of Korea
in the Fifteenth Century

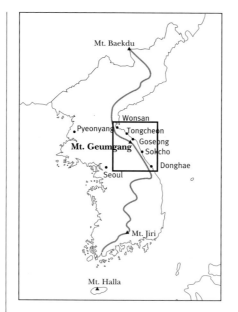

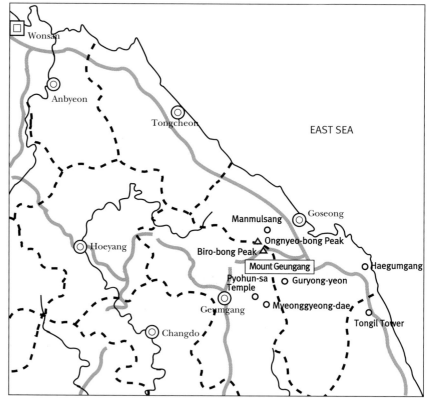

5. Mount Geumgang with Important Scenic Districts

List of Maps

List of Illustrations

Tomb at Gangseo 江西大墓玄室天井〈山岳圖〉. Gangseo district, Pyeongannam-do province

Fig. 14) *Landscape*, 6th-7th century. Wall Painting of Tomb No.1 at Pyeongjeong-ri 坪井里1號墳〈山水圖〉. Anak district, Hwanghaenam-do province

Fig. 15) Landscape Elements on Lidded Silver Cup with Saucer, 6th century. Excavated from Tomb of King Munyeong 武寧王陵出土 銀托盞. Buyeo National Museum

Fig. 16) Landscape Scene on Earthernware Tile 山水文塼, 7th century. 28.6× 28.8×4 cm. National Museum of Korea, Seoul

Fig. 17) *Landscape*, 11th century. Woodblock print from the *Imperially-Composed Explanation of the Secret Treasure* 御製秘藏詮 (IX-3), 28× 54.4 cm. Nanzen-ji temple, Kyoto

Fig. 18) *Landscape*, 11th century. Woodblock print from the *Imperially-Composed Explanation of the Secret Treasure* 御製秘藏詮 (VI-3), 22.7 ×52.6 cm. SungAm Archives of Classical Literature, Seoul

Fig. 19) Yi Je-hyeon, "Crossing the River on Horseback" 騎馬渡江圖, 14th century. Album leaf, ink and light color on silk, 73.6×109.4 cm. National Museum of Korea, Seoul

Fig. 20) No Yeong, *Bodhisattva Ksitigarbha* 地藏菩薩現身圖, dated 1307. Lacquered screen with gold pigment, 22.5×13 cm. National Museum of Korea, Seoul

Fig. 21) Seo Gu-bang, *Water Moon Bodhisattva with a Willow Branch* 水月觀音圖, dated 1323. Hanging scroll, ink and color on silk, 165.5×101.5 cm. Private collection, Japan

Fig. 22a-b) Attributed to Go Yeon-hui, *Summer Landscape* (right) and *Winter Landscape* (left) 山水圖對聯, 14th century. Pair of hanging scrolls, ink on silk, 124×57.9 cm. Konchi-in temple, Kyoto

Fig. 23) Guo Xi, *Early Spring* 早春圖, dated 1072. Hanging scroll, ink and light color on silk, 158.3×108.1 cm. National Palace Museum, Taipei

Fig. 24) Li Zai, Landscape in the Manner of Guo Xi 倣郭熙山水圖, early 15th century. Hanging scroll, ink and light color on silk, 83.3×39 cm. Tokyo National Museum

Fig. 25) Attributed to An Gyeon, "Late Winter" 晩冬, one leaf from *Eight*

Views of the Four Seasons 四時八景圖, 15th century. Album of eight leaves, ink and light color on silk, 35.2×28.5 cm. National Museum of Korea, Seoul

Fig. 26) Attributed to Ma Yuan, *Banquet by Lantern Light* 華燈侍宴圖, 13th century. Hanging scroll, ink and color on silk, 125.6×46.7 cm. National Palace Museum, Taipei

Fig. 27) Attributed to Yi Sang-jwa, *Walking under a Pine Tree in Moonlight* 松下步月圖, 1st half of 16th century. Hanging scroll, ink and light color on silk, 197×82.2 cm. National Museum of Korea, Seoul

Fig. 28) Gang Hui-an, "Scholar Gazing at Water" 高士觀水圖, 15th century. Album leaf ink on paper, 23.5×15.7 cm. National Museum of Korea, Seoul

Fig. 29) Attributed to Seo Mun-bo, "Landscape" 山水圖, 15th-16th century. Album leaf, ink and light color on silk, 39.7×60.1 cm. The Museum Yamato Bunkakan, Nara

Fig. 30) Unidentified artist, *Evening Rain on Plantain Leaves* 芭蕉夜雨圖, colophon dated to 1410. Hanging scroll, ink on paper, 96×31.4 cm. Private collection, Japan

Fig. 31) Attributed to Shūbun, *Mountain Peaks and Water Bathed in Light* 水色巒光圖, dated 1445. Hanging scroll, ink and light color on paper, 107.9×32.7 cm. Okayama Prefectural Museum of Art, Japan

Fig. 32) Mun Cheong, *Landscape with Pavilions* 樓閣山水圖, 15th century. Hanging scroll, ink and light color on paper, 31.5×42.7 cm. National Museum of Korea, Seoul

Fig. 33) Kim Si, *Clearing after Snow in Wintry Forest* 寒林霽雪圖, dated 1584. Hanging scroll, ink and light color on silk, 53×67.2 cm. The Cleveland Museum of Art, Ohio

Fig. 34) Kim Si, *Boy Pulling a Donkey* 童子牽驢圖, late 16th century. Hanging scroll, ink and color on silk, 111×46 cm. Ho-Am Art Museum, Seoul

Fig. 35) Yi Bul-hae, *Walking with a Staff* 曳杖逍遙圖, 2nd half of 16th century. Hanging scroll, ink on silk, 18.6×13.5 cm. National Museum of Korea, Seoul

Fig. 36) Yi Heung-hyo, *Landscape* 山水圖, dated 1593. Hanging scroll, ink on silk, 29.3×24.9 cm. Private collection, Korea

Fig. 37) Yi Gyeong-yun, *Landscape* 山水圖, 2nd half of 16th century. Hanging scroll, ink and light color on silk, 91.1×59.5 cm. National Museum of Korea, Seoul

Fig. 38) Yi Gyeong-yun, "Viewing the Moon" 觀月圖, one leaf from *Album of Figures in Landscape* 山水人物帖, 2nd half of 16th century. Album of 10 leaves, ink on silk, 31.2×24.9 cm. Korea University Art Museum, Seoul

Fig. 39) Yi Jing, *Evening Bell from Mist-shrouded Temple* 煙寺暮鍾圖, first half of 17th century. Hanging scroll, ink and light color on silk, 103.9 ×55.1 cm. National Museum of Korea, Seoul

Fig. 40) Yi Jing, *Gold-painted Landscape* 泥金山水圖, 1st half of 17th century. Hanging scroll, gold pigment on silk, 87.8×61.2 cm. National Museum of Korea, Seoul

Fig. 41) Yi Jing, *Old Villa in the Hwagae District* 花開縣舊莊圖, dated 1643. Hanging scroll, ink and light color on silk, 89.3×56 cm. National Museum of Korea, Seoul

Fig. 42) Kim Myeong-guk, *Snow Landscape* 雪景山水圖, mid-17th century. Hanging scroll, ink and light color on silk, 101.7×55 cm. National Museum of Korea, Seoul

Fig. 43) Kim Myeong-guk, *Viewing the Waterfall* 觀瀑圖, mid-17th century. Hanging scroll, ink and light color on silk, 176.6×100.2 cm. National Museum of Korea, Seoul

Fig. 44) Unidentified artist, *Gathering of Scholars at the Dokseo-dang Reading Hall* 讀書堂契會圖, ca. 1570. Hanging scroll, ink on silk, 102×57.5 cm. Seoul National University Museum.

Fig. 45) Detail of *Gathering of Scholars at the Dokseo-dang Reading Hall*

Fig. 46) Han Si-gak, *Special National Examination for Applicants from the Northeastern Provinces* 北塞宣恩圖, dated 1664. Right half of handscroll, ink and color on silk, 57.9×674.1 cm (whole scroll). National Museum of Korea, Seoul

Fig. 47) Detail showing example of hemp-fiber texture strokes 披麻皴. From the *Wintry Groves and Layered Banks* 寒林重汀圖, attributed to Dong Yuan, ca. 950. Handscroll, ink and color on silk, 181.5×116.5 cm. Kurokawa Institute of Ancient Cultures Gallery, Japan

Fig. 48) Detail showing example of moss dots 苔點. From the *Seeking Truth in Autumn Mountains* 秋山問道圖, attributed to Juran, ca. 960-980. Hanging scroll, ink and light color on silk, 156.2×77.2 cm. National Palace Museum, Taipei.

Fig. 49) Detail showing crab's claw texture strokes 蟹爪描. From the *Fishing on a Wintry River* 寒江釣艇圖, attributed to Li Cheng, 1st half of 10th century. Hanging scroll, ink on silk, 170×101.9 cm. National Palace Museum, Taipei

Fig. 50) Detail showing example of raindrop texture strokes 雨點皴. From the *Travelers by Streams and Mountains* 溪山行旅圖 by Fan Kuan, ca. 1000. Hanging scroll, ink on silk, 206.3×103.3 cm. National Palace Museum, Taipei

Fig. 51) Detail showing example of Mi ink-dots 米點. From the *Spring Mountains Ringed with Pines* 春山瑞松圖 by Mi Fu (1051-1107), but possibly later copy. Hanging scroll, ink and color on paper, 35×44.1 cm. National Palace Museum, Taipei

Fig. 52) Detail showing example of hemp-fiber texture strokes 麻披皴. From the *Dwelling in the Fuchun Mountains* 富春山居圖 by Huang Gongwang, dated 1350. Handscroll, ink on paper, 33×636.9 cm. National Palace Museum, Taipei

Fig. 53) Detail showing example of folded-ribbon texture strokes 折帶皴. From the *Rongxi Studio* 容膝齋圖 by Ni Zan, dated 1372. Hanging scroll, ink on paper, 74.7×35.5 cm. National Palace Museum, Taipei

Fig. 54) Detail showing example of ox-hair texture strokes 牛毛皴. From the *Autumn Mountains with a Solitary Temple* 秋山蕭寺 by Wang Meng, mid-14th century. Hanging scroll, ink on paper, 142×38.5 cm. National Palace Museum, Taipei

Fig. 55) Yi Jeong-geun, *Mi-style Landscape* 米法山水圖, 1st half of 16th century. Right half of handscroll, ink on paper, 23.4×119.4 cm (whole scroll). National Museum of Korea, Seoul

Fig. 56) Yi Yeong-yun, *Landscape after Huang Gongwang* 倣黃公望山水圖, late 16th-early 17th century. Hanging scroll, ink on paper, 97×28.8 cm. National Museum of Korea, Seoul

Fig. 57) Yi Jeong, "Leaf No. 4" from *Album of Landscapes* 山水畵帖, early

17th century. Album of 12 leaves, ink on paper, 19.1×23.5 cm. National Museum of Korea, Seoul

Fig. 58) Yi Jeong, "Leaf No. 2" from *Album of Landscapes* 山水畫帖, early 17th century. Album of 12 leaves, ink on paper, 19.1×23.5 cm. National Museum of Korea, Seoul

Fig. 59) Yi Yo, *A Solitary Fishing Boat* 一片魚舟圖, first half of 17th century. Fan, ink and light color on silk, 15.6×28.8 cm. Seoul National University Museum

Fig. 60) Jo Sok, "Gathering Mist in the Village by the Lake" 湖村煙凝圖, mid-17th century. Album leaf, ink and light color on paper, 38.5×27.6 cm. Kansong Art Museum, Seoul

Fig. 61) Yun Du-seo, "Thatched Pavilion by the Water's Edge," 水涯茅亭圖, one leaf from *Album of Paintings,* late 17th - early 18th century. Ink on paper, 16.8×16 cm. Yun Memorial Museum, Haenam, Jeollanam-do province

Fig. 62) Jeong Seon, "Complete View of Inner Mount Geumgang," 金剛內山全圖, one leaf from *Album of Paintings of Pungak Mountain in the Sinmyo Year [1711]* 辛卯年楓岳圖帖. Album of 13 leaves, ink and light color on silk, 36×37.4 cm. National Museum of Korea, Seoul

Fig. 63) Jeong Seon, *Complete View of Mount Geumgang* 金剛全圖, dated 1734. Hanging scroll, ink and light color on paper, 130.8×94 cm. Ho-Am Art Museum, Seoul

Fig. 64) Detail of *Complete View of Mount Geumgang* 金剛全圖 (Fig. 63)

Fig. 65) Mount Geumgang, Gangwon-do province. Photograph by Yi Song-mi, 1999.

Fig. 66) Jeong Seon, "Jeongyang-sa Temple" 正陽寺, one scroll from *Eight Paintings of Mount Geumgang* 海嶽圖屛, first half of 18th century. Set of eight hanging scrolls, ink and light color on paper, 56×42.8 cm. Kansong Art Museum, Seoul

Fig. 67) Jeong Seon, "View-Hole Peak" 穴望峰, first half of 18th century. Album leaf, ink and light color on silk, 33×22 cm. Seoul National University Museum

Fig. 68) Jeong Seon, *Rock Gate at Tongcheon* 通川門岩, first half of 18th century. Hanging scroll, ink on paper, 131.6×53.4 cm. Kansong Art

Museum, Seoul

Fig. 69) Yi Yun-yeong, "Goran-sa Temple" 皐蘭寺, dated 1748. Album leaf, ink and color on paper, 29.5×43.5 cm. Private collection, Seoul

Fig. 70) Yi In-sang, "Terrace of the Immortal's Retreat" 隱仙臺, mid-18th century. Album leaf, ink and light color on paper, 34×55 cm. Kansong Art Museum, Seoul

Fig. 71) Choe Buk, "Pyohun-sa Temple" 表訓寺圖, 18th century. Album leaf, ink and light color on paper, 38.5×57.3 cm. Private collection, Korea

Fig. 72) Pyohun-sa Temple. Photograph taken from Colonial period (1910-1945) black-and-white photo album of Mount Geumgang (n.p. and n.d.)

Fig. 73) Sim Sa-jeong, "Bodeok-gul Dwelling" 普德窟, second half of 18th century. Album of four leaves, ink and light color on paper, 27.6×19.1 cm. Kansong Art Museum, Seoul

Fig. 74) Gang Hui-eon, "Mount Inwang Seen from Dohwa-dong" 桃花洞望仁王山, second half of 18th century. Album leaf, ink and light color on paper, 24.6×42.6 cm. Private collection, Korea

Fig. 75) Kim Eung-hwan, "Complete View of Mount Geumgang" 金剛全圖, dated 1772. Album leaf, ink and light color on paper, 22.3×35.2 cm. Private collection, Korea

Fig. 76) Gang Se-hwang, *Self-portrait* 姜世晃 自畫像, second half of 18th century. Hanging scroll, ink and light color on paper, diam. 14.9 cm. Collection of Gang Ju-jin, Korea

Fig. 77) Gang Se-hwang, "Approach to Yeongtong-dong" 靈通洞口圖, one leaf from *Album of Journey to Songdo* 松都紀行帖, ca. 1757. Album of 16 leaves, ink and light color on paper, 32.8×53.4 cm. National Museum of Korea, Seoul

Fig. 78) Gang Se-hwang, "View of Songdo" 松都全景, one leaf from *Album of Journey to Songdo* 松都紀行帖, ca. 1757. Album of 16 leaves, ink and light color on paper, 32.8×53.4 cm. National Museum of Korea, Seoul

Fig. 79) Kim Hong-do, "Oksun-bong Peaks" 玉筍峯, one leaf from *Album of the Byeongjin Year [1796]* 丙辰年畫帖. Album of 20 leaves, ink and light color on paper, 26.7×31.6 cm. Ho-Am Art Museum, Seoul

Fig. 80) Oksun-bong Peaks, Danyang, Chungcheongbuk-do province. Photograph by Yi Song-mi, 2001

Fig. 81) Kim Hong-do, "Flying Phoenix Waterfall" 飛鳳瀑, one scroll from *Paintings of Sea and Mountains* 海山圖屛, late 18th century. Set of eight hanging scrolls, ink on silk, 91.4×41 cm. Kansong Art Museum, Seoul

Fig. 82) Flying Phoenix Waterfall. Photograph taken from Colonial period (1910-1945) black-and-white photo album of Mount Geumgang (n.p. and n.d.)

Fig. 83) Yi In-mun, "Mount Geumgang Viewed from Danbal-ryeong Ridge" 斷髮嶺望金剛山, late 18th century. Album leaf, ink and light color on paper, 23×45 cm. Private collection, Korea

Fig. 84) Mount Geumgang, Gangwon-do province. Photograph courtesy of JoongAng Daily

Fig. 85) Jeong Su-yeong, "Mount Geumgang Seen from Cheonil-dae Terrace" 天一臺望金剛圖, four leaves from *Album of Sea and Mountains* 海山帖, dated 1799. Album of 46 leaves, ink and light color on paper, 37.2×123.8 cm. National Museum of Korea, Seoul

Fig. 86) Jeong Su-yeong, "Snow-Spewing [Cataract] Pond" 噴雪潭圖, one leaf from *Album of Sea and Mountains* 海山帖, dated 1799. Album of 46 leaves, ink and light color on paper, 37.2×31 cm. National Museum of Korea, Seoul

Fig. 87) Gang Se-hwang, "In Imitation of Shen Shitian's Clear Summer Day under a Paulownia Tree" 倣沈石田 碧梧清署圖, second half of 18th century. Album leaf, ink and light color on paper, 30×35.8 cm. Private collection, Korea

Fig. 88) *Shen Shitian's Clear Summer Day under a Paulownia Tree* 沈石田 碧梧清署圖. Woodblock print, from the *Mustard Seed Garden Manual of Painting* 芥子園畫傳 (First complete edition pub. 1701)

Fig. 89) Jeong Su-yeong, *Landscape in the Style of Huang Gongwang* 倣子久山水圖, early 19th century. Hanging scroll, ink and light color on paper, 101×61.3 cm. Korea University Art Museum, Seoul

Fig. 90) *Landscape in the Manner of Huang Gongwang* 模黃子久山水圖. Woodblock print, from the *Mustard Seed Garden Manual of Painting*

芥子園畫傳 (First complete edition pub. 1701)

Fig. 91) Jeon Gi, "Streams and Mountains with Abundant Reeds" 溪山苞茂圖, dated 1849. Album leaf, ink on paper, 24.5×41.5 cm. National Museum of Korea, Seoul

Fig. 92) *Landscape in the Manner of Ni Zan* 摹雲林山水圖, Woodblock print, from the *Mustard Seed Garden Manual of Painting* 芥子園畫傳 (First complete edition pub. 1701)

Fig. 93) Kim Jeong-hui, *Winterscape* (Sehan-do) 歲寒圖, dated 1844. Handscroll, ink on paper, 27.2×70.2 cm. Private collection, Korea

Fig. 94) Detail of *Winterscape* 歲寒圖

Fig. 95) Heo Ryeon, "Landscape after Wandang" 倣阮堂山水圖, second half of 19th century. Album leaf, ink on paper, 37×31 cm. Private collection, Korea

Fig. 96) Jang Seung-eop, *Village Dwelling in the Luxuriant Forest* 茂林村庄圖, dated 1884. Handscroll, ink on paper, 26.8×160.5 cm. Sunmun University Art Museum, Asan, Chungcheongnam-do province

Fig. 97) An Jung-sik, "Autumn Thoughts among Streams and Mountains" 谿山秋意圖, dated 1917. Album leaf, ink on paper, 25.8×28.3 cm. Seoul National University Museum

Fig. 98) Attributed to Kim Hong-do, "Chongseok-jeong Pavilion" 叢石亭圖, one leaf from *Album of the Four Districts of Geumgang* 金剛四郡帖, date undetermined. Set of five albums with 60 leaves, ink and light color on silk, 30.4×43.7 cm. Private collection, Korea

Fig. 99) Kim Hong-do, "Chongseok-jeong Pavilion" 叢石亭圖, one leaf from *Album of the Eulmyo Year [1795]* 乙卯年畫帖. Album of three leaves, ink and light color on paper, 23.2×27.7 cm. Private collection, Korea

Fig. 100) Attributed to Kim Hong-do, "Chongseok-jeong Pavilion" 叢石亭圖, one leaf from *Album of Sea and Mountains* 海山圖帖, date undetermined. Set of albums with 40 leaves, ink and light color on paper, dimensions unknown. Private collection, Korea

Fig. 101) Attributed to Kim Hong-do, "Pearl [Cataract] Pond" 珍珠潭, one leaf from *Album of the Four Districts of Geumgang* 金剛四郡帖, date undetermined. Set of five albums with 60 leaves, ink and light color on silk, 30.4×43.7 cm. Private collection, Korea

Fig. 102) Unidentified artist, "Pearl [Cataract] Pond" 珍珠潭, one leaf from *Album of Travel to the East* 東遊帖, ca. 1825. Set of albums with 22 leaves, ink and light color on paper, 26.7×19.8 cm. Sungkyunkwan University Museum, Seoul

Fig. 103) *Mount Geumgang and its Old Temples* 〈木版畫〉金剛山中古刹圖帖, undetermined date. Woodblock print, 61.6×37.2 cm. Toyama Museum of Fine Arts, Japan

Fig. 104) Yi Ui-seong, "Front View of Coastal Geumgang" 海金剛前面圖, one leaf from *Album of Sea and Mountains* 海山圖帖, early 19th century. Set of albums with 20 leaves, ink and light color on paper, 32×48 cm. Private collection, Korea

Fig. 105) Kim Ha-jong, "Nine Dragons [Waterfall] Pond" 九龍淵, one leaf from *Album of Sea and Mountains* 海山圖帖, dated 1815. Set of albums with 25 leaves, ink and light color on silk, 29.7×43.3 cm. National Museum of Korea, Seoul

Fig. 106) Nine Dragons [Waterfall] Pond. Photograph by Yi Song-mi, 1999

Fig. 107) Kim Ha-jong, "Clear Mirror Terrace" 明鏡臺, one leaf from *Album of Sea and Mountains* 海山圖帖, dated 1815. Set of albums with 25 leaves, ink and light color on silk, 29.7×43.3 cm. National Museum of Korea, Seoul

Fig. 108) Kim Ha-jong, "Clear Mirror Terrace" 明鏡臺, one leaf from *Album of Autumn Foliage Mountain* 楓嶽卷, dated 1865. Set of four albums with 58 leaves, ink and light color on paper, 49.3×61.6 cm. Private collection, Korea

Fig. 109) Jo Jeong-gyu, *Nine Dragons [Waterfall] Pond* 九龍淵, dated 1860. Hanging scroll, ink and light color on paper, 108×48 cm. Kansong Art Museum, Seoul

Fig. 110) Unidentified artist, *Mount Geumgang* 金剛山圖十曲大屛, 19th century. Ten-panel screen (four panels), ink and light color on paper, 123×597 cm. Private collection, Korea

Fig. 111) Unidentified artist, *Mount Geumgang* 金剛山圖八曲屛, late 19th century. Eight-panel screen (three panels), ink and light color on paper, 82.5×44.5 cm (each panel). Ho-Am Art Museum, Seoul

Fig. 112) An Jung-sik, *Chehwa-jeong Pavilion* 棣花亭十曲屛, dated 1915. Ten-

panel screen (five panels), ink and light color on silk, 170×473 cm. Ho-Am Art Museum, Seoul

Fig. 113) Byeon Gwan-sik, *Pearl [Cataract] Pond in Inner Geumgang* 內金剛珍珠潭, dated 1960. Hanging scroll, ink and light color on paper, 263×121 cm. Ho-Am Art Museum, Seoul

Fig. 114) Yun Suk-nam [Yun Seong-nam], *Nine Dragons [Waterfall] Pond* 九龍瀑布, dated 1999. Beads, oil and acrylic on white pine panels, 250×400×70 cm. Collection of the artist

Fig. 115) Nine Dragons [Waterfall] Pond. Photograph by Yi Song-mi, 1999

Select Bibliography

I. Books and Articles in English and Other Languages

Ahn, Hwi-joon. "Korean Influence on Japanese Ink Paintings of the Muromachi Period." *Korea Journal* 37, no. 4 (Winter 1997): 195-220.

_____. "Development of Paintings in the Chosŏn Period." In *Masterpieces of the Ho-Am Art Museum*, vol. 2, 191-197. Seoul: Samsung Foundation of Culture, 1996.

_____. "Literary Gatherings and Their Paintings in Korea." *Seoul Journal of Korean Studies* 8 (1995): 85-106.

_____. "A Scholar's Art: Painting in the Tradition of the Chinese Southern School." *Koreana* 6, no. 3 (March 1992): 26-33.

_____. "Korean Landscape Painting of the Early and Middle Chosŏn Period." *Korea Journal* 27, no. 3 (March 1987): 4-17.

_____. "Chinese Influence on Korean Landscape Painting of the Yi Dynasty (1392-1910)." In *International Symposium on the Conservation and Restoration of Cultural Property: Interregional Influences in East Asian Art History*, 213-223. Tokyo: Tokyo National Research Institute of Cultural Properties, 1981.

_____. "An Kyŏn and a Dream Journey to the Peach Blossom Land." *Oriental Art* 26, no. 1 (Spring 1980): 60-71.

_____. "Two Korean Landscape Paintings of the First Half of the 16th

Century." *Korea Journal* 15, no. 2 (Feb. 1975): 31-41.

Bush, Susan and Hsio-yen Shih. *Early Chinese Texts on Painting: Su Shih (1037-1101) to Tung Ch'i-ch'ang (1555-1636)*. Cambridge: Harvard University Press, 1985.

Chung, Hyung-min. "Adoption and Transformation of the Mi Tradition in Landscape Painting of the Late Chosŏn Dynasty." Ph.D. diss., Columbia University, 1993.

Chung, Yang-mo, Ahn Hwi-joon, Yi Song-mi, Kim Lena, Kim Hongnam, Pak Youngsook, and Jonathan W. Best. *Arts of Korea*. New York: The Metropolitan Museum of Art, 1998.

Duncan, John B. *The Origins of the Chosŏn Dynasty*. Seattle: University of Washington Press, 2000.

Haboush, Jahyun Kim. "Constructing the Center: The Ritual Controversy and the Search for a New Identity in Seventeenth-Century Korea." In *Culture and the State in Late Chosŏn Korea*, 46-90. Edited with Martina Deuchler. Boston: Harvard University Press, 1999.

_____. "Public and Private in the Court Art of Late Eighteenth Century Korea." *Korean Culture* 14, no. 2 (Summer 1993): 14-21.

Jungmann, Burglind. *Painters as Envoys: Korean Inspiration in Eighteenth Century Japanese Nanga*. New Jersey: Princeton University Press, 2004.

_____. *Die Koreanishe Lanschaftsmalerei und die Chinesische Che-Schule*. *Munchener Ostasiatische Studien*. Stuttgart: Franz Steiner Verlag, 1992.

Kim, Kumja Paik. "Decorative Painting of Korea." In *Hopes and Aspirations:*

Decorative Paintings of Korea, 8-21. San Francisco: Asian Art Museum, 1998.

_____. "Chŏng Sŏn (1676-1759): His Life and Career." Artibus Asiae LII, no. 3 / 4 (1992): 329-343.

_____. "The Introduction of Southern School Painting Tradition to Korea." Oriental Art,XXXVI, no. 4 (Winter 1990/1991): 181-197.

Kim, Lena, ed. World Cultural Heritage: Koguryŏ Tomb Murals. Seoul: ICOMOS-Korea, Cultural Properties Administration, 2004.

Kim, Youngna. Modern and Contemporary Art in Korea. Vol. 1 of Korean Culture Series. New Jersey and Seoul: Hollym, 2005.

Kim-Renaud, Young-key ed. King Sejong the Great: The Light of 15th Century Korea. Washington, D.C.: The International Circle of Korean Linguistics, 1992.

Korean Cultural Heritage, vol. 1 (Fine Arts). Seoul: The Korea Foundation, 1992.

Ku, John H. and Andrew Nam eds. An Introduction to Korean Culture. New Jersey and Seoul: Hollym, 1997.

Lee, Ki-baik. New History of Korea, trans. by Edward W. Wagner with Edward J. Shultz. Seoul: Ilchokak, 1984.

Lew, Young-ik ed. Korean Art Tradition. Seoul: The Korea Foundation, 1993. Modern Art Collection. Seoul: Samsung Foundation of Culture, 2005.

Munakata, Kiyohiko. Ching Hao's Pi-fa chi: A Note on the Art of the Brush. Ascona: Artibus Asiae, 1974.

Richono kaiga『李朝の繪畫』(exhibition catalog of Paintings of the Chosŏn Period). Tokyo: Fuji Art Museum, 1985.

Richono kaiga:『李朝の繪畫: 坤月軒 コレクション』(exhibition catalog of Paintings of the Chosŏn Period from the Kongetsuken Collection). Toyama: Toyama Museum of Fine Art, 1985.

Sohn, Pow-key, Kim Chŏl-choon and Hong Yi-sup. *The History of Korea.* Seoul: Korean National Commission for UNESCO, 1970 edition.

Suibokuga no shihō『水墨畫の至寶』(exhibition catalog of Supreme Treasures of Ink Painting). Okayama: Okayama Prefectural Museum of Art, 1993.

Traditional Art Collection. Seoul: Samsung Foundation of Culture, 2005.

Yang, Xin and Richard M. Barnhart. *Three Thousand Years of Chinese Painting.* Hong Kong: Yale University & Foreign Languages Press, 1997.

Yi, Sŏng-mi. "Koreans and their Mountain Paintings." *Koreana* 8, no. 4 (Winter 1994): 18-25.

_____. "The Southern School Painting of the Late Chosŏn Period." In *The Fragrance of Ink*, 177-192. Seoul: Center for Korean Studies and Korea University Museum, 1996.

_____. "The Birth and Evolution of Landscape Painting in Korea: from the Fifth to the Thirteenth Century." In *Ashia ni okeru sansui hyogen ni tsuite*『アシアに おける 山水表現に ついて』(Concerning Landscape Painting in Asia), 23-28. Tokyo: The Society for International Exchanges of Art Historical Studies, 1984.

_____. "Ideals in Conflict: Changing Concepts of Literati Painting in Korea."

In *Taiwan 2002 Conference on the History of Painting in East Asia*, 219-235. Taipei: National Palace Museum, 2002.

Zhongguo banhuashi tulu 『中國版畫史圖錄』 (Illustrated Catalog of the History of Chinese Woodblock Prints). Shanghai: Renmin meishu chubanshe, 1983.

II. Books and Articles in Korean

Ahn, Hwi-joon 安輝濬. *Hanguk hoehwa sa yeongu* 『한국 회화사 연구』 (A Study on History of Korean Painting). Seoul: Sigong-sa, 2000.

_____ and Yi Byeong-han 李炳漢. *An Gyeon gwa mongyu dowondo* 『安堅과 夢遊桃源圖』 (An Gyeon and his Dream Journey to the Peach Blossom Spring). Seoul: Yegyeong saneop-sa, 1991.

_____. "Hanguk namjong-hwa ui byeoncheon 韓國 南宗畵의 變遷" (The Vicissitudes of Korean Southern School Painting). In *Hanguk hoehwa ui jeontong* 『韓國 繪畵의 傳統』 (Traditions of Korean Painting), 250-309. Seoul: Munye culpan-sa, 1988.

_____. "Joseon hugi mit malgi ui sansuhwa 朝鮮 後期 및 末期의 山水畵" (Landscape Painting at the End of the Joseon Period). In *Sansuhwa* 『山水畵』 (Landscape Painting), 163-175. Vol. 11 of Hanguk ui mi 韓國의 美 (Beauty of Korea Series). Seoul: JoongAng Daily, 1982.

_____. *Hanguk hoehwa sa* 『韓國繪畵史』 (History of Korean Painting). Seoul: Iljisa, 1980.

_____. "Joseon wangjo hugi hoehwa ui sin donghyang 朝鮮王朝 後期 繪畵의 新動向" (New Trends in Late Joseon-Period Painting). *Gogo Misul* 『考古美術』 134 (June 1977): 8-20.

Areumdaun Geumgangsan 『아름다운 金剛山』 (Beauteous Geumgangsan), exhibition catalog. Seoul: National Museum of Korea, 1999.

Bak, Eun-sun 朴銀順. *Geumgansan-do yeongu* 『金剛山圖 研究』 (A Study of Paintings of Diamond Mountains). Seoul: Ilji-sa, 1997.

_____. "Hosaeng-gwan Choe Buk ui sansu-hwa 毫生館 崔北의 山水畵" (Landscape Painting of Choe Buk). *Misulsa Yeongu* 『미술사 연구』 5 (1991): 31-73.

Byeon, Young-seop 邊英爕. *Pyoam Gang Se-hwang hoehwa yeongu* 『豹菴姜世晃繪畵研究』 (A study of Painting of Gang Se-hwang). Seoul: Ilji-sa, 1988.

Cheongjeon Yi Sang-beom 『靑田 李象範』 (Cheongjeon Yi Sang-beom), exhibition catalog. Seoul: Ho-Am Art Museum, 1997.

Choe, Gang-hyeon 崔康賢. *Hanguk gihaeng munhak yeongu* 『韓國 紀行文學研究』 (A Study on Korean Travelogs). Seoul: Ilji-sa, 1982.

Choe, Wan-su 崔完秀. *Gyeomjae ui Hanyang jingyeong* 『겸재의 한양 진경』 (Gyeomjae's True-view Landscapes of Hanyang). Seoul: Donga ilbo-sa, 2004.

_____. *Jingyeong sidae* 『진경시대』 (The Era of True-view Landscape Painting). 2 vols. Seoul: Dolbegae, 1998.

_____. *Gyeomjae Jeong Seon jingyeong sansuhwa* 『謙齋 鄭敾 眞景山水畵』 (True-View Landscape Paintings of Gyeomjae Jeong Seon). Seoul: Beomu-sa, 1993.

_____. "Gyeomjae Jeong Seon jingyeong sansuhwa-go 謙齋 鄭敾 眞景 山水畵 考." (A Study of the True-View Landscape Paintings of Jeong Seon). *Kansong Munhwa* 『澗松文華』 21 (1981): 39-60.

Choe, Yeong-seong 崔英成. *Hanguk yuhak sasang-sa*『韓國儒學 思想史』 (History of Korean Neo-Confucian Thought). Seoul: Asea Munhwa-sa, 1995.

Danwon Kim Hong-do: Tansin 250 junyeon ginyeom teukbyeoljeon『檀園 金弘道 탄신 250주년 기념 특별전』 (Danwon Kim Hong-do: An Exhibition Commemorating the 250th Anniversary of the Artist's Birth), exhibition catalog. Seoul: Samsung Foundation of Culture, 1995.

Gang, Gwan-sik 姜寬植. "Joseon hugi misul ui sasangjeok giban 朝鮮後期 美術의 思想的 基盤" (The Intellectual Foundations of the Arts of the Late Joseon Period). In *Hanguk sasangsa daegye*『韓國思想史大系』 (An Outline of Intellectual History of Korea), 535-592. Seongnam: The Academy of Korean Studies, 1992.

_____ . "Geumgang jingyeong jeongsin-go 金剛眞景傳神考" (A Study on the True-view Landscapes of Mount Geumgang). In *Kansong Munhwa*『澗松文華』56 (1999): 81-109.

Guggyeok Seongho saseol『國譯 星湖僿說』 (Vernacular Korean translation of the *Seongho saseol*). Vol. 1. Seoul: Minjok Munhwa Chujinhoe, 1977/1982.

Hanguk geundae hoehwa myeongpum『韓國近代繪畵名品』 (Modern Paintings of Korea: Tradition & Transformation), exhibition catalog. Gwangju: Gwangju National Museum, 1995.

Hanguk gungnip jungang bangmul gwan Hanguk seohwa yumul dorok『韓國國立中央博物韓國書畵遺物圖錄』 (Illustrated Catalogue of Paintings and Calligraphy in National Museum of Korea). Seoul: National Museum of Korea, 1998.

Hong, Seon-pyo 洪善杓. "Choe Buk ui saengae wa uisiksegye 崔北의 生涯와

意識世界" (The Life and Art of Choe Buk). *Misulsa Yeongu*『미술사연구』5 (1991): 11-30.

_____. *Joseon sidae hoehwasa ron*『朝鮮時代繪畫史論』(Essays on History of Korean Painting). Seoul: Munyechulpan-sa, 1999.

Hwaga wa yeohaeng『화가와 여행』(Artists on Journey), exhibition catalog. Seoul: Seoul National University Museum, 2004.

Jeong Seon『鄭敾』. Vol. 1 of Hanguk ui mi 韓國의 美 시리즈 (Beauty of Korea Series). Seoul: JoongAng Daily, 1977.

Jin, Jun-hyun 陳準鉉, *Danwon Kim Hong-do yeongu*『단원 김홍도 연구』(A Study of Kim Hong-do). Seoul: Ilji-sa, 1999.

Jo, Seon-mi 趙善美. "Dongyu-cheop go 東遊帖考 (A Study on the Dongyu-cheop)," *Dongyu cheop*『東遊帖』(Album of Travel to the East). Seoul: Sungkyunkwan University Press, 1994.

Joseon hugi gukbojeon『朝鮮後期國寶展』(Treasures of the Late Joseon Dynasty 1700-1910), exhibition catalog. Seoul: Ho-Am Art Museum, 1998.

Joseon jeongi gukbojeon『朝鮮前期國寶展』(Treasures of the Early Joseon Dynasty 1392-1592), exhibition catalog. Seoul: Ho-Am Art Museum, 1996.

Kim, Won-yong 金元龍 and Ahn Hwi-joon 安輝濬. *Hangukmisulsa*『韓國美術史』(History of Korean Art). Seoul: Sigong-sa, 2003.

Mongyu Geumgang: geurimeuro boneun Geumgangsan 300 nyeon『夢遊金剛: 그림으로 보는 금강산 300년』(Diamond Mountain Dreams: Three Hundred Years of Mount Geumgang Art), exhibition catalog. Seoul: Ilmin Museum of Art, 1999.

Mun, Myeong-dae 文明大. "Noyeong ui Amita Chijang bulhwa e daehan gochal 魯英의 阿彌陀 地藏佛畵에 대한 考察" (On No Yeong's Amitabha and the Bodhisattva Kstigarbha). *Misul Jaryo*『美術資料』25 (Dec. 1979): 47-57

Myeongpum dorok: Hoehwa『名品圖錄: 繪畵』(Korean Art Treasures: Paintings [in the Collection of Sunmoon University Museum]). Vol. II. Asan: Sunmoon University Museum, 2000.

O, Ju-seok 吳柱錫. "Hwaseon Kim Hong-do, geu ingan gwa yesul 畵仙 金弘道, 그 人間과 藝術" (The Immortal Painter Kim Hong-do: His life and Art). In *Danwon Kim Hong-do*『檀園 金弘道』, 6-112. Seoul: Samsung Foundation for Culture, 1995.

O, Se-chang 吳世昌. *Geunyeok seohwa-jing*『槿域書畵徵』(Biographical Dictionary of Korean Calligraphers and Painters). Seoul: Bomun seojeom, 1975 reprint.

Owon, Jang Seung-eop: Joseon wangjo ui majimak dae hwaga『吾園 張承業: 조선 왕조의 마지막 대화가』(Special Exhibition of Paintings of Jang Seung-eop: The Last Master of Painting of the Joseon Dynasty). exhibition catalog. Seoul: Seoul National University Museum, 2000.

Pyoam yugo『豹菴遺稿』(The Collected Writings of Pyoam). Seongnam: The Academy of Korean Studies, 1979.

Yi, Dong-ju 李東洲. "Gyeomjae ilpa ui jingyeong sansu 謙齋 一派의 眞景山水" (True-View Landscape Paintings by a Group of Followers of Gyeomjae). In *Urinara ui yet geurim*『우리나라의 옛 그림』(Old Paintings of Our Country [Korea]). Seoul: Bakyeong-sa, 1975.

Yi, Ju-seong 李周成. "Choe Buk gwangye munheonjaryo 崔北관계 문헌자료" (Documentary Sources on Choe Buk). *Misulsa Yeongu*『미술사 연구』5 (1991): 5-9.

Yi, Man-bu 李萬敷. *Jihaeng-rok*『地行錄』(Records of Traveling the Land). Vernacular Korean trans. by Yi Chang-seop. Seoul: Mongnan munhwa-sa, 1990.

Yi, Song-mi 李成美. "Cheongjeon Yi Sang-beom ui hoehwa 청전 이상범의 회화" (Cheongjeon Yi Sang-beom's Paintings). In *Hanguk ui misulga: Yi Sang-beom*『한국의 미술가: 이상범』(Korean Artist: Yi Sang-beom). Seoul: Ho-Am Art Museum, 1997.

_____. "Hangukin ui jeongseo: Cheongjeon Yi Sang-beom ui hoehwa 韓國人 의 情緒: 靑田 李象範의 繪畫," (Korean Ethos: The Paintings of Cheongjeon Yi Sang-beom). In *Cheongjeon Yi Sang-beom*『靑田 李象範』, 16-29. Seoul: Ho-Am Art Museum, 1997.

_____. "Imwon gyeongjeji e natanan Seo Yu-gu ui jungguk hoehwa mit hwaron e daehan gwansim" 林園經濟志 에 나타난 徐有榘의 中國繪畫 및 畫論에 대한 關心," (Seo Yu-gu's Interest in Chinese Painting and Painting Theory as Expressed in the *Imwon gyeongjeji* [Treatise on Rural Economy]). *Misul Sahak Yeongu*『美術史學研究』193 (March 1992): 33-61.

_____. "Goryeo chojo Daejanggyeong ui Eoje Bijangjeon panhwa 高麗初雕 大藏經의 御製 秘藏詮 版畫" (Woodblock Illustrations of the "Imperially-Composed Explanation of the Secret Treasure" in the First Edition of the *Tripitaka Koreana*). *Gogo misul*『考古美術』169-170 (1986): 14-70.

_____. "Bukhan ui misulsa yeongu hyeonhwang 北韓의 美術史 研究 現況 "(Art History Research in North Korea Today). In『北韓의 韓國學 研 究 成果 分析』(An Analysis of Korean Studies Research Results in North Korea), 293-358. Seongnam: The Academy of Korean Studies), 1991.

Yi, Tae-ho 李泰浩. "Han Si-gak ui Buksae Seoneun-do wa Bukgwan

Silgyeong-do 韓時覺의 北塞宣恩圖와 北關實景圖" (Han Si-gak's Painting Depicting the Scenery of Northern Frontiers and the Site of the Special State Examination). *Jeongsin Munhwa Yeongu*『정신문화연구』34 (1988): 207-235.

_____. "Joseon hugi jingyeong sansuhwa ui baldalgwa toejo 朝鮮 後期 眞景山水畵의 發達과 退潮" (The Development and the Decline of True-view Landscape Painting of the Late Joseon Period). In *Jingyeong Sansu-hwa*『眞景山水畵』(True-view Landscape Painting), exhibition catalog. Gwangju: National Museum, 1987.

_____. "Jiujae Jeong Su-yeong ui hoehwa 之又齋 鄭遂榮의 繪畫." (The Paintings of [Chiujae] Jeong Su-yeong) *Misul Jaryo*『美術資料』34 (June, 1984): 27-45.

_____. "Jingyeong sansu ui jeongae gwajeong 眞景 山水의 展開 過程." In *Sansuhwa*『山水畵』(Landscape Painting), 212-220. Vol. 12 of Hanguk ui mi 韓國의 美 (Beauty of Korea Series). Seoul: JoongAng Daily, 1982.

_____. "Jinjae Kim Yun-gyeom ui jingyeong sansu 眞宰 金允謙의 眞景山水" (True-View Landscapes of Kim Yun-gyeom) *Gogo misul*『考古美術』52 (Dec. 1981): 1-23.

Yi, Ye-seong 李禮成. *Hyeonjae Sim Sa-jeong yeongu*『玄齋 沈師正 研究』(A Study of Sim Sa-jeong). Seoul: Ilji-sa, 2000.

Yu, Hong-jun 兪弘濬. *Hwain yeoljeon*『화인열전』(Biographies of Korean Painters) 2 vols. Seoul: Yeoksa bipyeong-sa 역사비평사, 2001.

_____. *Geumgangsan*『금강산』(Mount Geumgang). Seoul: Hakgojae, 1998.

Yu, Jun-yeong 兪俊英. "Gogun Gugok-do reul jungsim euro bon sipchil segi silgyeong sansu baljeon ui illye 谷雲九曲圖를 중심으로 본 17세기 實

景山水發展의 一例" (One Seventeenth-Century Example of Actual Scenery Painting: The Nine-Bend Stream of Gogun). *Jeongsin Munhwa*『精神文化』8 (1982): 38-46.

_____. "Gugok-do ui balsaeng-gwa gineung e daehayeo 九曲圖의 發生과 機能에 대하여" (On the Origin and Function of Paintings of the Nine-Bend Stream). *Gogo misul*『考古美術』151 (1981): 1-20.

Yun, Jin-yeong 尹軫暎. "Joseon sidae gugokdo ui suyoung gwa jeongae" 朝鮮時代 九曲圖의 受容과 展開 *Misul Sahak Yeongu*『美術史學研究』217/218 (1998): 61-89.

Uri ttang, uri ui jingyeong『우리 땅 우리의 진경』(Our Land, Our True-view Landscapes), exhibition catalog. Chuncheon: Chuncheon National Museum 국립춘천박물관, 2002.

Glossary and Index of Names and Terms